selling Art without galleries

Toward Making A Living From Your Art

daniel grant

**ALLWORTH
PRESS**
NEW YORK

© 2006 Daniel Grant

10 09 08 07 06 5 4 3 2 1

Published by Allworth Press
An imprint of Allworth Communications, Inc.
10 East 23rd Street, New York, NY 10010

Cover design by Derek Bacchus
Interior design by Dianna Little
Page composition/typography by Integra Software Services, Pvt. Ltd., Pondicherry, India

ISBN-13: 978-1-58115-460-3
ISBN-10: 1-58115-460-7

Library of Congress Cataloging-in-Publication Data:

Grant, Daniel.
 Selling art without galleries: toward making a living from your art/ Daniel Grant.
 p. cm.
 Includes index.
 ISBN-13: 978-1-58115-460-3 (pbk.)
 ISBN-10: 1-58115-460-7 (pbk.)
1. Art—United States—Marketing. I. Title.

N8600.G71 2006
706.8—dc22

 2006026630

Printed in Canada

Table of Contents

Introduction

●

For many up-and-coming artists, the goal is to get into a gallery. That is not necessarily synonymous with selling one's work or supporting oneself from those sales, but it is easy to get lost in the idea that a gallery equals prestige, art world acceptance, and a ready group of buyers. Certainly, galleries stay in business because they do sell artwork, but not every artist they show or represent makes out as well. Lots of gallery shows take place that do not result in sales or reviews; they may not be advertised or memorialized in a catalogue (two expenses that dealers increasingly have cut back on), and the exhibiting artists may find themselves out the cost of framing, shipping, and insurance (dealers have cut back there, as well). Many places that call themselves galleries primarily make their money as poster or frame shops, with original art as a sideline. Added to this, there are far more artists who want to exhibit and sell their work than galleries to show it.

A growing number of artists are looking at galleries as just one part— or, perhaps, not even a part at all—of their plans to show and sell work. They look to a variety of exhibition venues, such as nonprofit art spaces, cooperative galleries, art fairs, and even their own studios, to present their work, unmediated by a dealer who also takes a hefty percentage of the sale price. These artists are also aware that they can speak for their art better than any third party and that, in fact, many collectors are eager to speak with the artists directly rather than with a gallery owner.

Working without exclusive gallery representation is not just for the young and uninitiated artist. Many renowned artists, with years of experience in galleries, have found that they can better represent their own interests than can dealers. "Some artists just want to live like

hermits, sending in their art to a gallery and otherwise avoiding the art world, but not me," said seventy-something-year-old Pop Art painter James Rosenquist. "I like to meet my collectors." He has had a lot of that in the past few years, having left New York's Gagosian gallery in a dispute ("There was no communication. I said to Larry, 'I can never talk to you,' and he said, 'That's the way it is' "). Before returning to a gallery's fold in 2005, he was the main source of his new and unsold older work for would-be collectors, handling inquiries out of his studio. There had been commissions and get-togethers with younger and more mature buyers. Perhaps some of the face-to-face stuff lost its appeal, but there were some benefits, principally not having to lose so much of the sale price in a gallery commission and not needing to rely on those mercurial beings called dealers.

Rosenquist has not been alone in this. Painter Frank Stella also has taken on the responsibility of arranging exhibitions and commissions. "As Barnett Newman used to say, 'I'm flying under my own colors now,' " Stella said. He does not claim to enjoy acting as the primary agent for his own sales. "I'm not particularly good at it, and I don't particularly like doing it, but that's life. Someone has to sell the pictures." One trend that emerged in the 1990s is for artists to reject an exclusive relationship with a particular dealer, opting instead for what painter Peter Halley called "a constellation of galleries that represent my work." Exclusivity means that all exhibitions and sales go through a particular dealer. Halley had exclusive relationships with the Sonnabend Gallery and Larry Gagosian, but left both in part because dealers elsewhere did not want to share sales commissions with New York galleries, resulting in lost revenues. "Seventy-five percent of my market is in Europe," he said. "My collectors are not likely to come to New York to buy. Dealers in Europe chafe under the requirement that they pay half of the commission they earn to my New York dealer. Europeans like to buy from dealers they know and trust and with whom they have a personal relationship. For instance, I have found that German collectors will only buy from a German dealer. I found that I could do better establishing relationships with half a dozen dealers around the world than by participating in an exclusive relationship with a New York dealer."

His point has been taken: Artists are no longer willing to be defined by their gallery, and a growing number have grudgingly or happily taken on the job of promoting sales of their own work. Andrew Wyeth, for example, the grand old man of American painting, is not represented by any gallery and hasn't been since New York's Coe Kerr Gallery closed its doors in 1990. He continues to produce new work, directing particular pieces to an agent in Tennessee and others to galleries in a few cities around the United States.

Halley's other point has also been heard, as dealers are recognizing the need to pursue sales opportunities around the world, traipsing from art fair to art fair, spending less time in their galleries even while some artists strive to get into them. (Perhaps gallery owners have been learning what the artists and craftspeople who regularly participate in arts festivals have long known.) More and more, these fairs are where the action is, where a growing chunk of the contemporary art market is going on. New and sometimes staggering amounts of wealth are being generated in China, Russia, the Middle East, and in a variety of countries that used to be categorized as the Third World, and these new buyers expect sellers of art to come to them rather than having to travel to, say, New York or London. In many instances, dealers have the artist on hand at these fairs to meet with prospective buyers because they also know that collectors frequently want to meet the creator and that investment in time makes a sale more likely. In addition, when they are not packing for the next art fair, dealers are spending an increasing amount of time online, sending JPEGs to would-be collectors and arranging sales to people around the world. The traditional brick-and-mortar gallery still has primacy, but far less than five or ten years ago. It is sometimes thought that by working outside the dealer-gallery artist-critic-curator nexus, artists are isolating themselves from the value mechanics of the market for art, limiting their prestige and prices. However, the changing patterns of exhibiting and buying art have weakened somewhat that center of power.

One also sees that museum curators more and more are on the prowl for new artists, refusing to wait for gallery shows and purchases by collectors to affirm the importance of artwork—almost all of the

exhibitions of digital art to date have taken place at museums and fairs, for instance. These curators of contemporary art know that the work of less well-known artists may become expensive, seemingly overnight, and they have become aggressive in seeking out pieces that their limited budgets can afford, rather than waiting for donations sometime down the road.

There still is a place for the artist who wants to be a hermit (albeit a hermit with a large following of collectors) and, certainly, not every artist has the personality or temperament to be the spokesperson and seller of his or her own work. Talking about one's own art, determining the audience for that art, promoting it, and negotiating its price are not skills that anyone is born with. These need to be learned and, like everything else, require practice. This book describes what is involved in artists exhibiting and selling their work directly to the public, where much of this activity takes place. The ideas and examples presented are drawn from the experience of artists themselves, as often as feasible in their own words, rather than through a dry discussion of theoretical possibilities. This is not a how-to book but a description of options available to artists; being grown-ups, artists can determine for themselves the avenues they choose to pursue. Right and wrong take a back seat to what has or has not proven effective for certain artists. The only directive is for readers—artists—to think of themselves as directing the course of their own careers, not waiting for the career to begin when someone else takes over the business aspects and not requiring some gallery owner to validate them as professionals.

part

1

Marketing and Selling Outside of Galleries

chapter

Adjusting Expectations

Beth Kantrowitz, director of the Allston Skirt Gallery in Boston, Massachusetts, tells her mostly emerging and mid-career artists the same thing before a show and after a show. "I always say, the show will be the best we can do," she said. "I can't promise that we will sell anything. I can't promise that the artist will get a review." Such candor and earnestness should go a long way toward assuaging dashed hopes, yet Kantrowitz must still face some bitterly disappointed artists who had expectations for something much better. Some percentage of these artists believe (dream?) that the exhibition will sell out, that reviews will be written (and be glowing), that a major New York City gallery will snatch the artist up—the cover of *Art in America* and museum retrospectives to follow.

Are You Being Realistic?

And why not? Most students in art schools and university art departments are only connected to the practicing art world through the art magazines, which highlight success and the latest new thing. Expectations soar for something big and soon to happen, and the reality rarely comes close. Kantrowitz stated that an artist "should expect a gallery to do what it says it will do," but some artists hear more than the words spoken to them.

Unrealistic expectations may get in the way of building a career—for instance, if the artist launches into a diatribe when sales and acclaim do

not follow the very first exhibition ("The critics hated the Impressionists, too"), or if a dealer or exhibition sponsor is treated as a stepping stone to another that is more prestigious, or if useful gallery affiliations are passed over because an artist has his or her heart set on a particular dealer. Such expectations can lead to self-defeating behavior (the artist strikes people as angry, the artist doesn't work as hard or produce as much). Framingham, Massachusetts, painter Ben Aronson noted that, early in his career, he had sabotaged relationships with some dealers by being too "self-directed," rarely talking with the dealers and gallery staff, never showing up at gallery openings and other events. "You can't just produce work, send it on to the gallery, and expect everything to go well," he said. Another painter, John Morra of Stuyvesant, New York, claimed that he took a bad attitude toward galleries into his first meeting with San Francisco art dealer John Pence. His friend and former teacher Jacob Collins "got me into the John Pence Gallery by going to bat for me," Morra said, but at that meeting "I was being grumpy and weird, saying, 'I don't want to be a careerist.' At the time, I thought that supporting myself as an artist was selling, but John Pence said to me, 'Young man, you should make a more professional presentation.'" Time and economic necessity brought a change in Morra's thinking.

One self-defeating belief is that pursuing potential buyers and sales is contrary to the nature of art, and that such a use of time should be labeled "careerism." (There are a lot of terms that artists who do not have a history of sales use to boost their own egos and others—derogatory—for artists who do exhibit and sell.) Collectors, critics, and dealers don't beat a path to one's door, and artists need to be proactive in presenting themselves and their work to a world in which there is an ever expanding oversupply of art.

The artists on whom this more assertive approach is probably the most incumbent are those living in rural areas, apart from other artists (who could provide support and feedback) and separated by vast distances from exhibition opportunities. There are often few places to find certain art supplies, as well as discrimination against these artists both within the rural setting (where they may be viewed as oddballs) and in the larger cities (simply because the artists live in the boondocks).

Artists who put where they want to live ahead of where the art scene is happening sometimes adjust to their surroundings in the way they buy materials and ship artwork (downsizing their pieces, reducing weight, or even changing media, from oil on canvas to watercolor on paper), learning how to build a crate (to save money on shipping), buying a comfortable van or station wagon and learning to enjoy long rides (distances west of the Mississippi are measured less in miles than in hours in the car). They may focus on the local audience, offering lower priced pieces (watercolors are less expensive than oils) of recognizable subject matter, or they might gain local attention through teaching and demonstrations (at libraries and local clubs, for instance), which, perhaps, will turn some locals into buyers. They join clubs, societies, and artist membership organizations, as well as getting on the mailing list of the state arts agency (which sends useful information about art competitions and news in the field) and developing good work habits that allow them to continue working at a high level even when lonely.

Expectations change through life experience. When he entered an art career, Longwood, Colorado, painter Scott Fraser looked for one big, powerful gallery—such as Marlborough or Pace Wildenstein in New York City—to handle his work. His experience with some larger galleries led him to see that "I like more galleries and smaller ones, where I can talk to the director." In addition, he found out "pretty early out of art school that I can't just do one big painting and assume that will make my reputation. Now, I want to sell regularly."

Part of the maturation process for an artist is learning to align one's hopes with reality, or it may entail changing the reality. Daniel Sprick, a painter in Glenwood Springs, Colorado, spent twenty years grumbling about what his dealers were not doing for him. In 2002, he decided to become his own dealer, advertising in *American Art Review* (always including the line "No dealer inquiries"), developing a Web site, and selling his work directly to buyers.

"When I left school, I thought I'd get a dealer who would take care of all the selling and financial stuff, so all I would have to do is paint," he said. He went through a number of dealers—there was a problem with

5

almost every one—before becoming his own salesman. Sprick claimed that he does a superior job of discussing his artwork than any dealer ever did ("When you communicate through an intermediary, a lot is lost," he said. "No one cares about your baby the way you do."), and he prefers to earn all of the money from sales, rather than just half. "When I had heard of other artists who were selling their own work, I thought they were crazy, egomaniacs," he said. "There is a specter of self-promotion that is ugly, but I'm over that now. I serve my needs better than anyone else." He added that "all my work of the past two years has sold."

Much of what an artist wants to happen might happen anyway, but the process may take a far longer period of time than he or she anticipates. The 1980s generated the idea of the fine artist as rock star, coming on fast and furious at a young age, entering the international art circuit, cashing in quickly because no one lasts more than a decade. It can happen—it has happened—but it doesn't happen very often. Julian Schnabel, David Salle, Mark Kostabi, Robert Longo, Kenny Scharf, and a variety of others may not be the most appropriate role models for artists who, instead, need to understand that it takes years to develop a collector base.

Nobody paints simply to have a studio filled with paintings. Art is a form of expression, and artists, like everyone else, want their voices to be heard. But they want more than to have their works seen, they want appreciation and esteem—they want their work to be coveted. If they see themselves as professionals, artists want sales and they want to be written about; dare we say they want fame? A person who decides to become an artist primarily because he wants to be a celebrity or because he wants to prove he is unique is likely to be disappointed. In a world where there appears to be an oversupply of artists, many feel the need to stand out from the crowd: Will artwork that shocks public sensibilities or blocks traffic do the trick? Certainly, as many artists discover, renown is quite limited in scope and brief in duration, and even successful artists—success defined as the ability to support themselves from the sale of their work—remain on fame's periphery.

Expectations aren't something that only get lowered; in time, they may broaden and reach unanticipated levels. When she began her

career, Watertown, Massachusetts, artist Susan Schwalb wanted her work in the type of New York galleries that didn't exhibit her type of art, just because they were the "hottest" galleries, and she "wanted to be on the cover of *Art in America*, like someone else might want to be Miss America." Neither of those hopes panned out, but her work was taken on by a Manhattan art dealer (Robert Steele Gallery) and a half dozen others around the country, as well, and her goals changed with the increasing number of sales during the 1990s. "At a certain level, you begin to see the possibilities at a higher level," Schwalb said. "The Museum of Modern Art owns one of my works; I want them to acquire more. I would like a print publisher to come to me to produce an edition of prints. I would like a write-up in *The New York Times*. I'd like a retrospective at a museum and a book about my work. When I started out, I wouldn't have been thinking in these terms, but now I don't see it as so unrealistic."

Marketing Artwork

Before trying to sell anything, one needs to find the appropriate audience. This is the central concept of marketing, and it is as true for artwork as it is for toothpaste and automobiles. Not everyone is going to want to buy a work of art, and not everyone who collects art is likely to purchase a particular artist's work. Finding the right niche— the type of collectors who are interested in one's art, or the specific galleries or juried art shows featuring a certain type of artwork, for example—is the most important first step to developing sales.

There is often a lot of trial and error in marketing, as artists winnow down the potential avenues for sales to those that show the best results. "I used the spaghetti method of marketing," said James Wall, a painter in Charlottesville, Virginia. "You throw spaghetti at the wall and what sticks, you stay with." He tried sending out brochures of his work to art consultants ("haven't done a great deal for me"), art dealers ("not a lot of interest"), licensing agents ("nothing has happened") and print publishers ("nothing"). He offered to paint a mural on the wall of a restaurant for the modest price of $2,000, believing that "a lot of people will see my work that way," and that has resulted in some sales to diners.

Most successful for him has been entering local art exhibitions, where digital reproductions of his botanical motif paintings have sold to both Charlottesville natives and tourists, usually while he is present. For all the effort Wall has put into his paintings and brochures, it is his personality that assures potential buyers that his artwork is the product of someone in whom they can feel confidence. "I used to worry about what to say to people when they looked at my work," he said. "Often, I didn't say anything, or not much. Then, I relaxed about the whole thing and just started talking naturally to people, about their children, about the weather, about anything. If they asked me questions about my work or my technique, I would answer them, but I never put pressure on anyone to buy something." Based on his experience, Wall now makes a point of being at shows of his work as often as possible, "because my presence really has an effect."

Like James Wall, New York City abstract expressionist painter and printmaker Mike Filan also struck out in a variety of directions when he first began to seek his market, investing $8,000 one year for a booth at the annual Art Expo in Manhattan ("I sat there for a week, and people just walked by") and $300 for a booth at the annual conference of the American Society of Interior Designers ("it didn't pan out for me"). Yet another $300 was spent on bottles of wine ("good wine seemed like the capper") for a three-day open studio sales event that a friend who was looking to become a corporate art consultant organized on his behalf, but that also didn't result in any sales. In contrast to James Wall, the benefit of his presence and personality did not create any converts; however, Filan did have more luck than Wall with brochures.

He spent $2,000 to print 4,000 foldout brochures that featured a number of color images of his work with a small bio on the back, and another $2,000 for mailing. Filan was fortunate that the design of the brochure by another friend only cost one of his prints in barter. Several hundred dollars were also spent on purchasing mailing lists of art dealers and consultants. Between 5 and 7 percent of those people to whom he sent a brochure responded to his mailer and, "out of that, 3 percent have actually sold work," he said. "All you need is one, two, or three corporate consultants to sell your work regularly." Most of

the sales have been prints—a dealer in Florida sold five, while a dealer in Texas sold ten, and there were sales of five others to Colgate-Palmolive, ten to Pfizer, and twenty to a group of teachers. All in all, Filan has earned $30,000 from that one mailer.

Joan Gold, a painter in Eureka, California, also has had success marketing artwork to consultants who, in turn, act as agents for her work to private—usually corporate—clients, taking a percentage of the sales price (from 30 to 50 percent) as a commission. "Eureka is at the end of the world," she said. "There aren't many galleries close by." She added that her few experiences going from one gallery to the next were "just plain bad."

Gold purchased her list of consultants from artists' career advisor Caroll Michels and sent each person on the list a brochure of her work. The result was responses from dozens of consultants to whom she began sending out her original paintings, rolling her canvases and placing them into hard cardboard tubes that are sent through Federal Express. "The benefit of consigning work to consultants is that you get a commission without additional expenses," she said. "The consultant pays for framing." Gold works with thirty consultants, twenty of whom are actively promoting her paintings at any given time, and "I keep in touch with all of them by cards, mailers, phone calls—they need to be reminded of who you are and what you do." One or two paintings (with an average price of $3,000–6,000 before commission) sell somewhere each month, and she has sold between thirty and forty paintings over the past two years.

There are probably as many successful approaches to marketing art as there are artists who have sold their work; some artists have sold work through a Web site, while others earn a following at selected juried art competitions. Still other artists maneuver to know the right people.

Many artists also have found it advisable to have a friend, relative, or spouse on hand at exhibitions, art fairs, and open studio events in order to take on some of the business aspects of marketing and sales, allowing the artist to take a more Olympian role (talking about art, sources of inspiration, technique, philosophy, or artistic influences,

among other topics). A spouse, for instance, might lead visitors over to the guest sign-in book or discuss the price range for artworks on display or just chat up guests who show interest in the art. What type of art do they like? Whose artwork have they purchased? Where do they live? What are their domestic arrangements? Do they have children? Where do they work? What are their hobbies or interests? Are they members of any clubs or associations? This is the kind of survey information that constitutes marketing and, when conducted informally, is not likely to irritate visitors. Most people like to talk about themselves, and the information that an artist or a spouse/ friend/relative can gather will help determine where future exhibitions should take place and who should be invited.

Determining one's audience is crucial, because not all art appeals to everyone. Some artwork may find a greater response among women than men, homeowners rather than apartment dwellers, corporate office decorators more than homeowners, the young more than those over forty. The knowledge will inform where future exhibitions might take place.

Exhibits ought to be seen as an element of marketing rather than just a vehicle for sales. Art shows are major events for artists, but to most other people they come and go without leaving much of a trace, maybe a line on a résumé; a catalogue provides a record of an exhibition and gives a longer afterlife, but catalogues are expensive (the artist usually pays all or most of the costs) and usually are not produced. Often, artists go a year or two or three between shows, and it is not at all clear that the people who came to the last show will remember whatever enthusiasm they might have felt back then when the next exhibit occurs, if they even recall the artist's name. Artists need to maintain contact with the people who visited their shows (the guest sign-in book isn't just a formality) in those in-between times through periodic mailings of postcards, brochures, or newsletters that describe what the artist is doing—such as having a new exhibition, producing a new series of prints, teaching a class or workshop, giving a talk—and many of these communications can be personalized, depending upon how much information the artist has accumulated about the recipient: As the holiday season is approaching, how about buying your wife something unique for Christmas/Hanukkah/Kwanza/Ramadan (better find out

which one), such as an etching? What could be a better way to celebrate your twenty-fifth wedding anniversary than with a statue? Now that you bought that summer cottage on Martha's Vineyard, you are probably turning your thoughts to decorating. ...

Exhibitions start a process of developing a network that, eventually, may become a customer base. Of course, artists are not starting from zero in this; they already know people—colleagues and supervisors at work, friends and relatives (who also have colleagues and supervisors)—who know other people, and this may build out into an extensive list of potential collectors. If new exhibition opportunities are not soon in coming for a growing list of interested people, artists may create their own, by opening up their studios for visits (see chapter 3), creating a display of work in their own home or that of a friend, bringing work to the home or office of a prospective buyer (a modified Tupperware party) or arranging an exhibition at nonprofit (library, arts center, senior center, town hall) or commercial (bank lobby, restaurant, bookstore) space.

It was more than serendipity that enabled Denise Shaw, a yoga instructor and painter of abstract imagery on Japanese rice paper using oriental brush techniques, to sell all of the works from a show hung at the Yoga Connection in downtown Manhattan. A suitable mix of Eastern-oriented art and an audience of people involved in an Eastern exercise and meditation was the key. The Yoga Connection did not have a gallery space, but Shaw identified an opportunity and seized it. She also received several commissions for new work from people who practice yoga there and saw her art. "My work appeals to a certain kind of person who practices yoga, who is into my use of psychological concepts and poetry," Shaw said. Noting that her work regularly is displayed at the Yoga Connection, she called the studio "a pretty good venue for me," far superior to the commercial, nonprofit, and co-op galleries where her work has been exhibited in the past that did not result in sales.

While some marketing efforts are hit-or-miss, others are the result of painstaking planning and research. Long Island, New York–based painter and printmaker Anne Raymond scours art and general-interest magazines (*Art in America*, *ARTnews*, *The New Republic*, among others)

for the type of artwork that is appreciated and bought in certain cities around the United States ("the prices for my paintings are just too low for New York City, under $10,000"). She hones in on the galleries that feature realist painting in these cities, looking for the type of artists represented there and the price range, as well as how long they have been in business and their location. Many galleries also have their own Web sites from which other or corroborating information may be obtained. Finally, Raymond travels to the city—she averages two of these business trips per year (to Santa Fe, New Mexico, Scottsdale, Arizona, Boston, Philadelphia, Chicago)—to look at the galleries in person and show her work.

The level of courtesy that she finds at the gallery is very important to her—"if anyone is snobby or rude to me, that's a turn-off right away from an artist's point of view or a customer's—and Raymond also checks that the information she read or heard about a gallery is borne out.

"I go into a gallery and tell them, 'I'm Anne Raymond. I live in New York, and I'm going to be in town only two days. I'd really like you to look at my work.' It's important that I mention only being in town for two days, otherwise they might never get back to you." When she visited the Peter Bartlow Gallery in Chicago, she brought a sheet of slides, and the gallery director asked to see originals, of which there were some in her hotel room. "Since I was only going to be there for two days, the director agreed to see my work that afternoon." At first, the Bartlow gallery took on her monotypes but later began handling her paintings and has sold a number of both. There are now three other galleries around the United States that also show and sell her art.

Another artist who sought to broaden his market is Dan Namingha of Santa Fe, New Mexico. There currently are private and public collectors of his work on four continents, although his career might easily have taken a less global turn but for some aggressive marketing on his part and that of his wife. Winning awards such as "Distinguished Artist of the Year" from the Santa Fe Rotary Foundation and an "Award for Excellence" from the governor of New Mexico, as well as a number of exhibition credits at galleries and museums throughout the Southwest, Namingha, who grew up on a reservation in Polacca, New Mexico,

could have relied on a solid standing as a regional artist. He and his wife, Frances, opened a gallery (Niman Fine Arts) in order to display his work and that of their sculptor son Arlo, but they were not content to wait for people to find their way to the gallery. Frances Namingha invited Jorg W. Ludwig to visit Niman Fine Arts in the early 1980s, because she knew he was an exhibition coordinator for the United States Information Agency. Impressed by Namingha's painting, which interweaves Hopi symbols into his artwork, Ludwig in fact did arrange a series of shows of the artist's work at U.S. embassies and national museums in Central Europe (Austria, Bulgaria, Czechoslovakia, Germany, and Romania) from 1983 to 1986. These shows brought considerable attention to Namingha's work, leading to purchases by both public and private collectors abroad. Additionally, United States embassies in Caracas, Venezuela, and La Paz, Bolivia, have purchased Namingha's work for their collections.

Frances Namingha has also traveled to a number of art museums on the East Coast in order to make presentations of her husband's work to curators who "often had never heard of him," she said. The result has been major shows at such notable institutions as the Fogg Art Museum in Cambridge, Massachusetts, and the Reading Public Museum and Carnegie-Mellon in Pittsburgh.

A Short Course in Public Relations

If someone were to create a job description for a fine artist, the list of responsibilities might be very long indeed. There's making the art, of course, but then comes the part of letting others know that the artwork exists and is worth buying. (This is where the list lengthens.) Artwork must be photographed, perhaps framed (and matted), crated and shipped; it may need to be promoted to the media, dealers, curators, and critics, and advertised to the public. A Web site might be created, which then must be updated on a regular basis. A considerable amount of time may be spent with designers and publishers of brochures, postcards, and prints; telephone calls (and follow-up calls) ought to be made, personal notes should be written; and the people who are to receive the portfolios, brochures, cards, phone calls, and notes have to be researched or found by networking. That's a lot for any one person.

It was certainly too much for Brooklyn, New York, painter Robert Zakanitch, who, in 2000, contacted Pat Hamilton of Los Angeles to help promote his work to museum curators around the United States. "It's not part of my temperament to go and schmooze and be impersonal about it," he said. "You need a thick skin to do this, which I don't have. Someone says something about my work, and I take it personally instead of just smiling and keeping the conversation going. I pay Pat to be a buffer between me and the art world."

Among the services that Hamilton performed was producing a brochure about Zakanitch's work, which she sent to more than 200 museum directors, the result of which was a touring exhibit of the artist's work that traveled to five institutions in the course of a year. For another artist, Robert Dash, a painter in Sagaponack, New York, who is represented by Manhattan's ACA Galleries, Hamilton promoted the artist's work to a variety of media outlets, and there were reviews of Dash's shows in *Art Forum* and *ARTnews* magazines. One might have thought that Robert Dash's gallery would handle the job of aggressively pursuing reviews in major art publications and that Dash himself would not need to pay Hamilton a $1,500 per month retainer to hound the magazine critics and editors, but "ACA has a larger roster of artists—far too many, to my mind—and they can't attend to me and my work nearly as much as I would like," he said.

Art is often thought of as a go-it-alone profession, but many artists use studio assistants to create the work and a battery of other help (business managers, career advisors, artist representatives, Web designers, publicists, and extraneous others) to promote and sell the finished pieces. Each type of help is specific, but there is sometimes a blending of roles—some career advisors write press releases or arrange for shows, for instance, while some business managers negotiate sales agreements.

All of these helpers are middlemen, acting in the space between the artist and the collector. Publicists in the art field work with other middlemen—the media (press, radio, and television), as well as those who sell art (dealers) or present it (curators), preparing press releases, visual images, and biographical materials (occasionally venturing into

the creation of a catalogue or coffee-table art book—again, as a promotional tool), following up with telephone calls and personal appeals. "It's not brain surgery," said New York City publicist Robyn Liverant, "but you need to know who to contact and how to present information to people, and then follow up. It's very labor intensive work."

In the case of Robert Dash, an artist contracted the services of a publicist because his gallery was not publicizing shows to his satisfaction. Another artist, Gary Welton, a painter in Long Island, New York, hired Manhattan publicist Shannon Wilkinson to promote an upcoming university gallery show. She created a small catalogue for the exhibition, which was then mailed to a variety of museum and gallery directors around the world. "Shannon knows a lot of people in the art world," Welton said, "and she made sure the right people saw the catalogue." Her efforts resulted in Welton's work being shown in a number of locations, including three in Minneapolis, two in Puerto Vallarta, Mexico, and one in Jaipur, India.

The job of a publicist is to not only tout some person or object to the world but also to "position" the client in the world, establishing that individual's or object's uniqueness. To Shannon Wilkinson, getting a lot of attention earns a person a "buzz," and other people think it "cool" to be around that individual or what the person creates. That is no easy task in the art world, where there is an abundance of artists. "Promoting one over another seems very subjective," said Richard Phillips, president of the Sedona, Arizona, publicity firm Phillips & Partners. As a result, when Curt Walters, a California painter who has created numerous images of the Grand Canyon, some of which he has donated in lieu of a cash contribution to the Grand Canyon Trust, came to the company several years ago to develop a media campaign to augment the promotional efforts of his gallery, Phillips made the focus of Walters' publicity not so much the quality of his art ("you don't want to deal with the subjectivity of who's a better artist") as his devotion to the cause of environmental conservation.

"We developed a program of promoting him as an environmentalist," Phillips said. "You couldn't get anyone to just write about his art, but we were able to find newspapers and television stations that were very

willing to report on him as an expert on environmental conservation who happens to also be an artist."

Working with a publicist can be quite expensive, and the results are neither assured—no publicist will guarantee that an artist's show will be reviewed or that the artist will be profiled in a newspaper or magazine—nor necessarily even measurable. Walters' career has prospered during the three years that he has worked with Phillips, but are these sales attributable to the work of the publicist or the natural progression of an increasingly successful artist's career? No one can definitively say. What is clear is that Phillips charges a monthly retainer of $2,500, or $30,000 per year. "If you want the car to run, you've got to put gas in the tank every month," Phillips said. Many months can go by before any results take place, "results" defined as something written about the artist. Phillips noted that he "worked for three years to get an Associated Press story of Curt Walters," making that a very costly article for the artist, which may not have been read by art collectors. Shannon Wilkinson has a range of fees—per project ($5,000) and a monthly retainer ($4,000)—depending upon the type of work required, although she stated that "you never know for certain if something will happen." With Gary Welton, what happened was a number of exhibitions of his work, but these shows have not been accompanied by a number of sales that would pay for the work Wilkinson did and the costs of producing the 2,000 copies of a catalogue. Claiming that "I'm not in a position right now to spend more money on publicity," Welton said that "if I know it would produce income for sure, I wouldn't hesitate to spend the money."

The primary rule of tumb for publicity, as for advertising, is that this is a long-term commitment; results cannot be purchased on the cheap, with one professionally produced press release or a few telephone calls. "You may not find a lot of people willing to work with individual artists," Robyn Liverant said, "because they don't usually have the means to pay." She largely confines her work to larger arts organizations and arts institutions, taking on the occasional fine artist. Liverant turns away many artists, such as the painter who "wanted me to do four months worth of work for $500. I was never more insulted in my career."

Every professional is told of the importance of investing in one's career, but publicity is an investment that may not work for every artist. "If little is happening in a career—not much is selling, there's no connection to a gallery, there's no collector base—you have the lowest potential results," Wilkinson said. "Getting a critical review in a major art magazine or the *New York Times* is the most measurable thing, and it is the least likely to happen. It takes a long time to develop a marketing presence and to cultivate saleability." On the other hand, she noted, self-supporting, mid-career artists whose work is regularly exhibited should earn twice the amount they spend on publicity and marketing over a two-year period. Because of the very real potential that an artist may spend a considerable amount of money and still not garner any significant media attention or resultant sales, Wilkinson and other publicists who work with individual fine artists usually offer an initial consultation to determine what the artist wants and expects and how likely it is that that can be achieved.

Artists need to carefully interview prospective publicists to insure that their hopes are realistic and to determine what is possible (critical review, feature article, calendar listing, or smaller mention). Liverant said that, when contacting a large public relations agency, artists should ask whether the person whom they are interviewing will handle their account "or if it will be staffed out to someone else at the firm. It's not uncommon that you'll interview a senior person at the firm, and then the work is delegated to more junior people." At a smaller firm or with an independent publicist, artists should inquire "what kind of client load the person is carrying. Will you get personal attention, or is the publicist juggling too many people?"

Artists would also want to know what other types of arts-related projects and clients the publicist has previously represented, in order to determine how strong a relationship the publicist has with that segment of the press, and they might ask to look at a clip book (containing stories generated through a past public relations cam-paign) or an outline of a publicity campaign. "The subject of money," Liverant said, "should come up later in the conversation. You want to get a sense of how long a project might take and what the publicist believes that he or she can realistically do for you. If it is publicizing

one show, that may require a certain number of months of work. Image-building, on the other hand, may take much longer."

She added that, when an exhibition is planned, artists may suggest to their galleries the idea of sharing the costs of hiring a publicist, which would be to the dealers' benefit, since the people who are brought to the galleries by the media are apt to return even when other artists' work is shown. The likelihood of galleries agreeing to this arrangement is small, however, Richard Phillips stated, because "media relations is long-term and therefore seen as a waste of time by galleries, which only want advertising and to sell paintings."

The Public Relations Society of America (33 Irving Place, New York, NY 10003-2376, (212) 995–2230, *www.prsa.org*) offers information to would-be public relations clients on which publicists might be best suited to their needs. By telephone, one may speak with counselors, who would take down information and create a list of eligible publicists or firms. Online, there is a searchable "red book" directory of publicists, categorized geographically and by fields of expertise.

Certainly, artists can learn some basic principles of publicity, taking on the job themselves. The material sent to a reporter or editor should consist of a well-written, interesting press release and high-quality, reproducible (in a newspaper or magazine) visual images. A press package contains a press release, but it also includes additional material that may be of interest to a reporter or editor, such as illustrations (slides, photographs, or color copies), biography or résumé of the artist, artist statement (if relevant), and clippings of past articles about the artist's work or career (those with photographs of the artist and/or his or her work are most likely to catch the eye of a journalist, who may not choose to read the entire article). It is extremely rare that a journalist will actually read through a previous article; the fact that the artist has been written about before makes that person more worthy of being reported on again, regardless of whether the original article or review was praising or scornful. If the artwork is key to the story, as in an exhibition or demonstration, there should be an accompanying image, or more than one. Bombarded by a myriad of press releases, journalists need their information presented in the most

time-efficient manner, and a good quality image—no snapshots—says more than a thousand words.

Usually, if the press release isn't absolutely pertinent to what the editor or reporter is doing, it is tossed out. Journalists also are inundated with press releases, which requires that the information they receive be eye-catching, concise, and followed up with additional releases and telephone calls. A somewhat cynical rule of thumb in marketing events to journalists is that the second you hang up the telephone, they have forgotten the entire conversation. Second mailings (and subsequently telephone calls) should note that there had been a conversation with the journalist, with a clear and concise summary what the artist wants the journalist to do. Follow-up work is the major activity of publicists, contacting media sources repeatedly in the hope of generating coverage, which is the reason that their clients often hire them on a monthly retainer even when their work involves one single event.

Magazines have a longer "lead" time than newspapers, and artists should prepare press releases and packages for them as much as six months in advance. With newspapers, six weeks is usually sufficient, unless there is a holiday tie-in, which may involve a special section and more time. According to Wilkinson, "most artists (and many, many other types of clients, too), begin publicity five months too late. Most people, in fact, will call a month or two weeks before an exhibition opens to discuss publicity. It is not only too late for 99 percent of public relations people, it is too late for 99 percent of publicity."

When preparing a media campaign, there are two critical points: to whom the press release or package should be sent, and how to write the release. In most cases, a press release should mimic a news article in a newspaper, with a headline in bold letters that tells journalists something quickly about the event and keeps them reading. According to Jane Wesman, who heads a New York City–based public relations firm of the same name that specializes in artists and writers, "You could write, 'Jane Wesman to Talk about Art World at Conference,' which is all right if everyone knows who Jane Wesman is. Probably better is, 'World's Greatest Publicist Presents Inside Look at the Art World.' "

The press release should be in a newspaper's inverted pyramid style, with the most important news featured at the beginning and the less vital information at the end. Many smaller publications type news releases directly into the newspaper and, if there are any cuts to be made (usually for reasons of space), the editing is done from the bottom up. The most important information is what is happening (exhibition, demonstration, class) when (time and dates) and where (street address, floor number), noting the significance or uniqueness of the event (for instance, printed by photogravure, first time these works have been shown publicly, honoring a recently deceased parent or public figure). Depending upon the nature of the event, this initial lead could be followed up by more information about the artistic process, the cost of attending the class or demonstration, or a quote by the artist or a third party (a critic or gallery director, perhaps) about the nature of the artwork.

The artist's previous experience (where exhibited or taught before) and educational background may have greater value to the local media if that show or class or schooling took place locally, and it might be placed higher in the press release; otherwise, this information should appear further down. As an absolute, contact information—where to reach the artist (home, office or studio telephone, cell phone, e-mail)—must be included for reporters who have additional questions.

Beyond learning how to write a release, artists should become familiar with the media outlets where they live or where their work will be displayed in order to make their own contacts. Reading the newspapers, and listening to the radio and television stations, on a regular basis is the most immediate way to find out who does what. Additionally, Bacon's (*www.baconsinfo.com*) and Burrelle's (*www.burrelles.com*) both publish media directories that list the names and titles of reporters and editors, as well as how to contact them. These directories are published annually, costing $200 apiece, but they are often found in public library reference departments. Of course, journalism and the media in general is a nomadic profession, in which people may change jobs regularly; artists should check with the media source before sending off any material to an individual listed in even the most recently updated directory.

Artists should also look to cultivate relationships with journalists and other members of the media that will last longer than just the most current exhibition but will be extant for the next show and project after that, creating an investment in one's career on the part of the particular editor or reporter. And, since journalists tend to migrate from one job to another, artists should be prepared to like the new editor or reporter as much as the last. This relationship may start with an invitation to one's studio or—a more neutral territory—a museum, art gallery, or café. "The New York artists I represent, who have become friendly with freelance art critics, are generally the most successful," Wesman said. "You need to cultivate the people who can be helpful in your career."

Newspapers cover a wide range of interests and are read by many more potential art buyers than those who avidly follow the critics. Among the possible editors of sections to contact are the lifestyle editor, home (or home and garden) editor, real estate editor, business editor, features and Sunday features editor (often, two different people), hometown editor, learning or education editor. There may also be a women's page editor or a specific writer who concentrates on the accomplishments of women. These editors may require a different "pitch" (story suggestion) than critics that ties in a topic with a certain news event or trend and would include compelling visuals that will entice them into wanting to know more. Wesman noted that artists should not confine themselves to art magazines in their press marketing efforts, perhaps sending press material to an airline or fashion magazine. "You want to broaden your audience to people who don't necessarily read art magazines, because those people may have money and interest, too," she said.

What Does or Doesn't Impress a Collector?

There are ways in which meeting a new collector is similar to applying for a job. An artist wants to show expertise and an agreeable personality; presumably, the artwork itself will reflect competence and achievement, but it is not uncommon to indicate that others have regarded the artist's work highly, as well. This is the reason that clippings of past reviews or feature articles are put out for visitors to an exhibition to peruse. It may not even matter whether or not the write-

up is favorable, just that the artist's work has drawn the attention of a publication that saw some previous exhibit as important enough to publish a review, although as a practical matter most reviews in all but a tiny number of periodicals are quite positive.

Beyond reviews, artists may wonder what else a visitor wants to know, what might add to their prestige. Perhaps having received an art degree (Bachelor's of Fine Arts, Masters of Fine Arts) from some noted art school or university art program might seem significant, although it is not clear how important this information is to prospective collectors. Having studied with a particularly renowned artist may have greater standing.

Signature Letters

An artist's prestige may also be suggested through the use of "signature letters" at the end of the artist's name. A form of nonacademic credentialing, these letters that follow artists' names refer to the membership society to which they belong. The use of the signature letters after one's name is more likely to carry weight for artists who are members of recognized national—as opposed to regional or local—societies. The National Sculpture Society, for example, is a well-recognized association of artists from all over the United States who work in a variety of styles and materials, while the Cowboy Artists of America and the National Academy of Western Art—both of which offer signature letters to members—are more regional in focus and specific in content.

Both the American Watercolor Society and National Watercolor Society divide their members into two levels. The National Watercolor Society has both associates and signature members—the first group may join without jurying, the second requiring acceptance into the society's annual exhibition and then an additional jurying of three more paintings—while the American Watercolor Society has sustaining associates and active members. At the highest levels, members are permitted to include AWS or NWS after their names for professional purposes. The National Academy of Design also has two levels of membership, both of which include signature privileges: The first is an

associate member (ANA), who is proposed by a current associate and approved in an election by at least 60 percent of the entire associate membership; the second is an academician (NA), who is chosen from the associates and elected by 60 percent of the academicians. Unlike the national watercolor societies, no jurying of individual works of art or acceptance into past or current annual exhibitions is part of the entry process.

Members of the major regional and national groups claim that signature initials confer stature upon an artist and may help advance one's career. "The National Watercolor Society is a very prestigious organization, and the jurying in is so strict that to be able to put NWS after one's name is really a feather in one's cap," Meg Huntington Cajero, a past president of the society, said. "The letters NWS matter to dealers who would be more inclined to represent an artist, knowing that the artist has been seen as having attained a very high level of skill and accomplishment, and dealers would point out the NWS to potential collectors."

Signature letters have no specific value. To be a signature member of the Florida Watercolor Society, allowed to use the society's initials (FWS) after his or her name, for example, one must have been accepted into three of the society's juried exhibits. There are two other levels of membership to the Florida Watercolor Society that do not permit the use of signature letters: The first is associate membership, which can be anyone who is a Florida resident and pays the membership fee, and the second is participating membership, enabling one to vote for officers, policies, and venues for the society's annual juried exhibition, and these artists must have had one painting in a juried show. Other societies, on the other hand, allow anyone who pays the annual dues become a member and use the group's signature letters.

The degree to which signature letters appended to one's name aids an artist's career is not fully clear. Perhaps if I were to write my name Daniel Grant, FWS, an onlooker might be intrigued enough to ask what the initials stand for, but the transition from curiosity to a sale would seem long. Lawrence diCarlo, director of the Fischbach Gallery in New York City, stated that signature letters don't mean anything to his collectors or to himself, and Frank Bernarducci, director of

Tatistcheff and Company, another New York art gallery that represents artists who work in watercolor, claimed that all the signature letters may do for artists is "help keep their egos under control, perhaps." Painter Will Barnet, who is a national academician as well as a member of the American Academy of Arts and Letters and the Century Club but does not use any of these signature letters after his name, said that the letters "have more of a human value than they are a benefit to one's career. It means something to me personally that other artists have accepted my work, but it doesn't matter to people who buy my work."

Prizes and Awards

In another quest for professional standing, some artists choose to list on the biographical pages they offer visitors to their exhibitions or studios the prizes and awards they have won. There are many opportunities to win prizes, some offered by art material suppliers (the cash value of which is often is redeemable in the manufacturer's own products), some that are purchase awards by museums, others established by foundations, art schools, advertising agencies, and art show sponsors that provide modest amounts of money. In addition to top awards, second and third place prizes as well as honorable mentions are also frequently offered that may involve money or a certificate—something to include on a résumé.

All of these visual arts awards and prizes have far less value to the artist than an Oscar or Tony. It is not uncommon that someone is described as an "award-winning artist" without ever noting which award(s) the artist has won. That may be just as well, as few people would have heard of the particular award anyway. Receiving a Grumbacher medal does not assure a visual artist that a line of patrons will appear at his or her door the next day, or that the artist will appear on the cover of *People* magazine or be ranked among the top artists of one's time. In fact, the most lionized and successful artists, whose works are featured in museum retrospectives or whose faces adorn the covers of *ARTnews* or *Art in America*, are unlikely to ever enter the competitions that offer prizes and awards. It was not even much of an event, for instance, when a Jasper Johns won the top prize at the 1988 Venice Biennial, as his standing in the art world was already greater than that of the award.

Still, thousands of artists compete annually for awards and, for many, the awards and prizes area on their résumés is quite expansive. However, there is a wide range of opinion concerning to whom these prizes actually matter. On one end of the spectrum, there is a belief that prizes and awards do not matter at all. "Winning an award is nice when it happens for the artist," Janelle Reiring, director of New York's Metro Pictures gallery, stated. "It makes the artist feel good, I guess. It doesn't make any difference to me or to the collectors I deal with. Our collectors are certainly concerned with what critics and museum curators think, but not at all with what prizes or awards the artist may have won."

Other art dealers take a different view. "Which awards the artist has won matters to me, and matters to collectors," Benjamin Mangel, owner of the Mangel Gallery in Philadelphia, Pennsylvania, said. "They are especially beneficial to an emerging artist, who may have little else to show. I have collectors who need to see that the artist has credibility, and it helps when I can talk about the artist's scholarships, awards, prizes. It's not a crucial factor in selling a work but, when you've got someone who is on the fence and says, 'Let me read something about this artist,' if you show the collector a blank sheet of paper, that collector is not going to buy the work. If you can show that the artist has won awards and prizes—that the artist has credibility in someone else's eyes—nine times out of ten that collector is going to buy the work. The only time that kind of information doesn't matter at all is when the collector falls in love with the work and doesn't care who the artist is."

A number of other dealers around the United States agree that prizes are of greatest importance for artists who are younger or who need some kind of third-party validation because they don't yet have a reliable market for their work. As the artist enters a later stage of his or her career, those credentials tend to be jettisoned, and the prizes and awards category disappears from the résumé. The artist doesn't need to refer to first prizes anymore.

The category of prizes and awards is frequently elastic, expanded by artists to include fellowships from foundations and governmental agencies as well as project grants from those same (or other) sources.

The differences in prestige between who gives awards or prizes may be enormous. A number of art dealers, who otherwise claim that the fact of an artist winning a prize is of no importance to them, stated that their interest is piqued by artists who have received a Guggenheim fellowship, for instance. Gregory Amenoff, a painter in New York City, said that "when I am to give a talk somewhere, I am frequently introduced to the audience as the recipient of three National Endowment for the Arts grants. Obviously, that has given me a certain status with some people, but I wouldn't want to overemphasize its importance. I've never heard a collector say, 'I heard you've received three NEAs and wanted to see what your work looks like.' "

Most awards and prizes are not career-makers, however, and the amount of money an artist may receive is a few hundred dollars or less, more of a pat on the back than a vault into stardom. Winning the top prize from the National Sculpture Society in 1993, which included a $1,000 award, was heartening for Seattle, Washington, sculptor John Sisko. "Getting this kind of recognition from your peers gives you a lot of confidence that someone is paying attention to your work," he said. "It made me feel more convinced that I was on the right track with my work." An additional benefit of receiving the prize was the new, higher regard with which he found himself treated. "I noticed that, when I went to my foundry in Santa Fe, I was introduced to people as this award-winner," Sisko stated. "I think that the foundry saw that its prestige had risen because it was associated with me." Another Seattle sculptor who has won fellowships from the Washington State Arts Commission and elsewhere, Terry Furchgott, also noted that "people know me from the awards. Three years ago, I would call some art agency for a project grant, but I didn't feel like an equal with the people I was talking to, like I had to ask them for favors. Now, when I call, I notice that they treat me as an equal or as someone they are honored to be speaking with."

Is That an Insult?

It sometimes seems as though being an artist gives the rest of the world a license to be insulting, if unintentionally: Can you really make a living from this? Is that a cat? Could you do that in yellow?

Wouldn't it look better flipped on its side? Artists who sell directly to the public regularly face those and other questions and comments that seemingly denigrate their professionalism and their art. What's more, the same questions get asked repeatedly by different people at exhibitions and fairs, which could turn sensitive souls sarcastic and mocking, hardly a good way to engender sales.

Perhaps, the most often heard question is, How long did it take you to paint that? On its face, the question is matter-of-fact, but many artists take it as a challenge, as though the person asking "wants to know how many dollars per hour you earn, so they can calculate it into wages," said Dorothy Fagan, a landscape painter in Cobbs Creek, Virginia, or the person "wants to make sure he's getting his money's worth," painter Ann Powell of Milwaukee, Wisconsin, said. A snide riposte some artists are tempted to make is, "Well, how much do you make an hour?" but artists are more apt to soften the blow or reframe the question. Taking the latter approach, Fagan describes her method of working, which is painting a series of canvases, "moving between paintings as one work or another calls out for attention." She added the need to "allow time for things to dry and for ideas to coagulate," which makes a precise determination of how long the painting took impractical.

An often-used response to the how-long question is "my whole life," suggesting that a given artwork is the product of years of training, experimentation, and intellectual growth, while Powell's answer is more of a straight-on " 'Some take hours, some take months, but that has nothing to do with the price.' The quicker ones are actually more expensive; everything just works. The ones I struggle on are less expensive, because things didn't flow as easily." Some of her buyers prefer the lower priced paintings, she believed, since they associate the longer process with higher value, causing her to chuckle inwardly.

At other times, the laugh can be enjoyed by all. "I was at this one show, and an old farmer walked by," said Hamden, Connecticut, painter William McCarthy. "He took a look in my booth, then said about one painting, 'How long did it take you to do that, ten minutes?' He was a large man, not to be reckoned with, and I said, 'Oh, maybe about

twenty-five seconds.' He then let out a big belly laugh, and we started talking. He actually said he liked my paintings." The farmer was not a buyer ("he may have bought a hot dog there"), but a testy situation was defused. In rare instances, McCarthy has found that what starts as a confrontation turns into a sale. Visitors enter his booth display and begin voicing criticism of one thing or another ("People think that artists are invisible, that they leave their feelings at the door," he said), such as that they hate the painting, they hate the colors, they hate the frame. Although he was not part of the conversation, McCarthy may interject himself, saying, " 'Well, the intention of that painting was …' or 'I wanted to use those colors, because …' or 'I thought that frame was appropriate, because …' which catches people off-guard. They take a second look." In fact, some sales have resulted, which "surprised me: They started out saying they hated a painting that they end up buying."

It is rare that visitors to a booth or exhibition are looking to quarrel— after all, they often have paid admissions to enter the fair and have some idea of what to expect—but simply want to strike up a conversation (itself a compliment of sorts) and don't know what to say. Artists are sometimes told that they dress like artists, which may seem like a backhanded compliment (are their clothes oddly matched or funky or ill-fitting or in disrepair?), or that their work reminds the visitor of some other artist's (is their art derivative, unoriginal, plagiarizing?). It is likely that both comments are meant in a positive light, indicating in the first instance that the artist is a unique individual and in the second that the artist's work is as good or as pleasing as someone else's. Knowing how to find the positive side of a potentially negative remark may turn an awkward situation into a more relaxed moment. Shows can go for days, and artists may become tired and irritable by the end, apt to find a question insulting simply because they have heard it repeated so many times. Possibly, there is no ulterior motive to the question of how long it took to paint that picture. Artists might simply need to refresh themselves periodically in order to maintain a positive attitude.

The old maxim, There are no stupid questions, may help artists turn a seemingly thoughtless remark into a learning opportunity, helping someone who might be intimidated by art into a potential collector

at some point (maybe, right now) or just letting visitors know that artists are normal people like themselves. Susan Osmond, a painter in Marshfield, Vermont, was once asked by a visitor at a fair, surveying a long row of booths, " 'Do you all travel in a group?' Oh, my God, as though we were gypsies or a circus. After I stopped laughing, I told him that not everyone goes to the same shows. I explained the process of applying and being selected for shows and that we all have homes and don't live in our vans."

Often, the knowledge to turn a conversation around takes practice. Artists who sell directly to the public need two quite separate sets of skills, the first is the technical ability and a conceptual framework to produce the desired work of art, while the second is the capability to put that technique and concept into words and to be a good salesperson. Salesmanship is not only concerned with negotiating the terms of a purchase, which assumes that prospective buyers know exactly what they want, but trying to answer the questions that are really being asked. Fagan noted that she is frequently asked where she gets her landscapes and has experimented with various replies. At times, the questioner may want to know if she takes photographs of a particular place and uses them for her painting, "and if I say that the imagery is imaginary I get a deadpan look. What I've found works better is showing a sketchbook, where they see how everything started: A little idea becomes a big painting." The question of where she gets her landscapes turns out to be concerned with the mechanics of the artistic process, "how do you get from here to there."

Similarly, the question "Can you really make a living from this?" may not be " 'How can anyone make a living selling this crap?' but 'What's it like to be a professional artist?' " said Gary Stretan, a watercolor artist in Spencer, Ohio. Or, the question may be more specific, leading many artists to state that they wouldn't be there if they didn't make money at it and that, otherwise, they are doing well in their careers. Perhaps, it is a vicarious longing to be artists themselves or just nosiness that leads visitors to ask about an artist's livelihood. Money questions—how artworks are priced and why one work is more expensive than another—may also be specific to the objects on display or a glimpse into the artistic process.

On occasion, questions and comments that seem insulting may be just that. Buyers who come into a booth at the last hour of the last day of a show seeking large price reductions irritate Stretan and other artists, because they "seem to be putting down my work and me as a professional." He noted "when someone comes into my display, they're not under any obligation to make my day or to support me," but to visitors who appear "belligerent and want to bust your chops" he gives short answers to their questions and recommends that they "take a look at some of the other displays."

chapter

Juried Shows, Art Fairs, and Festivals

Every year, an estimated 10,000 to 15,000 art fairs, arts and crafts festivals, and juried art competitions take place throughout the United States. They offer artists an enormous opportunity to present their work directly to the buying public, allowing them in part or completely to bypass the art gallery system, where commissions are high, exhibitions are rare, and salesmanship may often seem indifferent. However, choosing among the 10,000–15,000 shows is an enormous undertaking, and it is difficult for newcomers and even for more experienced hands to feel confident, especially when the cost of participating in a given show is understood (entry fees, booth fees, insurance, shipping, crating, mileage, accommodations, meals, "lost" production time). Which fairs feature artists and artwork at my level? Which shows actually draw in visitors, and how much actual buying takes place? At what price range? How well run are these shows? Does "arts and crafts" mean crafters?

Finding answers to these and other questions is a job in itself. The best way to collect information involves a bit of trial and error—taking part in one or more shows, talking with other artists and exhibitors, even talking with collectors about competitions and festivals they would recommend.

Selecting among the Many Fairs and Festivals

There is a two-step process involved in obtaining information about suitable shows when you don't have the guidance of someone who has been there and done that: The first is discovering when and where all these events are being held, and the second is evaluating those shows that seem to hold the greatest potential. No one publication or Web site will provide complete information, requiring artists to check a number of different listings. Probably the largest single source of information is the monthly magazine *Sunshine Artist* ($34.95 per year, 4075 L.B. McLeod Road, Suite E, Orlando, FL 32811, (800) 597-2573, *www.sunshineartist.com*), which lists upcoming shows, complete with numerical coding, such as this sample:

Apr 30—May 1
Richmond, Virginia
34th Arts in the Park. Byrd Park.
Deadline 1/15/2005. Notification 2/1/2005. Space size: 10 × 10. Jury by 1 slide of work and 1 of display. Est. public attendance: 80,000 (source: police). 34 yrs. at this site. 450 exhibitor spaces.
100 percent outdoor. 600 applicants last year.
Event category: 1
Acceptable work: 1,2,3,7,11
Section method: 2
Contact: Mrs. R.S. Lovelace, III, 1112
Sunset Avenue, Richmond, VA 23221.
804-353-8198. *www.richmondartsinthepark.com*.

The magazine also pays local reviewers to attend certain shows, reporting back briefly on how well a show did, how well it looked, how well managed the event seemed, and what unnamed participating artists and other exhibitors had to say about it. Every other year, the magazine publishes its *Audit Book* ($54), which recapitulates in brief those magazine reviews for approximately 5,000 shows, giving each event a rating on a scale from 1 to 9. (A less expensive way to obtain some of that information is through the Web site *www.artandcraftshows.net*, whose database of 2,000 or so open-entry events is provided by *Sunshine Artist*.)

There are far more shows taking place than the magazine or the *Audit Book* describe, in part because the magazine charges show organizers

for listings, making it more of an advertising section than editorial space. Presumably, there is no fault to be found with the shows whose organizers did not choose to pay a $20 listing fee.

Another publication that rates shows around the United States is the annual *Harris List* (P.O. Box 142, La Veta, CO 81055, (719) 742-3146, *www.harrislist.com*, $65), which looks at a far more select group of "top 135 shows," defining "top" as events for "medium- to high-end fine artists and craftsmen (work priced $50 up to thousands of dollars)." Based on what publisher Larry Harris observes when he visits shows and what exhibitors have told him about others, he has created a five-tiered rating system, starting with "?" for events that seem to be a gamble, "?-G" for shows that are marginal to good, "G" for good, stable shows, "G-T" for good-to-very-good events, and "T" for the top, best shows. As an example of a listing:

> July 23, 24, 25 Bellevue (Seattle), WA—19th Bellevue's Festival of the Arts (O)
> (?-G)d 1916 Pike Place, PMB 146, Seattle, WA 98101
> Phone: 206-363-2048 Fax: 206-789-8043
> Comments: In parking lot of shopping center, affluent crowd, some high end sales here. Was the "Rest of the Best Festival"
> Fee: $365+ Space size: 8-10 × 10-20 200 arts 45/45/10 40K free closes: Mar 15

Harris, who also provides career and market consulting to artisans, noted that show sponsors do not pay for listings, nor does he accept advertising.

Yet another nationwide information source on shows, fairs, and competitions is the Web site Art Deadlines List (*www.artdeadlineslist.com*), which provides monthly, updated information on shows and competitions both in the form of electronic mail and as hard copy (a printed listing) to subscribers. There are two types of subscribers, free and paid, and those who pay the $36 per year charge receive a larger listing, usually several hundred notices per month. Art Deadlines List similarly has a two-track policy regarding listings: Paid listings, or advertisements ($90 per month), are sent out to a larger group than those listings that did not come with a check.

The listings themselves range from a lot to a little detail—notices are not standardized as in *Sunshine Artist* or *The Harris List*—although a typical notice is below:

> **Call For Entries**—Sculpture at Noble Horizons fifth annual outdoor group exhibit, Salisbury, CT. Large scale, all media, prizes, low commissions, no entrance fee. For a prospectus send an SASE to: John Emmons, Executive Director, 151 Music Mountain Road, Falls Village, CT 06031 or *www.noblehorizons.org*

Other information about shows and competitions is scattered about, listed in magazines (such as *American Artist, Art Calendar, The Artist's Magazine, ARTnews, The Crafts Report, Southwest Art,* and *Wildlife Art*) and in the bulletins of artists' membership organizations. Since many of these are paid listings, with show sponsors charged by the word, they tend to be quite brief and not wholly informative. Many state arts agencies publish listings for shows on their Web sites, under the heading "Opportunities" or "Call for Entries," when the event takes place within their borders (all of the state arts agencies can be found at the National Endowment for the Arts' Web site, *www.arts.gov/partner/state/SAA_RAO_list.html*). These agencies do not solicit information on shows but publish notices that are sent into their offices; listings on their Web sites also do not get updated with great regularity.

Most of the magazines, books, and Web sites listing shows, fairs, and competitions provide basic information about the event without any narrative or qualitative judgment. Just-the-facts can become confusing, however, when, in some publications and on certain Web sites, there is a wide array of abbreviations, requiring readers to refer regularly to a glossary. The eleven issues per year *Craft Master News* (P.O. Box 39429, Downey, CA 90239, 562-869-5882, *www.craftmasternews.com*, $35), for instance, offers a description of a fair in San Antonio, Texas, as:

$30–55,8X8–14X14, AC, FA, CL, CMR, DB, F, JU
250+ATTN, IS, OS,$5 PWR,$5 TR
60–67 BTHS, FREE AND,9AM–4PM

A number of publications provide listings of shows and competitions on a regional basis, such as the monthly *Art & Craft Show Yellow Pages* (P.O. Box 13, Red Hook, NJ 12571, (888) 918-1313, *www.craftshowyellowpages.com*, $37 per year if mailed bulk rate, $43 per year if mailed first-class), which focuses on shows, fairs, and festivals in Connecticut, Delaware, Maryland, Massachusetts, New Jersey, New York, Pennsylvania, Vermont, and Virginia. The *Midwest/USA Arts & Crafts Events Guide* (4251 Hamilton Avenue, Cincinnati, OH 45223, (800) 825-4332, *www.midwestartscraftsguide. com*, $29.95 per year) lists more than 3,400 events in the states of Indiana, Illinois, Kentucky, Michigan, Ohio, Tennessee, and Wisconsin, as well as Florida and Georgia. *The Art Fair Source Book* (2003 N.E. 11th Avenue, Portland, OR 97212-4027, (800) 358-2045, *www.artfairsource.com*) publishes a two-volume nationwide listing of 600 "top selling" shows and competitions ($197 for each print edition, $179 online) and four regional editions (Midwest, Northeast, Southern, and West) that include between 125 and 150 top selling events, priced at $97 for the print edition, $87 online. Additionally, *The Craft & Art Show Calendar* ($16 per year, P.O. Box 424, Devault, PA 19432, (610) 640-2787, *http://hometown.aol.com/ rbfinkel/myhomepage/index.html*) provides basic who-what-and-where listings of events in the Mid-Atlantic States, while *The Crafts Fair Guide* ($45 per year, P.O. Box 688, Corte Madera, CA 94976, (800) 871-2341, *www.craftsfairguide.com*) offers annotated listings of shows in California.

Is This Show for You?

None of the listings, paid or unpaid, long or abbreviated, tells enough, however. Online or hardcopy listings of shows offer the who, what, and where, but tend to be short on details, such as who is assigned responsibility in the event of damage, fire, loss, or theft, how art is to be shipped and insured (and who pays for shipping and insurance), if there will be prizes offered (and in which categories), if the show sponsor will take commissions on sale of artwork (will the artist report sales to the sponsor or route sales through the sponsor), whether or not every item must be for sale (or within a certain price range), and whether the artists are obliged to provide "door prizes" or other donations to

the sponsor. For this, artists should request a prospectus, outlining what the show is, where and when it will take place, how many artists are to be selected, the type of art (subject matter and media) that will be featured, the names of the jurors selecting among the applicants and other relevant information. Artists should send for this information before submitting slides and any money to be in the exhibits.

Other questions may arise that the prospectus does not answer, and artists should make inquiries (by e-mail or regular mail, even by telephone) before submitting their applications: If the event is outdoors, what provisions have been made in the event of rain? What type of marketing (to potential visitors and collectors) and promotion (to the media) are planned to ensure strong attendance and media coverage? Some show organizers highlight the prize money they offer to artist exhibitors who are judged to be winners in certain categories, and this acts as an inducement to bring in better artists, but they may have no budget for advertising, which would bring in more visitors. If an artist has to choose between one show with possibly better artists and another with potentially more sales, which would he or she pick? If this is the first year of a show, what experience do the sponsors have in staging an event of this sort? If the show took place in prior years, what was the overall attendance and gross sales, and is that information documented (for instance, in newspaper accounts)?

Whenever there is a jurying system, artists should be informed who the judge(s) or juror(s) will be in advance of applying, as it is the prestige of those persons that give importance and validity to the event. If one also knows something about the juror—he is a dealer of mostly avant-garde art, she paints watercolor landscapes—that may help potential applicants assess the chances of having their work selected. It doesn't tell potential applicants much when Art Enterprizes of Lompoc, California, announces that its First Annual Art Competition will be "juried by professional artists." Similarly, the "International Biennale" [sic], organized in Miami, Florida, for the Musee d'Art Moderne in Bordeaux, France, will have art chosen "by international selection committee appointed by museum director." For some artists, the possibility of having their work displayed abroad

may outweigh not knowing who the jurors are and the unwillingness of the French museum to take responsibility "for loss or damage of any kind for any work." It is a difficult decision to make, but artists should at least know what they are facing.

Arts and arts and crafts fairs come in all types. At times, a prospectus or a publication's description won't reveal enough, requiring artists to ask questions of current or past exhibitors or just attend the event as a visitor. If a fair advertises itself as having only original art, does that allow for reproductions of an exhibitor's original art, such as an offset lithograph or digital print? If the event is an arts and crafts fair, are the craft items unique (one-of-a-kind) or production pieces (such as coffee mugs), non-utilitarian (sculptural) or useful (a vase, for instance), high-end (costly, artistic) or crafter (lower-priced gift items)? Some crafts shows feature or include what is called "buy-sell" items, meaning objects manufactured elsewhere that the exhibitor may have adorned to a large or small degree. Certain show sponsors will still call items "handmade" if they determine that a certain percentage (40 percent? 50 percent?) of the finished piece was actually produced by the exhibitor, such as the face of a clock or base of a lamp (it is not assumed that craftspeople should make their own timepieces or lamp sockets). The distinctions between types of work are important, because certain categories will appeal to different prospective buyers. A fine artist surrounded by crafters is not a good mix, for instance, because the collectors of one will not be interested in the other: The fine artist is apt to be seen as overpriced or, worse, in the league of crafters. There tend to be more arts and crafts fairs than pure original art shows, requiring artists to be selective.

Online Jurying

Artists are generally unique individuals but, on one subject, they tend to speak as with a single voice: Filling out applications, rounding up slides, and mailing off the whole package to juried art show organizers is nothing but time-consuming drudgery. Because many artists enter a variety of these exhibitions and fairs every year, the cost in time, expense, and patience can be considerable. The alternative, however, has been to not take part in these events at all,

which is no option at all to those artists whose livelihood depends upon the sales these shows generate.

A third way, and one of growing interest for artists, particularly those who set up booths at art fairs and festivals, is to submit both applications and images of their work electronically, allowing them to save the cost of postage and, perhaps, time. The Western States Arts Foundation, or WESTAF (1743 Wazee Street, Suite 300, Denver, CO 80202, (888) 562-7232 or (303) 629-1166, *www.westaf.org*), working with the National Association of Independent Artists (*www.naia-artists. org*), has set up a system allowing artists to submit their work and applications online to a number of major arts and crafts festival organizers. Artists fill out a standardized application ("Zapplification") and store their images in digital form. The participating artists select particular works that, along with their application information, are transmitted to specific festival sponsors. On the average, a survey by WESTAF has indicated the artists and craftspeople that regularly show and sell their work at fairs and festivals participate in between seven and twelve shows annually. Applying online can considerably reduce the time they spend filling out applications.

The sponsors of these fairs and festivals that take online applications also save time and money by collecting the applications and images electronically, since there is less need of a large staff to painstakingly type in information about the artists, descriptions of their art, addresses for mailing labels, and other documentation, as well as set up slide presentations for jurors, which they must do for mailed-in applications.

For example, the Smithsonian Craft Show reduced from twenty to five the people it needed to track the annual festival's 1,300 applicants when it permitted artists to apply online in 2003. According to Heidi Austreng, program coordinator for the Smithsonian's Women's Committee, which runs the craft show as a fundraiser for the Washington, D.C.–based museum complex, "the process of taking slides out of envelopes, putting them in slide carousels, and labeling the carousels properly used to take days. Lord forbid someone drops a carousel. Then, we needed to requisition projectors and countless carousels." Having everything stored within a computer's memory

lightened the chore load immeasurably. The savings in efficiency were offset by the cost of designing and operating a computer system to handle this event ($16,500), but that expense will be amortized over the years that the computer program is in use.

Approximately one third of the applicants to the Smithsonian Craft Show applied online; the other 900 artists who applied in the traditional manner (mailing in an application and slides) were required to pay a higher entry fee—$55 instead of $45—to cover the costs of typing in artist information and digitizing, or scanning, slides.

Certainly, computers have become ubiquitous in the United States, and a great many artists have created (or have paid to have created) sites that display their artwork on the Web. Still, many people, artists included, are not comfortable with computers. The Smithsonian Craft Show surveyed artists about the online application system, finding that the response was mixed. Those who preferred the older application process noted that they were "not computer literate" or that "they have slides of their work already," Austreng noted. While believing that online system is the way of the future, the Smithsonian allowed mailed-in applications, because "we don't want to lose exhibitors who aren't happy using computers." However, even artists who loathe computers would be able to make use of WESTAF's art show database by sending in biographical information and slides that could be typed in or scanned into the computer. "There would be some nominal cost for data input," said Larry Oliverson, president of the National Association of Independent Artists.

Artists need not pay WESTAF as a server, since art fair sponsors pay for the cost of the program, although it is possible that these sponsors may increase entry fees to cover the expense. Participating artists, who take a user name and password, should expect to pay ordinary festival entry fees by credit card online.

Electronic submission changes two pieces of the jurying process: The first one is the application process, which becomes cheaper, speedier, and more efficient—for both artist and jury. The other aspect is that altering the submission media means that judges are now evaluating

digital images, rather than slides, so artists must be able to procure the best possible copies of their work in this media. Artists will either allow others (or pay others) to digitize their work or, if they are going to create computer files of artwork themselves, become conversant in an area of technology that is expanding regularly.

"It's time jurying came into the computer age," said Mary Ann Cherry, president of the Pastel Society of the Northern Rockies. "Our members e-mail each other all the time, often sending images of their work for critiques or just to show what they have been working on. We could see absolutely no reason then not to let people submit work for our juried show by JPEG [a format used in digitizing images]. The responses have been pretty favorable."

Artists who have seen images on a standard computer monitor but are unfamiliar with high-resolution screens are likely to feel some trepidation about seeing their work digitized. Along with reading a show organizer's prospectus for a variety of basic event facts—dates, location, the names and affiliations of the person(s) jurying the entries, provisions for insuring and maintaining security for the work, among other provisions—they may need to check on image specifications for digital files and the monitors used to view them.

At present, shows that allow for online submissions still accept mailed-in applications, turning traditional photographic slides into digitized images for the computer through a scanner. The Paradise City Arts Festival, which sponsors shows in Florida, Massachusetts, and Pennsylvania, created perhaps the nation's first online jurying process in 2000, when it began scanning traditional photographic slide images, which were then projected from the computer onto a wall for judges to make selections. Those images stay on file with the Paradise City Arts Festival organizers, and artists may use the same artworks when reapplying for the company's other shows.

"There's no requirement that the works submitted to a jury be brand new," said Linda Post, director of the Northampton, Massachusetts–based festival sponsor. "Having works already in our computer system takes away the whole pressure thing: 'I've got to get

my work in on time, so I can continue to make a living.' The works are here already; just tell us which works you want to submit for which show. Artists can also change works in their file, if they have something they think will work with a jury. Just send in a slide or a CD." Because the same images may be submitted again and again, the actual artwork may be sold within this time period. However, Paradise City Arts Festival also does not require that the art sent in for jurying is physically present at the show. "As long as the juried image is representative of the artist's work, that's fine," she said. "We've gotten letters and e-mails from artists thanking us for this new system of jurying." WESTAF's database also allows artists to reuse images when submitting work for jurying by different show sponsors.

Photographic slides are uniform, but the quality of digital images varies widely based on the number of dots or pixels (picture elements) per inch. There are different file formats for computer images (JPEG, GIF, and TIFF, for instance) and different platforms (Macintosh and PC). Some art festival organizers may ask for work to be submitted by e-mail, by CD-ROM, or on a floppy disk. Ideally, all show sponsors would adopt the same formats for submissions and use the same high-resolution computer monitors or plasma screens in the jurying process so that artists need not create different digital slides for different shows and they will have a good idea of how their work will look to jurors, but that isn't fully in place as yet.

Presumably, all artwork submitted electronically to a festival jury would be sent based on the same specifications and viewed on the same monitors or screens, allowing decisions to be made solely on the quality of the works. However, artists with more technological know-how may gain a certain advantage through the use of programs—Photoshop, for instance—that allow images stored within a computer to be altered and enhanced. The backgrounds may be neutralized or given tints that set off the object in the foreground, and colors within the artwork may be sharpened or changed. Linda Post, herself a painter, mentioned that she often performs "minor color correcting through Photoshop, because the film used in making a slide causes the work to look greener or yellower than it actually is." A number of fairs currently have art review committees

that examine the works on display at the shows to insure that the actual pieces accord to the slides submitted to the jury. The ease of Photoshop-conversant artists to change colors and smooth out imperfections may increase the number of potential violations of festival rules and, at least, create a gray area in art show ethics (How much alteration is acceptable? How much computer enhancement is allowable in a field that is about the handmade?). The result may need to be the establishment of more review committees at shows that must be ever more vigilant.

There are fewer ethical problems with the older style slide, if only because fewer artists are likely to know how to manipulate its content. Still, there are few people who enjoy looking at slides of artwork, least of all the organizers of shows. "The traditional slide is cumbersome to work with; slides need to be handled, put in slide trays, projected—finding enough bulbs for projectors is no easy thing," Oliverson said. "The volume of space needed to handle thousands of slides is considerable. None of those problems exist with digital files. After you have gone through one jurying round with slides, you have to take out the images that were rejected so that you can go through a second round. That means moving all the remaining slides, so there aren't a lot of blank spaces between slides. It's a very time-consuming process that, in a computer, can be taken care of in a few clicks."

However, as a fine art photographer, Oliverson noted that he prefers the traditional slide as a truer representation of the original image. These slides "have more data. There is a continuous gradation of, say, the color blue, whereas in the digital world information is broken down into pixels that approximate but don't exactly provide the same amount of information. However, as a practical matter, there is an adequate amount of information on a digital slide, and a layman probably wouldn't be able to tell the difference." Others have also noticed slight differences between slides and digitized images—a bit of clarity is thought to be sacrificed with the JPEG, and digital versions of very detailed and colorful work may not show up as well—but it is not clear that these are significant enough to cause worry.

A Last Word on Slides

Slides are traditionally—meaning, for the past thirty or forty years—the way that artists have sent out images of their work to the world. As a tool for presentation, it was always limited and now may be heading for history's dustbin. The first problem is that few people have or use a slide projector. Chicago art dealer Rhona Hoffman, for instance, has a slide projector—"it's probably fifty years old, at least," she said—and she hasn't used it for "quite a while." The Barbara Krakow Gallery in Boston has a slide projector "somewhere, but I'm not sure where it is," according to gallery director Andrew Witkin. Still, for hopeful artists sending slides of their work to dealers, those responses are more promising than that of Roberta Brashears, director of Nedra Matteucci Fine Art in Santa Fe, New Mexico, who stated flatly that "No, we don't have a slide projector but, can you believe it, artists still send us slides."

When slides come in and the dealers choose to look at them, Hoffman, Witkin, and Brashears hold them up to the ceiling lights for somewhere between one-half of a second to two seconds. "It hurts my neck to do it much longer than that," Hoffman said. Rare is the dealer who treats slides in any other way: The projector is somewhere in the back room; no one remembers the last person to use the slide viewer, a smaller device for viewing one slide at a time, so its whereabouts are likewise unknown; the light table, if there is one, has a lot of books and papers on it. Artists have gone to a lot of effort to get their work looked at so hastily and inappropriately.

The second problem is that Kodak, the largest producer of slide projectors in the world, discontinued making them in 2003, concentrating more and more on digital representations, leaving only a handful of smaller producers (Eiki in Japan, Simda in France, Leica in Switzerland, and Vivitar in California) to supply the dwindling market. "We used to sell thousands of slide projectors a year," said Howard Winch, national sales manager for Elmo Manufacturing Corporation in Plainview, New York, "and we still have some inventory. We may sell between twenty and fifty a month, but our production has ceased." For its part, Kodak will continue to produce color slide films, as well as provide service and parts for its projectors until 2011.

"Slide projectors are yesterday's technology," said a sales representative at the online audio-visual products vendor FocusCamera.com, adding that the company no longer has any in stock. Winch noted that eBay is a better source of slide projectors and light boxes than camera stores these days. For artists, the question may be are art galleries and juried show sponsors looking for today's technology—digital images, sent as a TIF or GIFF or JPEG or on a CD-ROM or a printed-out digital file, or the address of an artist's Web site—or do they still want slides but are just not buying or using slide projectors?

The answer is not clear-cut, in part because galleries increasingly are accepting images in a variety of formats. "I used to tell artists to send a maximum of twenty slides," Arthur Dion, director of Boston's Gallery NAGA, said. "Now, I tell artists a maximum of twenty images." Ruth Braunstein, director of San Francisco's Braunstein/Quay Gallery, which uses its two slide projectors several times per week, noted that she's "not that computer-wise," although the gallery accepts JPEGS. A benefit of JPEGS over slides, she said, is that "you don't have to send them back."

In 2000, 90 percent of the images sent to the gallery were slides, Addison said, but now slides may only represent half, as artists submit CD-ROMs, DVDs, transparencies, printouts from digital files, and even photographs. "I don't expect to be working with slides five years from now," he noted.

Making Art Look Good

A question every artist wants answered: What actually sells a work of art? Perhaps good art sells itself, or it may be the price or something the artist (or dealer) says. Maybe the difference between selling or not has to do with the artwork already being attractively framed or how the exhibition space is designed. Artists all want to believe their art is compelling enough not to need any props, but most of them sense that more is required than just putting something on view. Artists who sell directly to the public, particularly at fairs and festivals where there may be hundreds of booths and tents filled with artwork and the individual artists who created it (all earnestly describing their technique and inspiration), recognize a need to set themselves apart. At

outdoor fairs, most tents are white canopied (many show organizers require them to be white), and some artists have had positive results from creating an environment within them that enhances the visitor's experience of looking at the art.

"I have the usual white tent, like everyone else, four-sided, 10' × 10'," said Christopher McCall, a painter in Doylestown, Pennsylvania, who has been setting up his tent at various shows since the early 1990s. His prior experience in retail sales, as a gift shop owner in New York City, led him to customize his tent, adding dark gray fabric on the walls and a large vase with fresh flowers on a round table covered by a tablecloth, "to present things as it would look in someone's home." Under the table is a CD player that pipes in classical music—Bach, Beethoven, Haydn—that "complements the art," he said. People have commented on the look and sound of the display, often favorably, sometimes comically: "They see the tablecloth and flowers and think they need a reservation for dinner."

In all, the display has cost McCall approximately $2,500 ($1,000 for the tent, another $1,000 for the fabric to cover nine display panels being the largest expenses), which he believes has been recompensed by more sales than if he hadn't created such an environment. A high-toned presentation also may suggest high quality and be its own justification for high prices.

Other artists have also seen advantages in putting more time and money into their tent or booth display, which Linda Post of Paradise City Arts Festival claimed is a "carryover from the crafts world. Customers are willing to buy arts and crafts and pay more for them if they can picture the pieces in their own homes." A display that suggests someone's living room, and "not just a painting hanging on chicken wire mesh," allows visitors to visualize owning the artwork more easily. To that end, some artists have put down rugs ("It's nicer to walk on than cement," said Marshfield, Vermont, painter Susan Osmond), equipped their booths and tents with trak lighting to spotlight works, spent more on framing and panel fabric ("My paintings look more illuminated against the long black fabric, much more so than with the shorter light bluish-gray covering I used to use," said

Willow, New York, painter Marty Carey) and designed their displays more like curators than salesmen.

Beth Ellis, a painter in Glastonbury, Connecticut, who participates in half a dozen outdoor fairs annually, stated that all the frames she uses are of one type (gold leaf) and that the artworks exhibited are on one theme, such as all landscapes or landscapes with figures or landscapes and still lifes. "People shift their energy every time they go into another booth, and that can be very tiring," she said. "If your display has a lot of different types of work, that can take even more energy. I only have a small window of time to capture their attention, and I don't want to waste it on works that make people shift their energy more than once."

She added that her displays are intended to reflect the light and airy feeling of her mostly plein air paintings. To that end, Ellis custom-ordered a booth whose dome is heavy-duty transparent plastic (rather than a fully white top or one with plastic skylight) that filters ultraviolet rays while providing natural illumination of her artwork. The cost of that tent was $1,500.

Ellis believes that the extra care and expense has led to increased sales, but added that "it's not a measurable thing." The fact is, no artist can claim a one-to-one correspondence between the type of tent he or she buys, how it is decorated, how artwork is displayed, or anything else and the sale of art. What collector ever says, "I would have bought a painting at the next booth, but I liked the rug you put down"? Sometimes, Plainfield, Massachusetts, painter Larry Preston uses a Persian rug in his tent (a particularly expensive prop, because hundreds of visitors will give the rug a real beating), and he also bought gray fabric panels ("When you are outside, a white background is too bright and the paintings become hard to see") and a consistent set of frames for all his works. The tent, rug, fabric, and panels cost him a combined $3,000. Additionally, he cut down the number of paintings on display, sometimes as few as twelve if they are at the 36″ × 48″ size, more if closer to 12″ × 16″. Fewer works on exhibition are "easier to see, and each is perceived as more important," Preston said, although he noted that the drawback of not having as many paintings on display is that prospective buyers may not

know that they have a choice of sizes, images, and prices. (Preston keeps other pictures on hand for visitors who make inquiries.)

"When I put a rug on the floor, so people weren't just on the grass, my booth seemed cozier and sales went up," he said. "When I changed my panels, sales went up. When I went to one style of frame and put up fewer paintings, sales went up." In past years, he sold ten or so paintings per year and now sells between forty and fifty. Another change was no longer selling prints of his paintings, which perhaps had given the impression that his display was low-end. "When I took prints out of my booth, sales went up." It is possible that eliminating the prints did the trick, and the bulk of the $3,000 spent on customizing his tent display was for naught, or it may be that his artwork improved over time or that how he spoke with visitors to his tent became more polished. The components of success are difficult to disentangle, but a growing number of artists are looking to how their booth and tent displays—amidst a sea of others at fairs and festivals—might stand out and get them noticed.

Talking to Collectors

By now, it should be clear to all that artists really aren't discovered while hidden away in some garret (what is a garret anyway?); that artists have to be out in the world making contacts and talking, talking, talking about their work. But what to say? Painter Bill Jensen said, "The worst thing in the world [is] to be a salesman. It's better to be yourself." Yet, all conversations that one has as an artist with a prospective collector have an element of salesmanship, whether the product is specifically a work of art or more diffusely the artist him- or herself is a serious, knowledgeable, interesting person. Those opportunities to be The Artist may be few—an opening of an exhibition of one's artwork—or frequent (manning the booth at an art fair, holding an open studio event, giving a public talk or demonstration, introducing oneself professionally at a party), but they all require the same understanding of the need to find something to say. The anguish and dread of saying something wrong or irrelevant or making a poor impression has driven some artists to look for the nearest garret in which to hide. Cyberspace has become the new garret: Too many artists these days

believe they will be discovered through some chance Internet search, relieving them of the need to face the world in person and in words.

Conversations between artists and collectors, usually starting in the form of question-and-answer, may be straightforward ("Where were you when you painted that landscape?"), or have an underlying purpose. "People want to feel your level of commitment," Tom Christopher, a painter in South Salem, New York, said. "They want to know if you're for real or just a charlatan, someone with a bit of talent out for a quick buck." Christopher paints crowded, colorful New York City streets, and he talks to would-be buyers about how he started drawing and why Manhattan's main and side streets have been his principal subject. He refuses to talk about money ("I have dealers for that") and deflects requests to paint certain locations ("Could you do 77th Street and York Avenue?"). Sometimes, the question may seem insulting ("like, 'Why don't I paint Frankfurt, Germany?'"), but he responds by expressing enthusiasm for New York City, often finding that humor is helpful. "I've been asked, 'Have you always been an artist?' and I say, 'Well, I tried other jobs, but none of them stuck,'" adding that collectors "don't really want a soul-searching answer."

Turning the conversation around, Christopher sometimes becomes the one asking the questions: "What do *you* like about New York? Where do you live? What do you see? What turns you on about the city? If you were a painter, what would you paint? How do you like the ragged drip edges of my paintings?" Never straying all that far from his own artwork, Christopher broadens a discussion that can easily devolve into rote responses. He keeps brochures and catalogues on his work handy—they may answer a familiar question or just give visitors at an exhibition something to do—"but openings are, what, two or three hours, two or three times a year. That's not so much."

For Western artist Howard Terpning in Tucson, Arizona, the talking may go on for days at a time, such as at the Prix de West competition that lasts a long weekend ("I get a little hoarse by the end of it," he said), and the questions are always the same. "I'm asked a million times how I got started in this business. I sometimes wish I had a printed sheet to hand out" or could just tell people to read one of the books

written about him to get their answers. However, sarcasm and touchiness would be self-defeating, and "I patiently explain to each and every one of them how I got started in the business, how I started painting the Plains Indian." Like Christopher, Terpning won't talk money, referring collectors to his gallery for paintings and to Greenwich Workshop for prints. Unlike Christopher, Terpning carries no business cards or brochures, relying solely on his vocal chords.

Wildlife artist John Seerey-Lester, who lives in Osprey, Florida, goes a step beyond brochures, running a video or slide presentation that describes his background in art and how he paints, and he sometimes adds commentary while the video is on. Usually, the questions that follow are a continuation of those themes: Where something was painted, why he chose to paint that, sources of his inspiration. Talk that is less open-ended and more specific to the artwork on view makes the process of conversing with strangers more manageable for him. Wildlife collectors, he noted, respond favorably to "stories of where I was when I painted something, the hazards I faced, any dangerous incidents, funny stories. I've done walkabouts in a gallery, telling anecdotes about this or that work, and usually all the pieces are sold by the time I'm done talking."

Since art is a luxury rather than a necessity, what is generally thought of as sales talk may not be all that helpful in getting someone to make a purchase. Instead, the contagion of an artist's enthusiasm or information about who else has collected the artist's work ("People feel more confident paying $15,000 for a painting when they know they're not alone," Christopher said) may help a sale take place. Art is a commodity to be bought and sold but, as a vessel bearing the ideas and feelings of the artist, it is also a very personal product, affecting the relationship between buyer and seller. For sculptor Elyn Zimmerman, collectors sometimes become friends. "People come up to me at an opening and ask me questions," she said. "They see something in my work that touches them deeply, and a relationship builds, because we share certain fascinations."

At other times, she noted, the questions merely reflect puzzlement over what's going on in the art, requiring explanation.

The confidence that artists feel in their ability to speak to strangers is proportionate to the degree to which they believe that talking to collectors is actually useful. Painter Harriet Shorr said that, during studio visits, collectors who have purchased pieces usually make their choices immediately, "and they're not particularly interested if I'm talking or not," while those who tell her they need to think about it first "generally aren't going to buy anything, and I could talk myself blue in the face." Like many artists, she prefers to be approached by a collector than to strike up a conversation with a stranger looking at her work. Like many artists, she prefers a dealer talking up her art rather than herself. However, "one time, I approached someone at a party who was talking about art. I thought, 'What the hell, I might as well let him know I'm an artist.' It was at a point in time when I didn't have a dealer. I invited him to my studio, but nothing came of it. It seldom does."

Not every collector is eager to meet artists or go to their studios, at least not right away. Edward Broida, a noted collector of contemporary art who lives in Malibu, California, said that he may "get to know the artists after I buy their work, but I dislike knowing them first, because it affects my objectivity. When I was living in New York City, artists would invite me for studio visits, but I found it very uncomfortable. They look at me and I look at them. What do I say? What do I do? I prefer to see art in an independent, third-party place, like an art gallery."

On the other side, a number of artists complained that the people who approach them frequently are looking to be allowed into their studios. "I feel close to abhorrence about strangers coming into my studio," said New York painter April Gornik. "It's very interruptive, and I don't want someone's unsolicited opinion." She added that she prefers to discuss finished pieces rather than those in progress.

It is not always clear how important it is for a collector to know the artist. Perhaps, during his own life, Rembrandt personally helped or interfered with the sale of his paintings, but nowadays his artwork stands on its own, talked about by people with doctoral degrees, and many living artists would hope that their art speaks for itself (or that a dealer will do the talking). Jamie Wyeth worries that something he might say about one of his paintings might "intrude on someone else's sense of what the

work is about." Renowned for his own work, as well as that of his father (Andrew Wyeth) and grandfather (N.C.Wyeth), he noted that the problem of making a bad impression "gets worse as you get more established. People have a preconceived idea about who you are, and you find you're probably a disappointment to them in the flesh."

Renown also increases the number of people who want to talk to an artist, although it may have little to do with collecting and more about creating an anecdote they can tell someone else. "I've had people come up to me and tell me they love my work; they have a painting of mine in their living room that's changed their lives," Wyeth said. "I ask them, 'Which painting is that?' and they say, 'Uh, um, well, there is a person in it, or something.' OK, better not go down that road." At other events, he has been congratulated for painting "Christina's World" and for illustrating *Treasure Island* ("I've learned to accept thanks for whatever people want to thank me for"), coming to the conclusion that many people simply want to hear their own voices.

Hearing themselves speaking to an artist or just wanting to hear the artist's voice, people may have a variety of reasons for talking to artists that have nothing to do with the purchase of art. Just as marketers send out flyers to names on a mailing list, with the hope that 2 or 3 percent of the recipients buy whatever they are selling, artists may have countless futile conversations for the prospect of talking to an actual collector who makes a purchase. However, conversations are not flyers, and the effects may be varied. For artists, putting their thoughts into words may help clarify their thinking and understanding of their own work. Hearing an artist discuss his or her work may help a listener gain a greater appreciation of art (and who can tell where that may lead?). Listening to people describe what they found in their artwork could give artists a fuller appreciation of what happens once their work goes out into the world. "Art is a conversation," Elyn Zimmerman said. "If it doesn't communicate, what's the point of making it?"

Sidewalk Ordinances

In the movie *Mary Poppins*, everyone was charmed by Bert, the chimney sweep, kite seller, and sometime artist whose sidewalk chalk

pictures opened up into adventures. Real life artists, however, often find that the world offers them and their work a quite different reception when sidewalks are involved. Drawing on a sidewalk generally is viewed as a form of defacement, comparable to graffiti and punishable by fines and imprisonment. (A sample ordinance by the City of Pineville, Louisiana, states that "It shall be unlawful for any person to write upon, paint signs upon, advertise upon, or in any other manner whatsoever, deface the sidewalks or streets within the city"—art and advertising are viewed as one and the same.)

Artists who look to sell their work on sidewalks or in parks may find that the world is only slightly more tolerant and often just as willing to threaten fines or jail terms. (For instance, the ordinance in Hattiesburg, Mississippi, states: "It is hereby declared to be a public nuisance and it shall be unlawful for any person to solicit, accost or canvas persons on the streets or sidewalks of the city for the purpose of selling any books, wares, merchandise or articles of any description. Such practice is hereby declared to be obnoxious to the personal rights, convenience and privileges of the public and is further declared as impeding orderly traffic on the streets and sidewalk.") In some instances, storeowners are the ones who complain the loudest, saying that they have to pay real estate taxes and should not have to compete with sidewalk vendors who don't. Some city leaders liken street vending and performances to panhandling, disturbing the peace, and generally blocking traffic. In Portland, Maine, the main objections to artists selling en plein air appeared to be safety—an easel, table, or display rack could hamper pedestrians, forcing walkers onto traffic-filled streets—and liability, in the event of someone tripping over an easel. Some artists were fined, while painter Ian Factor was told by Portland police to "move along." He actually had not been selling work but had set up his easel on a sidewalk outside his studio in order to paint a scene of some nearby street musicians when police confronted him with, "'You have a permit for that?' I said to them, 'This is a joke, right?'" It was no joke: City fines for placing a table, chair or—in this case—an easel on city property, such as a sidewalk, without a permit range from $50 to $500, and the cost to obtain such a permit is $225.

Selling artwork on a sidewalk or in a park is not for every artist. "Given the choice, artists would prefer to sell their work in a gallery than on the street," said Andy Frankel, executive director of Philadelphia Volunteer Lawyers for the Arts, "but it is an option that does come up." It is the preferred manner of selling for New York City mixed media artist Robert Bery, who noted, "selling on the street is sometimes equivalent to a good outdoor art festival. Sometimes, you can be at a good festival, but no one is buying anything." He noted that his income from sales is good, "I pay taxes, I have an accountant," and he doesn't need to split the selling price with a dealer.

The issue of whether or not artists need permits to sell their work on the streets has been popping up with increasing frequency all over the United States, including Boston and Cambridge, Massachusetts; St. Augustine, Florida; Salt Lake City, Utah; Hollywood, San Diego, and San Francisco, California; Portland, Oregon; and Seattle, Washington. Dozens of "street artists" were arrested in New York City during the 1990s as part of then Mayor Rudolph Giuliani's campaign to improve the city's quality of life, but a number of them—including Robert Bery ("I was arrested quite a few times")—brought lawsuits against the city. In 1996, the U.S. Court of Appeals ruled in his favor, claiming that the constitution's first amendment not only protects the right to create art but the right to sell it. "Furthermore," the court held, "the street marketing is in fact a part of the message of appellants' art. As they note in their submissions to the court, they believe that art should be available to the public. Anyone, not just the wealthy, should be able to view it and to buy it. Artists are part of the 'real' world; they struggle to make a living and interact with their environments. The sale of art in public places conveys these messages." The court also found that New York City rarely issued new permits to street vendors, requiring applicants to get on a waiting list that was backlogged fifteen years or more, resulting in a restraint of trade.

The Maine affiliate of the American Civil Liberties Union, which took on the cause of Ian Factor and other Portland artists, also has called the requirement for street artists to have permits unconstitutional. "Selling art is different than selling hot dogs," said Zach

Heiden, the civil liberties union lawyer. "There are legitimate health concerns in the sale of food, like hot dogs, requiring licenses and inspections. However, there is no reason ever for an artist to get a license. The courts have clearly held it to be a restriction on first amendment rights." However, while the decisions in those courts—in New York City, as well as in Hollywood, California, and St. Augustine, Florida—may prove influential, their rulings only apply to the specific municipalities and provide no precedent elsewhere. The large number of artists residing and working in New York City, and the degree to which their presence adds to the city's overall economy, may well have prodded a judge to rule in their favor, according to Sean Basinski, director of the Manhattan-based Urban Justice Center's Street Vendor Project. "Most cities are far behind New York on this issue," he said. "They consider unlicensed vending by artists a crime."

Artists who seek to challenge civic codes requiring them to obtain a permit would have to be prepared for the time and expense of a multi-year-long legal process, the outcome of which is uncertain. Many of the street vendor statutes around the country were enacted back in the nineteenth century, and they contain language ("pushcarts," for instance) that suggests they are still planning for hurdy-gurdy men. As a practical matter, Basinski noted, artists should look to obtain what-ever permits are required of other vendors. "If there is nothing on the books, you should probably get written permission from someone, because the police may just decide to hassle you," he said.

The cost of these permits and where they may be obtained is different in every city, and there could be more than one agency per municipal-ity that issues licenses. The Parks Department, for instance, may be in charge of public parks, while the police control vending on city streets. Those desiring a permit to sell non-food merchandise in Richmond, Virginia, are required first to obtain approval for a specific site by a tax enforcement officer of the city's Department of Finance; second, purchase a $300,000 liability insurance policy that names the city as co-insured; and third, pay a $225 fee to the city's License and Assessment Division. In the City of Syracuse, New York, permit applications must be sent to both the Department of Public Works and the Police Department (the cost is $20 for one day, $50 for one month, or $100

for one year), while the offices of the City Clerk in Lincoln, Nebraska, and the Town Manager in Brandon, Vermont, receive applications for sidewalk vending, and each charges a flat $100 fee. In general, city hall is probably the wisest starting point for information on where to obtain an application, the cost, and restrictions on vending sites and activities.

Artists looking for information may also contact the municipal arts agency, nearest chapter of the Volunteer Lawyers for the Arts organization or a local arts organization. "You want to find out what other artists are doing," said Jamie Bischoff, a lawyer who works with Philadelphia Volunteer Lawyers for the Arts. "Maybe there is a law on the books that works to the disadvantage of artists, but no one enforces it. Maybe, there is a law that needs to be changed, so artists might want to join forces and find a lawyer who will take the case on a pro bono basis or even contact the ACLU."

Municipalities may legitimately restrict street vending to a certain section of the town and specify the hours of the day that the activity is permitted to take place—usually, no earlier than 7:00 A.M. and no later than 11:00 P.M. (licenses often define acceptable behavior by the permit holder). The municipal code in Anchorage, Alaska, limits vendor sites to no longer than ten feet and no higher than six feet from the sidewalk, and they must be separated from any other vendor by at least ten feet; the permit from the city and a certificate of insurance must be visible at all times. In addition, the vendor cannot set up within fifty feet of "a business that traditionally sells the same goods or services that may be offered" by the vendor. For most municipalities, because of concerns of crowding, the number of permits that a city allows may be limited, and the determination of who receives a license may be decided by lottery or on a first-come, first-served basis.

Most sidewalk vending ordinances divide permits in terms of food and non-food sellers, and it is the rare regulation indeed that identifies artwork specifically as an acceptable type of goods. City officials may not determine which artist vendors receive permits based on the content of their work, although art deemed offensive or disturbing is likely to be barred with little reference made to who might find the work disturbing. As an example, the relevant ordinance of Salt Lake City refers to

the problem of artists "creating visual blight and aesthetic concerns," while any sound system used by a street vendor in Phoenix, Arizona, "[s]hall play only pleasing melodies. ..." (Call out the American Civil Liberties Union again?) Trickier still is the issue of what types of art will be allowed. Usually, municipalities prefer original art—paintings, sculpture, and handmade crafts, for instance—and shy away from graphic or photographic prints, posters, and images on T-shirts. However, two New York City graffiti artists, Christopher Mastrovincenzo and Kevin Santos, won their lawsuit in 2004 against the City of New York after the Department of Consumer Affairs refused to issue them a permit to spray-paint blank baseball caps (charging between $10 and $100 per hat) from a sidewalk stand. "Civilization," the U.S. district court judge wrote in his decision, "has traveled too far down the road in the evolution of art as embracing the whole spectrum of human imagination for the law to countenance a classification of an artist's design as art only when imparted in conventional shapes and forms sufficiently familiar or acceptable to a government licensor."

City officials around the country remain of two minds on allowing artists to sell their work—or, in the case of musicians, to perform—on the streets. They are reluctant to open the door to unruly behavior, noise, tax evasion, and littering (as a result of terrorist threats, the City of Boston sought to eliminate musicians in subway stations, worried that their music would drown out important messages, but then were convinced that the trains themselves were much louder), yet urban planners are consistently promoting the value of having artists in public spaces as a means of livening up otherwise lifeless city streets. This newer attitude may be found in a city council resolution in Salt Lake City ("It is in the public interest to enliven and increase commerce and create a festive atmosphere in the downtown area and in City parks by encouraging artists and entertainers to express themselves on the sidewalks and in the City parks"), Cambridge, Massachusetts, ("the existence in the City of street performers provides a public amenity that enhances the character of the City") and wherever the courts decide that artistic expression is different than the sale of hot dogs.

chapter

3

Open Studios

If artists are going to enjoy success in their careers, they need to put their work in front of people, but which people? A billboard image of their art on the side of the Santa Monica Boulevard in Los Angeles will certainly result in lots of people seeing it, but there are not likely to be many buyers. Marketing means finding the right audience for something that is for sale, and part of an artist's task is to find the most appropriate places to display—and, thereby, sell—their artwork.

The buying and selling of art takes place in a large number of ways, in galleries or at auction, through commissions, over the Internet or by mail order, at arts and crafts shows, at art fairs, and also directly from artists during studio visits. The open studio may be the most fun for prospective buyers, because it is often done with other people and tends to have a party atmosphere (food and drink are served, there might be balloons and flowers, and even the most irascible artist tends to be on good behavior).

Open Studio Events

Making art seem fun to the public, rather than mysterious, incomprehensible, and solitary, has led a growing list of artists and municipalities around the country to create community open studio events, taking place on one or two days or a series of weekends. There are so many of them that one association—the Boston Open Studio Coalition—was formed to coordinate the various events that different

groups in and around the city (East Boston Artists Group, United South End Artists, Jamaica Plain Artists, Roxbury Open Studios, Roslindale Open Studios, Newton Open Studios, Brookline Artists Open Studios, South Boston Open Studios, Fort Point Arts Community, Dorchester Open Studios, Allston Arts District, Hyde Park Art Association, Fenway Studios, and Artists Group of Charlestown) were holding to bar any overlap. That type of cooperation has been lacking in California's Bay Area, where the Web site of Silicon Valley Visual Arts offers pages of comparisons between its Open Studios and those of the similarly timed East Bay Open Studios and San Francisco Open Studios, describing numbers of visitors, numbers of studios, fees to artists, services to artists, and other points—as though Comet were taking on Ajax—but competitiveness reflects the degree to which the open studio concept has caught on.

These events range in size from a few dozen artists (East Boston Artists Group open studio has 40 or so participants) to hundreds (more than 700 take part in San Francisco Open Studios), and the geographical distances between studios may be sizeable. The East Boston Artists Group all have studios in one large building, making it likely that the same number of visitors look in on each participating artist, while the San Francisco event encompasses studios in homes and other buildings throughout the city, which means that visitors are apt to pick just one or two areas to concentrate on, most likely in buildings where a number of artists' studios are clustered. High gasoline prices may also limit potential visitors' willingness to travel great distances.

Turning Visitors into Buyers

Group open studio events primarily are an activity for the emerging artist; more prominent artists may bring longtime collectors into their studios on a by-invitation basis or allow someone to be brought by their dealers. As a result, these group events tend to have two separate and related purposes: The first is educational, to let the public know that artists exist within their midst and to provide information on the processes and materials by which art is made. The main purpose of the events is to teach people that "artists aren't crazy nutty people, and that art is a commitment, a life, not a hobby for them," said Patti Brady,

a painter and former chairperson of the Greenville (South Carolina) Open Studios Project. The second purpose is to sell artworks.

For participating artists, too, there is often an educational compo- nent, since many of the groups that organize these events offer entire workshops or possibly just recommendations on a Web site on how artists should promote their work, set up their studios, create a price list, or talk about their work. Open Studios, which is held annually in Boulder, Colorado, provides a marketing workshop before the event for the 140-plus participating artists that focuses on how to publicize artwork, the types of financing arrangements that may be set up, and "how to talk to people," said Gary Zeff, founder and executive director of Open Studios. "You want to get some conver- sation going, like 'Is this for you, or is it a gift?' and not just 'Will this be cash or charge?'" He added that collectors are interested in "a story that goes along with buying a piece," such as how it was created or what was the inspiration. In addition, asking visitors about themselves—what kind of art they like, where they live and work, how they heard about open studios, what do they see in this painting—both creates a bond between artist and prospective buyer and is a form of marketing: Artists learn who their audience is, as well as the visitors' taste in art and level of artistic appreciation.

What works and doesn't work in attracting and keeping visitors is a mat- ter of trial and error, and not everyone has had the same results. Something as basic as shaking a visitor's hand when that person enters and leaves the studio may add a note of ceremony to the occasion. A variety of suggestions are made by organizers of open studio events, such as:

- Show the artistic process, for instance, through displaying various stages, which might include preliminary sketches and oil studies or the materials and equipment used. Liz Lyons Friedman, a printmaker in Aptos, California, who has been a long-time participant in the open studio event organized by the Cultural Council of Santa Cruz County, displays her printing press, inks, blocks, and paper, as well as intermediate stages in the creation of prints on view, "which

really fascinates visitors. They just have no idea." This offers a number of conversation starters.

- Send out invitations electronically or by regular mail to people who have bought work in the past or just have shown interest in the artist's career, informing them of the time and place of the open studio. A postcard with a reproduction of the artist's work might be tacked to a bulletin board, lasting as a reminder longer than an easily deletable e-mail message. The same postcards should also be available in the studio when visitors arrive, along with other printed material, such as a brief biography of the artist, a price list and, perhaps, some information about the artwork itself (inspired by … , technique used … , commemorating … , for example), if it is not obvious. Visitors should be directed to sign a guestbook and include their addresses, in order that they may be placed on a mailing list for future shows or open studio events.

- Images, written materials, and elements of the artistic process generally keep visitors in the studio longer—during which time they might decide to buy something—so does food and drink. Ann Ostermann, event manager for the Cultural Council of Santa Cruz County, stated that there is "no correlation between food and sales; spending longer eating doesn't result in visitors buying art," but there may be other benefits. A bite to eat and something to drink makes people feel welcome and helps sustain them as they progress from one artist's studio to the next. Those who drop out to go to a restaurant may not return. Gary Zeff said "no alcohol for sure, you don't want the liability," but various artists spoke of serving white wine, as well as water and finger foods (nothing crumbly and keep a supply of napkins on hand). Artists should also remember to eat during the day, in order that their energy level stays high.

- Artists should try to get a good night's rest before the open studio, but they will stay refreshed longer if someone else

(friend, spouse, relative) is on hand to chat up visitors, directing them to the guestbook, keeping the food moving, and cleaning up any messes.

- Signs and posters (balloons?) should be set up outside, so that visitors know where they are to go. Inside, artists might want to put out of the way dangerous materials (solvents and resins, for instance) and machinery with sharp edges, as well as clean up spills that could cause a slip. Artists with studios in their homes may consider removing valuables and prescription medicines from the bathroom vanity (toilet paper should be in good supply). Some artists cordon off rooms in their homes that they want off-limits to visitors, but not all. To get to the studio of Marie Gabrielle, a watercolor artist in Santa Cruz who takes part in the citywide open studio weekends, visitors must walk through her house and backyard, and she considers her house a major selling point, because her framed paintings are on the walls. "I have a nice house, and people like the idea of seeing what my paintings would look like in a living room," she said.

- Among the DON'Ts that sometimes get mentioned are letting a dog run loose, wearing perfume, and trying too hard to sell things. While having a friend help out at the open studio makes the artist's job easier, both artists and their friends need to remember that they shouldn't just talk to each other but focus on visitors.

- Among the open points of discussion among artists is whether or not a studio should be reconfigured for the occasion to look more like an art gallery (will visitors take art more seriously if the setting is formal or do they come to see a more rough-and-tumble workplace?), if two-dimensional pieces should be framed (are people more apt to buy if artworks can be put directly up on the wall?), and if there is any return investment on providing food (does a better bottle of wine suggest that the artist is more prosperous and successful?).

The other main purpose of an open studio is to generate sales, and a number of factors help determine an event's level of success in this area. For instance, more participants increase both the amount and likelihood of sales. The sixty artists who opened their studios in Greenville, South Carolina, reported sales of $85,000 in 2005, while the 122 artists of North Coast Open Studios in Humboldt County, California, drew $220,000, and the 275 artists in Santa Cruz earned between $1.2 and $1.5 million. Additionally, a number of open studio organizers have instituted a jurying system for applicants in order to raise the (perceived) quality of the event to the public. The Greenville Open Studios requested artists to submit images both of their artwork ("We wanted professional quality work, not a free-for-all," Patti Brady said) and of their studios ("We wanted to know if they have a real studio space or just work in the kitchen," she noted).

Sales are difficult to predict, regardless of the quality of the artwork on display; in fact, if higher quality translates into higher prices, top-notch art will probably be a money-loser, because most open studio visitors don't actually come to buy and those who make a purchase usually spend very modest amounts. Laura Baltzell, a painting living in Brookline, Massachusetts, who rents a studio in East Boston, took part in both the East Boston Artists Group and Brookline open studio (in Brookline, she sets up her home as a gallery), selling a few digital reproductions of her paintings but none of the originals at either open studio. Loretta Shoemaker, a painter and pastel artist, brought out "all my lower-end things" for the East Boston open studio, such as some three-by-seven inch paintings; in all, she sold ten works for a total of $500.

Marie Gabrielle, on the other hand, regularly earns the bulk of her income at Santa Cruz's open studio weekend. In 2005, she took in $40,000, selling fifty watercolors that are priced between $300 and $2,000 to visitors who came by her house. She has shown her work at galleries and periodically tried to hold more private, by-invitation open studio events for her own collectors but never with as much success. "So many more people come at the community event, maybe 2,000–3,000," she said. "They look forward to open studios, and that's what I work for."

Painter and pastel artist Kerri Lawnsby also stated that she has done "pretty well" at open studios in Silicon Valley, selling six paintings (priced between $500 and $800) along with note cards and prints for a total of almost $4,000 in 2005. She credited her success, in part, to the fact that her work is shown with that of several other artists, which brought more people to their studios. "Silicon Valley is pretty spread out," she said. "People prefer not to drive as much; they prefer to see three artists at one place than drive to three different places to see three artists."

Open studio organizers recognize the need to promote these events in a variety of forums. The Metropolitan Arts Council of Greenville, for example, created a Web site (every artist had his or her own page), printed posters that were placed around the city, produced 15,000 artist postcards for participants to mail out, and published a catalogue that included a map showing where participating artists were located, as well as a bio, images, and contact information for each of the artists. One hundred and thirty thousand copies of the catalogue were distributed free in the area. In addition, the council staged a reception and exhibition in its gallery that featured one work by each artist, which drew another element of media coverage. The council raised a fund of $40,000 for this effort through corporate sponsorships (the catalogue's printing was provided by the *Greenville News*), grants, and from participation fees ($180) of the artists themselves.

Perhaps as critical to the success of an open studio as anything else is the desirability of the neighborhood in which the event takes place. The Cultural Council of Santa Cruz County had a sizeable budget for its three weekend-long open studios—$120,000—but it was already a destination for tourists. "Cultural tourism has become a big part of civic planning," Ann Ostermann said, adding that the Santa Cruz County Conference and Visitors Council packages "cultural getaways." "People plan their vacations around culture," she said

The new breed of open studio events is not just about artists showing and selling their work, nor are they principally intended to educate the public about art and artists. They are community events, bringing people out on weekends, benefiting shops and restaurants. They provide something different to do for both people interested in art and those who

may just want to see how other folks live, and their economic impact (measurable not on artists' income but on the entire business district) has led more and more nonprofit organizations and municipal or county agencies to take on the job of organizing and scheduling them.

Laura Baltzell earned almost $2,000 at the 2005 Brookline event, nothing at East Boston (they both take place in the spring, within weeks of each other), which she attributed to the fact that "Brookline is wealthier and has more and better restaurants," while East Boston is "still a poor, immigrant community. A lot of people don't know the area, and if they have to pick one open studio to go to they prefer Brookline." As a place to shop, East Boston has some big chain stores, such as Costco, while Brookline has a number of smaller, specialty shops that cater to people with money and a taste for novelty. A clear benefit of East Boston, Baltzell stated, is that she pays only $150 a month for her studio. If opening it up doesn't bring in many visitors, its affordability compensates the loss.

Or, By-Invitation Open Studios

Perhaps, group open studio events are more suitable for artists at the out-set of their careers or who are not steadily pursuing the marketing of their artwork. The sometimes circus atmosphere and the uneven quality and content of the work in these open studios may begin to work to the disadvantage of artists whose work has reached a higher level of esteem. For them, selling $25 knick-knacks would be a humiliating step down. These artists may continue to hold open studio events but just for their own studio and by invitation only. Their focus primarily will be on sales, commissions, and establishing relationships with serious collectors.

"I sell so much at my open studio," said Lynn Peterfreund, a water-color painter in Amherst, Massachusetts, who opens her studio to collectors, friends, and colleagues twice a year. "I make thousands." She noted that big group, open studio events have "an exhibitionary value to artists, but my aim is to sell."

When artists take on the job of selling their own work, they need not only to be the creator but also to take on some of the elements of

being an art dealer. Dealers have price lists, for instance, indicating what each piece costs. Artists should not fumble around in a desk for a price list when visitors are right there in the studio (that looks very unprofessional), and prices that are not committed to paper but simply stated to would-be collectors might make them feel ill at ease. (Visitors might wonder if the artist is stating the real price or sizing them up for how much they look like they can pay.) Postcard images or brochures should be available for visitors to take, as well as biographical or reference material (critical reviews or an artist statement—see chapter 4). Any purchases should result in the creation of a written sales receipt, listing the artist's name, artwork's title, size, medium, price, and the date of sale. United States law already protects creators, but they may also choose to include on a sales receipt the fact that copyright (unauthorized copies of the work may not be created) and moral rights (alterations, distortions, and destruction of the work without the consent of the artist) for the artwork are retained by the artist.

Additionally, as noted in chapter 1, it is useful to have a friend, relative, or spouse on hand to tend to the details (gauging particular visitors' interest in art and price range, guiding them to specific artworks, and making sure they sign the guest book, for instance) in order that the artist may speak on a loftier level.

Practice has made (almost) perfect for Richard Iams and Buck McCain, two painters living in Tucson, Arizona, who have been holding a joint annual open studio—actually, open house—every March since 1993. Organized and run by their wives, Donna Iams and Melody McCain, the event drew thirty walk-ins the first year and grew to the point where it is an invitation-only affair for 350 collectors. (The final number may be higher, because many invitees bring guests who they believe might also be interested in the artwork.)

From this experience, Donna Iams has learned what has and hasn't worked:

- "Start planning the open studio six or seven months in advance," she said. That planning includes checking that no other major events are taking place that day at neighboring

colleges or in the NCAA Final Four basketball tournament ("someone once asked us if we had a television"), scheduling the printing of brochures, flyers and postcards, hiring caterers, florists, and parking attendants.

- Notify people months in advance. "When we first started, we tried telling people a month in advance, but so many people had already made other plans," she said. "They told us, 'We wish you had let us know earlier, so we could have put it on our calendar.' " Richard Iams' holiday cards (Hannukah for Jews, Christmas for Christians) each contain a brief hand-written note about the show, followed up in late January by a postcard with information about the open studio event on the back and an image of a painting that will be on display. One month before the event, a newsletter is mailed out, containing between four and six images, the times and date of the showing, a map and a request for an R.S.V.P. ("The first time we had more than 300 people, we ran out of food").

- Make it one day. "The first few years, we did shows over two days, on Saturday and Sunday, from 2 to 5 P.M., but that was very exhausting," she said. "You have to set up twice and take everything down twice. We switched to a one-day show, from 10 A.M. to 7 P.M., and that's worked out a lot better." A problem with the second day, she noted, is that collectors believe that "if they didn't come the first day, everything will be gone, so they didn't come the next day." Over the course of that nine-hour day, she found that the flow of visitors was relatively constant.

- Have a range of artworks to show. Each artist puts out approximately twenty artworks, consisting of five paintings and the remainder sketches and small studies for larger pieces. It is the less expensive sketches that are most likely to sell, especially to visitors who are just starting to collect. "For the first three years," Donna Iams said, "we tried to make the display look like an art gallery," but they switched to a far less intimidating and formal approach, putting unfinished and unframed pieces on the floor, perhaps in a corner. (Their house looked like a house again.)

"People like to root through things. When they find something out of the way, they feel as though they've made a discovery."

- Provide food and drink. As the open studio became an all-day event, the foods need to change for different times of the day ("no one wants to eat a sandwich in the morning"). Before noon, the serving is similar to a continental breakfast, with cinnamon rolls and fruit, changing to carrots and celery sticks, chips and salsa, chimichangas and fajita sticks (kept in warming hot plates) by the afternoon and evening. "Sandwiches don't work," she said. "They dry out." Guests are limited to two free drinks, including beer, wine, and juices. "We try to use top-end wines, costing generally $15–20 a bottle. We don't want to invite people in and then give them cheap things to eat and drink. I've heard at gallery openings people say, 'Gee, this gallery must not be doing well if this is what they serve' or 'I think this wine has been watered down.' We want to project an image that we can provide nice things."

- Make yourself available. For the first three years, Donna and Melody prepared and served all the food and beverages themselves, "and we never had time to talk to people." That talking has proved quite valuable, discussing the business side with collectors (prices, commissions, how and when to make deliveries), making sure that visitors sign the guestbook and stepping in to continue conversations with visitors when their husbands are being monopolized by individuals for too long. They hired a caterer and a bartender, both of whom were allowed to put out their business cards. As a result, the caterer drummed up a considerable amount of business, too, and gave Donna and Melody a sizable discount (10 percent the first year, 50 percent most recently).

- "Name tags don't work," she said. "People hate them." Visitors prefer to remain anonymous to one another but are usually willing to put their name, address, telephone number, and e-mail address in the guest book, although they may need to be shepherded over to it.

- Flower arrangements add to visitors' pleasure, while parking attendants alleviate concerns about where to park and the safety of their cars. For her own peace of mind, Donna Iams removes prescription medications from the bathrooms, breakable pottery that may be bumped by people walking through the house, and pocket-size valuables (small sculpture, for instance) that might be stolen. She also purchased additional liability coverage for her homeowner's insurance policy (approximately $50) for that one day. The entire cost of staging the open studio is $1,500, including $575 for catering, $300 for wines, beer, and hard liquor, $150 for parking attendants, and the remainder for printing and mailing.

- Every visitor takes away a packet of images—postcards and brochures, mostly, and biographical information about the artists. Donna and Melody have also set up a print stand where visitors may purchase reproductions of their husbands' paintings.

- After the event, every visitor will be sent a handwritten thank-you note for coming. At the open studio, Donna and Melody hire a photographer to take pictures of visitors, posing actual buyers with the artist and the work purchased. These photographs will accompany the thank-you notes.

Studio Tours

Clearly, artists want to get their work out into the world, and perhaps the best way for some to do that is by bringing people into their studios. Community and by-invitation events are just two methods by which it happens. Sometimes, collectors contact artists directly, possibly to buy or commission a piece, and, at times, art dealers may bring a prospective or long-term collector to an artist's studio as a means of cementing a sale or a relationship. Yet another type is a tour group organized by a museum or other organization that brings visitors to a limited number of artists' studios where they may meet artists and "get a behind-the-scenes glimpse" of how art is produced, according to Sara Garden Armstrong, a painter who runs the Long Island City, New York–based cultural tour group company Art Entree.

As opposed to the community open studio event, a cultural tour group is smaller, coming and leaving within a specified period of time. In addition, they tend to be a more targeted group of potential buyers (having money and leisure time, for instance). Unlike a by-invitation open studio, the members of the tour group are generally unknown to the artist and represent a new potential market.

Started in 1982, Art Entree has been hired by banks, clubs, law firms, museum groups, and associations to lead tours of selected artists' studios. These groups contain "a lot of women," she noted. "Some of them are retired, some are the spouses of someone attending a convention, but we also get a lot of male and female corporate executives who want to get a taste of the art world." Armstrong attempts to discern a group's area of interest in advance—painting, sculpture, glass art, new media, "very contemporary or very accessible"—and selects artists who are appropriate. She discovers artists through suggestions from dealers and from one artist recommending another.

There are certain qualifications for artists who are part of a tour itinerary. Their studios, for instance, cannot be too small for a group that may contain as many as fifteen to twenty people, and they should not be up seven flights of stairs ("three or four is the maximum"), because of the age of some members of the group. Studios are checked to determine how safe they are, such as having open canisters of toxic materials or dyes that can spill on someone's coat. On the bus ride to the studios, Armstrong will offer some background information about the artists, but the artists themselves "should be articulate about their work. Not too articulate—you don't want a discourse—and not too shy." A typical Art Entree studio visit usually lasts twenty minutes in all, and the artist is paid an honorarium of between $50 and $125.

"I was frightened about speaking to a group," said painter Sissi Siska of Hoboken, New Jersey, "but I forced myself to do it. Artists need to speak up for themselves and not just hope other people will do it for them." That tour group was brought in by a Hoboken-based company called A Friend of New York, which arranges visits to artists' studios in New York City and coastal New Jersey. Siska has participated in Hoboken's annual community-wide open studio event, but found that tour group

members seem more serious about art and ask more incisive questions. She noted that some sales have taken place on the spot, although more have occurred later on. Tour group members are herded to different studios, transported by bus, and there rarely is enough time during the allotted hour to see all of an artist's work and negotiate a sale. Interested collectors are more likely to come back on their own or just make a telephone call to arrange a purchase. "I've gotten follow-up calls a year later," she said. "There may be an occasion when they want to buy a work of art, or they see something else that reminds them of something they saw in my studio, and they call me up." Better yet, she has sold pieces to a collector referred to her by someone who had been on a Friend of New York tour.

Some artists do fabulously by tour groups. Los Angeles sculptor Bruce Gray claimed that he has done so well—making 80 percent of his income from sales to members of cultural tour groups—that he has organized studio tour itineraries (including his own studio) for art galleries, museums, universities, the League of Women Voters, conventions, and other institutions in order to keep the collectors coming. "The more sophisticated the group is artistically, the more likely there will be sales," Gray said. "Groups from museums are collecting already, and they are always looking." He also noted that "professionals—lawyers, doctors, architects, film people" on tour groups are "one of my target audiences. They have money to spend, and they are always looking to buy."

Not every artist who is visited by a tour group has a lot of sales— painter Laura Alexander, who has also been on A Friend of New York tour itineraries, only sold one image (actually, the rights to use it) to the art director of Manhattan publisher John Wiley & Sons for a textbook, and the only benefit to New York City photographer Claude Samton was a profile in *New York Magazine* written about him by a staff writer who was part of a tour of artists' studios in lower Manhattan arranged by Art Entree—but most enjoy some tangible benefits. A few of the tour group members who have visited Sissi Siska's studio decided to take a painting class that she teaches. Gray noted that his work was included in a show at the Palm Springs Desert Museum after it had been seen by a museum board member who had participated in a tour group, while Manhattan-based sculptor Ann Gillen stated that "talking

about my work clarifies my ideas. I'll say something that hadn't occurred to me before and then think, 'Aha! That's what I'm doing.' "

A sort-of "Aha!" moment came to Caldwell, New Jersey, painter Lisa Palumbo when a tour group visited her studio and she realized how very basic the questions were that individuals posed to her. "As an artist, you're with yourself and your art all day, and you assume that everything is obvious about what you're doing," she said. "When people ask you questions, you realize that nothing's obvious. You really have to start from the beginning: how you started, where you get inspiration, the history of a piece of art."

Learning how to talk about one's artwork is perhaps the most difficult aspect of turning a group of strangers into potential buyers. What do you say about your own artwork? Should you explain it, describing the ideas behind the work or its relationship to art history? Does saying that it reflects a personal vision or experience mean that you have to talk a lot about yourself? Is a discussion of the technical process used in creating it likely to make listeners' eyes glaze over? Should you say anything at all, assuming that had you wanted to express yourself in words you would have done so? May artists praise their own work, or is that better left up to other people? All artists who strive for new effects or forms in their work initially feel like the emperor in his new clothes, fearful that someone will point out a basic, underlying flaw that will make all talk irrelevant.

"The first few times groups came to my studio, I said, basically, 'Hey, what do you want to know? Ask me some questions.' Now, I know the questions, because I've been asked them so many times," and his off-the-cuff remarks generally respond to these issues: Where he gets his ideas, where he sells his work, how long he has been working as an artist, and what is his educational background. These are known as "talking points." At times, he focuses on an individual piece or does a demonstration. "People are fascinated when you make something right in front of them."

chapter

Exhibiting in Non-Art Spaces

"Galleries were not welcoming to my art." Well, we've all heard that before: Rejections cause some artists to give up, others to change their work to something they hope dealers might like better, yet others to search harder for galleries that will take them in. Sculptor Don Howard of Winter Park, Florida, decided to look for other places to show his work, masks with exotic faces, but art galleries were not among them. "A lot of places that show art aren't art galleries," he said, adding that he has sold many of his wall-hung sculptures to clients: bars, libraries, restaurants, a copy center, and even a tattoo parlor. "There is a lot of waiting around in these places and, while they're waiting, people look at the walls around them. Sometimes, they stare seriously."

Art Is Everywhere

It probably helps sales that Howard, a retiree with a pension and social security income, prices his work quite modestly, charging $250–300 and sometimes as little as $125 for each sculpture. "I sell a lot, because my prices are so reasonable," he noted. "If I were in a gallery, I'd have to charge more and probably would sell a lot less."

Like love and marriage, art and art galleries seem to go together, but sometimes it is not an easy pairing. Some artists may not have enough work to satisfy a gallery owner, and they may not be ready (yet? ever?) to view their art as a saleable commodity or even know if anyone is likely to want to buy it. Putting artwork up for display is essential for any

artist's artistic and personal development, but venturing into commercial art galleries usually comes after a process of exhibiting pieces elsewhere. That elsewhere may consist of a wide variety of alternative spaces that may or may not have any relationship with art. "We used alternatives as a stepping stone, building a résumé and gaining experience," said Kate Burridge, wife and business manager of Arroyo Grande, California, painter, Robert Burridge. "We did it at the beginning of his career, and it helped get him ready for galleries, where people now buy his work."

During that time, the late 1980s and early '90s, Burridge's work was exhibited at coffee shops and restaurants, hair salons, libraries, and wineries. Sales were brisk, but usually on the low end, between $75 and $350 apiece, although once he did sell a $1,000 painting at a wine tasting. Perhaps, the lesson of all this is that artwork needs to go where people with money go; art galleries only attract a small fraction of those with disposable income, while everyone goes out to eat.

Restaurants and cafés are probably the largest sponsors of informal art shows in the United States. These exhibitions create, to Terry Keene, owner of The Artichoke Café in Albuquerque, New Mexico, a "win–win situation for us and for the artist. The artist gets to display work and make sales, and we get a free, ever changing source of decor."

At times, the artwork becomes a very integral part of the overall dining experience. At Café Tu Tu Tango, which has six locations (Atlanta, City of Orange, Hollywood, Miami, Orlando, and Toronto), the interiors are all designed to look like an artist's loft in Barcelona, Spain. Not only are there completed paintings and sculptures around the restaurant but also works in progress that artists are completing on the premises, working at easels or on a sculptor's table. "Metal sculptors sometimes use a spot welder," said Mark Amidon, general manager of the Miami restaurant. "The heavy work is done elsewhere and brought in to be assembled."

The interior of the Big Sky Café in San Luis Obispo, California, has an art gallery motif, staging six two-month shows, annually. "We have music there, too," said Christina Dillow, one of the restaurant's managers and a fine art photographer. "It's everything that makes people

happy—music, food, and art." Her own work was on exhibit this past summer, with six photographs selling ($75–100 unframed, $275 framed). She has thought about seeking out a regular commercial art gallery to show her work, but is "unsure. There are time issues, I mean, can I really keep up? I have a full-time job at the restaurant. I also don't know the art gallery business, how it works."

Another art-oriented restaurant is The Gallery, with locations in Santa Barbara and Montecito, California, which started out in the mid-1980s as a bookstore that showed artwork but has become in equal measure a bookstore, restaurant, and exhibition space. The art sales, however, now bring in the lion's share of revenues, according to Jeremy Tessmer, one of The Gallery's sales representatives. "You have to sell a lot of books to make what you can from the sale of just one painting," he said. The profitability of the art hasn't led The Gallery's owners to turn the space over exclusively to exhibitions, however, which Tessmer attributed to "the culture of Santa Barbara. There are innate reservations about art spaces in Santa Barbara. People have expectations when they walk into an art gallery, and they think of art galleries as so formal. A bookstore and café is much more informal; everyone can afford a book or lunch." He noted that "people may not take art as seriously in this setting as they might in a strictly art gallery, but I don't think it has hurt sales at all."

The arrangements that artists make with restaurateurs vary widely. At some restaurants, the manager selects the artist and the artwork; at others, the owner picks what will be shown. The 212 Market Restaurant in Chattanooga, Tennessee, relies on an outside art consultant to choose artists whose work will be on exhibition throughout the dining rooms for three months; other restaurants rotate shows on a monthly basis. Terry Keene noted that he used to put up twelve month-long, one-person shows a year ("customers liked some, didn't like others") but decided to simplify the process by turning all of the exhibition space over to one painter, Santiago Perez of Tijeras, New Mexico. "He's a very popular artist around here. My customers really love his work, and they notice when something new is up," Keene said. "As things sell, he brings in new works, and he changes paintings that have been around for a while. It's easier for me and more profitable for him."

Keene does not charge any commission on sales at the restaurant—some others do, ranging from 10 to 40 percent—but, in a written agreement with Perez, the owner absolves himself of any liability in the event of work being damaged or destroyed. The same is true for any stolen pieces—one smaller painting by the artist was stolen this past spring—which Perez has to accept as a part of doing business in this manner.

The possibility of damage and loss—or people simply not treating artwork with the respect more customarily found in commercial art galleries or museums—at more informal settings for exhibitions is an ever present concern. At a local library, a child pulled the tongue out of one of Don Howard's masks, and a smoker put out a cigarette in the mouth of another at Orlando's Blue Room Bar & Lounge. Twice in the past two years, customers have walked off with small paintings on display at Salt Lake City's Oasis Café—in the first instance, the artist brought a lawsuit and, in the second, the value of the artwork was less than the restaurant's insurance policy deductible (that artist received nothing)—and Kate Burridge had to scramble to retrieve fifteen of her husband's paintings locked inside a local restaurant that had gone out of business. "I drove by wanting to see how many people were there at lunchtime, and I found the doors locked," she said. "I waited until some workmen came by—they were there to take out the stove—and I just went in and took my husband's work out. No one asked who I was or what I was doing, thank God."

Ad hoc art spaces may reveal other drawbacks for artists as well. Artworks may not be properly hung or labeled; a librarian, for instance, may not be able to answer a question about who the artist is, the cost of a work, or how to get in contact. (Café Tu Tu Tango takes a 5 percent commission on sales, payable to the waiter, "in order to encourage them to sell the work," said owner Bradley Weiser, but other art-filled restaurants offer no incentive to promote actual sales. Prices of artworks are usually low, and revenues to the eatery through commissions are small.) Burridge noted that the tasting rooms at wineries, where artwork may be on display, are usually dimly lit, which may add ambience to the experience of sipping wine but make seeing the art more difficult. The heat generated by food at a restaurant or hair dryer at a salon may cause damage, as will smoke at a bar.

Various smells also get picked up, which stay with the art and are difficult to remove. Protecting the artwork, when it is incidental to the main function of the establishment, is not likely to be a high priority to the owners, but artists may discover that the cost of obtaining their own insurance coverage for these works—especially at a restaurant, where rates are set based on the likelihood of fires—is prohibitive.

Putting up artwork in a bookstore, café, pool hall, or car wash ("We've tried everything once," Don Howard said) is the goal of no one's artistic career, but it may lead to more and better things. Art dealers may stop in for a meal, look around, and ask an artist to show at their galleries; customers may want to buy what they see at the café or something else in the artist's studio or even commission the artist for a new piece. Intrepid artists bring their work to the places that wealthy people go, knowing that art-collecting can start or take place anywhere.

"Art increases business," Weiser said. "It becomes part of the entertainment of the restaurant." At times, that may not work to the benefit of the artist, if their creations simply become window dressing for some other money-making enterprise. "Some places try to trick me, and use my stuff as decor," Howard stated, but he also has a trick to use. "At one bar in Orlando, called Antigua, I told them I was going to take my pieces out and put them in a show in another place. Right then and there, they bought five of them to keep permanently."

Art in Health Care

Art has long been thought of as good for the soul, but it has been seen increasingly as good for one's health, as well. Based on studies of the beneficial effects of having art around, a growing number of hospitals have created art galleries in their public areas, purchased artworks for a permanent collection, and employed artists to hold regular workshops with patients. "For patients, art is a diversion and a resource to deal with their affliction or problem," said John Graham-Pole, a pediatrician and co-director of the Arts in Medicine department at Shands Hospital of the University of Florida at Gainesville. "It is also a way in which we re-humanize the connection between patient and caregiver."

Shands Hospital has two art galleries, offering a changing series of exhibits of the work of patients as well as of professional artists in the area, and an artist-in-residence program that employs up to eighty artists per year (part- and full-time). These artists work with patients individually or in groups on art projects; on occasion, they work with the families of patients.

Artists who work with hospital residents may find that this activity can be a muse, as well as a source of income. Dona Ann McAdams, a New York City photographer, photographed her Brooklyn Day Program students, which resulted in an exhibition and a book, entitled *The Garden of Eden*, which was published in 1998. Other artists have been able to exhibit their work in hospitals or sold pieces to the institutions. In 1980, Tracy Sugarman, a Westport, Connecticut, "reportorial artist," approached the director of the hospital in the neighboring town of Norwalk about creating "a series of reportorial drawings of each department, showing what goes on in the hospital in a warm, unbuttoned way." In all, Sugarman turned in more than 100 black-and-white line and wash drawings. Ten years later, the hospital invited him back to create a mural for its then newly refurbished pediatric wing. He painted a series of seventeen full-sheet (22″ × 28″ inch) watercolors, which were then enlarged by computers and affixed to panels that became the murals—the original watercolors themselves were hung in pediatric patient rooms.

By chance, the architect for the renovation of Elmhurst Hospital in Queens, New York, happened to see Sugarman's mural and recommended the artist to the president of Elmhurst Hospital. Again, the artist created a series of watercolors, and the images were blown up for a mural in the corridor.

The building of a new hospital or the renovation of an existing facility is a particularly apt time to sell artwork, because decoration is often a part of the budget. When the hospital is a city- or state-run institution, percent-for-art laws may apply. Dorothy Holden, a fiber artist in Charlottesville, Virginia, sold a wall-hung quilt to the University of Virginia when its Medical Center was built, and the

piece was purchased through a percent-for-art program. The Medical Center has a permanent collection with its own exhibition space—brochures provide information about the works and the artists for visitors' self-guided tours—and there is also a gallery for temporary exhibits near the elevators. Whether en route to visiting a patient or waiting to see someone, visitors have an unavoidable opportunity to look at the work of local professional artists. Holden has had a one-person show in the gallery and participated in a group exhibit. "I've had tremendous exposure through the shows," she said. "A lot of people have told me that they saw my work. Someone who was visiting a patient in the hospital stopped into the gallery and ended up buying a piece."

Another visitor to the hospital's gallery, a patient whose architect husband was currently designing Charlottesville's City Hall renovation, "recommended my work to the city of Charlottesville, which commissioned me to make two quilts for City Hall," she said.

Many of the hospitals with arts in medicine programs are members of the Society for the Arts in Healthcare (2437 15th Street, N.W., Washington, D.C., (202) 299-9887, *www.thesah.org*), and the organization's membership list, categorized by state, may be a useful resource for artists. Other possible sources of information are the International Arts Medicine Association (714 Old Lancaster Road, Bryn Mawr, PA 19010, (610) 523-3784, http://members.aol.com/iamaorg/) and Hospital Audiences, Inc. (220 West 42nd Street, New York, NY 10036, (212) 575-7696, *www.hospitalaudiences.org*)—the latter group employing artists to work in largely outpatient settings (nursing homes, residences, shelters and day programs) within the five boroughs of New York City.

When a hospital does not have an arts program, artists who look to work within or exhibit in or to sell work to the institution should contact the president or chief executive officer. Many hospitals also have volunteer auxiliary groups, one of which may be involved in decoration or cultural activities. In most cases, hospitals, especially those that are municipal or state facilities, work with local artists.

Cruise Ship Art

To some, Royal Caribbean's fleet of fifteen cruise ships are just big boats, but looking more closely one can see that they are actually floating art galleries. Hallways, lounges, dining rooms, and recreation rooms all contain a wide assortment of original paintings and prints. These artworks are the subject of free art walks and lectures that Royal Caribbean arranges during the course of the voyage, and they are all for sale during the four art auctions that generally take place on board during a seven-day cruise. "We do it because it's actually a way of getting cultural enrichment for our passengers, as well as some profit for us," said David Stanley, vice-president of shipboard revenue for Royal Caribbean, adding that the cruise line receives an undisclosed percentage of each sale. "It's a profit center that makes everyone happy."

Profits are certainly in abundance and, within the past decade, almost every ocean-going cruise line visiting ports in the United States has instituted a program of art auctions as an activity and entertainment for passengers. (Only Disney Cruise Lines does not offer art sales as part of its regular event planning, although it holds silent auctions of Disney animation cels and memorabilia on board.) The market for art on cruise ships is enormous, and approximately half a million works of art are sold annually through on-board auctions. On Royal Caribbean cruises, approximately 22,500 works of art are sold during the course of a year. Prices for the art start as low as $100 (posters, for instance) and may reach thousands of dollars (or tens of thousands of dollars) for limited-edition prints or paintings by renowned artists, such as Marc Chagall, Salvador Dali, Peter Max, Joan Miro, Leroy Neiman, and Pablo Picasso.

The average auction price for artwork sold during cruises tends to be more on the lower end, although the actual amounts differ from one cruise line to another and from one ship to the next, reflecting the demographics of the passengers. For instance, the average price of artwork sold during Carnival Cruises, a line that aims for the budget-conscious vacationer, is in the $250–300 range, while the more luxury-minded passengers of Cunard spend an average of $500. (Prices may be higher if the work is framed.) In general, the itinerary of the cruise, the

cost of being on the ship, and how new and luxurious the ship is will be reflected in the income levels of passengers, who spend accordingly.

The seagoing companies themselves do not purchase art or take it on consignment to sell but hire one or another of the handful of art businesses that operate auctions on cruise lines. The largest of these is Park West Gallery, which is headquartered in Southfield, Michigan, and has contracts with eight cruise lines (Carnival, Celebrity, Crystal, Holland America, Norwegian Cruise Lines, Royal Caribbean, Silver Sea, and Windstar), through which 300,000 artworks are sold annually. Park West has been in the art selling business since 1969, according to Albert Scaglione, the company's founder and chief executive officer, but only began working with cruise lines in 1991, "only because we hadn't thought of doing that before."

On-board art auctions, which are usually preceded by formal or informal art talks by the auctioneer (often called the "art director" by the cruise lines), hold a number of attractions for passengers, the cruise lines, and the companies staging the art sales. For passengers, "it's a great activity, very different than an off-shore excursion or gambling or bingo, and the cruise lines get good compliments for it," Scaglione said. Gabriel Hacman, auction manager of the North Miami, Florida–based Richmond Fine Arts, which is the cruise ship auction division of the art publisher London Contemporary Art in England and operates art sales on Radisson Seven Seas Cruises, noted "the attraction for passengers is entertainment and excitement. People like to bid against each other, and win."

Certainly, the people who take cruises are generally well-off financially and have a limited number of opportunities to buy anything on board. The atmosphere on a cruise, Scaglione said, is "relaxed, and people are favorably disposed to spending money." As opposed to a regular land-based art gallery, where "someone may come in, look around and then leave, and you never see him again," the art director has "a whole week to work with" potential buyers on board.

Passengers may also relax their usual skepticism, as the credibility of the cruise line—from which people already have bought tickets—is

extended to the art sales. Their main source of information about the art comes from a well-trained art director; there are no competing art galleries, and the Internet (most ships provide access, only charging fees for downloads) offers only limited help in learning about a previously unknown artist or even about a better known artist's sales history or investment potential. "A lot of people are intimidated by art galleries," said Richard Scriven, director of ships operations for the Pompano Beach, Florida–based Fine Art Wholesalers, which runs art auctions on Cunard, Orient, Princess, and Royal Olympic cruise lines. "They don't know what a lithograph is, what a giclee is, if something that is signed and numbered means it's a print." During the course of the voyage, Fine Art Wholesalers' art director meets with individuals and groups, describing the work of particular artists, defining the differences between various art media, and generally leading art appreciation tours around the ship, where between 400 and 500 works of art are placed throughout. Approximately 25 percent of the artwork will be one-of-a-kind pieces, such as oil, acrylic, or watercolor paintings, and the rest are prints.

Not every cruise passenger enjoys art auctions—ship loudspeakers regularly announce when the next one will take place, which tends to be every other day—but no one is required to attend and, if they attend, no one is required to buy. Some people just go for the free champagne.

Passengers rarely just take their art purchases home with them but have the works shipped by the company that arranged the auction, usually receiving the art within six to eight weeks. In part, shipping is a con venience to the buyers so they do not have to carry off one more item, and it also is because the auction company will send a duplicate print from the same edition—rolled in a hard, cardboard tube if unframed, crated if framed—from their storage facilities back home. Artworks, especially those on paper, and their frames are easily damaged in the tight quarters of a ship—vandalism and accidents resulting from passenger or crew member carelessness are the largest culprits—whereas the land-based storage facilities are more protective. Because auction buyers don't actually purchase the print they see on sale, there is an occasional problem that the artwork is out-of-stock, in which case the collector is given the choice of selecting another work or being reimbursed. One-of-a-kind artworks and their frames may also suffer

damage, and they will be repaired or, in the case of a frame, replaced. "You take your chances when you bring art on board a ship," Scaglione said. "We think of ourselves as being in the restoration business."

There is no one type or style of art that cruise ship collectors purchase, although Hossam Antar, president of the cruise ship division of the Miami-based West End Gallery, noted that the largest area of sales is "realism and Impressionism, especially figurative works, although we sell some still-lifes, some naïve work, and some abstract." He noted that the itinerary of the cruise sometimes influences the subject matter, such as on Mediterranean cruises where "collectors will want Mediterranean subjects." Scaglione also claimed that, on cruises to Alaska, buyers will purchase from "a high percentage of Alaskan and Canadian artists doing scenes of wildlife and the Alaskan landscape." However, marine subjects (harbors, boats, ducks, and dolphins) are not necessarily popular simply because passengers are spending time looking out over the ocean. "Cruise ships are more like hotels than boats," Antar said, and passengers tend to think quite broadly.

A chief selling point for the art directors is that the artwork costs less on board than it would at a land-based art gallery, where overhead costs of rent, promotion, and a 50-percent or more commission to the dealer keep prices high. (On-board purchases are also duty-free.) Testing that claim is not easily done, since the art auction companies are often the principal sources for buying the same artwork. Fine Art Wholesalers, London Contemporary Art, Park West Gallery, and West End Gallery primarily act as print publishers, producing editions of the very artists sold on board. Park West Gallery, which represents the Pop artist Peter Max, publishes two editions of the artist's prints every year, usually in quantities of 500, and these are sold in its Michigan gallery, through mail-order catalogue, and in auctions. Park West also sells the artist's one-of-a-kind paintings and collages; the company has similar arrangements with the 100-plus other artists it represents. For artists that Park West and the other companies do not represent, they usually seek to buy an entire edition from other publishers, which again makes comparison shopping difficult. It is only with artwork (prints, mostly) by very well-known masters (Chagall, Dali, Erte, M.C. Escher, Miro, Picasso, Rembrandt, Norman Rockwell, among

others), which these companies purchase—individually, rather than in bulk—on the secondary or resale market, that buyers have much of a chance to evaluate whether or not they are getting the work at a competitive price.

One last caveat: As at better known art auction houses, such as Sotheby's and Christie's, the buyer's final bid is not the total price that he will pay. Often, there is a "buyer's premium" of between 10 and 15 percent (payable to the auction company or the cruise line) that is added to the winning bid, and framing may be an additional charge. Shipping charges may also be tacked on, which vary from one company to the next. Fine Art Wholesalers, which sells all of its art framed, charges by the size of the piece ($31 for small works, $51 for medium, and $61 for large), while Park West charges $35 to ship an unframed work in a tube and $69 and up for framed pieces.

All of these auction companies search for new artists whose work might appeal to passengers of cruise ships, and the contracts that selected artists receive are generally publishing agreements. "Subject matter is more important to buyers than who the artist is," Hossam Antar said, adding that a principal criterion for picking suitable artwork is "the likelihood of the work selling quickly." Other companies' directors offered other, somewhat more artistic criteria—"earth tones work best," Gabriel Hacman said, "because they're easier than very vibrant colors to match with the carpets, rugs, and upholstery in someone's house," while Scaglione noted that the "content and what else is like it in the market" are major considerations—but the standard is an unspecified vision of what is commercially appealing. At Richmond Fine Arts, Gabriel Hacman looks through images that artists submit, passing on the most promising works to the president of London Contemporary Art, who makes the final decision. Two committees look over artists' submissions at Park West Gallery, a regular art selection group and a blue-ribbon oversight group consisting of a number of art experts, including Bernard Ewell, an appraiser at the Salvador Dali Museum in St. Petersburg, Florida; David R. Smith, a Rembrandt scholar at the University of New Hampshire; Tony Janson, co-author of the widely used college art textbook, *History of Art*; and Dr. Eleanor Hight, a Russian art expert at the University of New Hampshire.

Besides the print editions, these companies also accept artists' one-of-a-kind pieces for sale on cruise ships. However, as these auction companies make large profits through volume sales, rather than selling a small number of pieces for larger amounts of money, a premium is placed on artists producing a prolific number of works. Peter Max, for instance, turns in "hundreds of paintings" (sized 8″ × 10″) every year to Park West Gallery, according to Scaglione: "I've seen him work in his studio. He'll be working on a number of different paintings at the same time, each of them having different subjects, different colors, and he's using different brushes, too." Shana Dominguez, an artist in Miami, noted that she is usually paid between $100 and $200 per painting (watercolors, mostly, sized 16″ × 24″ or 24″ × 36″) by Fine Art Wholesalers, and she creates more than ten pictures per week. Although she claims to "love the fact that all I have to do is paint" and that she can leave all the "business stuff, all the dealing with customers" to Fine Art Wholesalers, Dominguez said that "my whole schedule is eat, sleep, and paint. I don't have time to do anything else."

The main sellers of art on cruise ships are:

Richmond Fine Art Sales, Inc.
1160 N.W. 163rd Drive
Miami, FL 33169
(305) 625-9566

Fine Art Wholesalers
1410 S.W. 29 Avenue
Pompano Beach, FL 33069
(954) 917-4770
www.fineartwholesalers.com

Park West Gallery
29469 Northwestern
Southfield, MI 48034
(800) 521-9654
http://parkwestgallery.acmeinfo.com

Attn: Phyllis Brown
West End Gallery
19048 N.E. 29 Avenue
Aventura, FL 33180
(305) 935-0255
or

54A London Road
Leicester LE2 0QD
England
0116-254-6546
www.westend-gallery.co.uk

Artists should send between ten and twenty images of their work, along with a brief biography and a history of exhibitions and art sales. It makes sense to check in advance what form these images should take. Park West Gallery, for instance, only accepts hard-copy photographs, as its review committee does not look at slides or CD-ROMs; other companies, however, will view art in different formats.

Art in the State Capitol

The state capitol building in Santa Fe, New Mexico, is often a very crowded place, with over 1,000 people—lobbyists, school groups, legislators, bureaucrats, and tourists—passing through on almost any given week. That's more than most art galleries and even tops attendance at many of the state's art museums. Perhaps some of those regulars and visitors to the capitol will pay particular attention to the artwork on display, because there is a lot of it—over 400 paintings and sculptures (mostly) by contemporary artists who are state residents, and the number is growing.

Since 1990, the Capitol Art Foundation of the State of New Mexico has been acquiring examples of the work of the state's noted and emerging artists in order to show "the cultural heritage and the artistic vitality of New Mexico," according to Cynthia Sanchez, director and curator of the foundation. "Exhibits in the rotunda typically draw the most attention and inquiries," she said. It is not uncommon that some visitors to the capitol asks about the artists whose work he has seen, and Sanchez offers a brief printed biography or even contact information. Where that information leads she doesn't know, adding that exhibits elsewhere and even sales "could well result."

New Mexico is not alone in its determination to acquire and display resident artists' work. Most states have a program of exhibiting art in their capitol and government office buildings. (The federal

government has its own version of this program, called Art in Embassies, which is run by the U.S. State Department and places work by contemporary artists in embassies and consulates around the world on three-year loans.) Sometimes, that art is of an historical nature, such as the collection of fine and decorative art from the eighteenth through the early twentieth centuries administered by the Maryland Commission on Artistic Property, but more often it includes contemporary work. Recipients of visual arts fellowships in a number of states have work displayed in their respective state capitols, for example, and the Governor's Gallery, a room near the office of Florida's governor, has a series of temporary exhibitions of artwork on the theme of Florida by state artists. In addition, there are five other gallery spaces within Florida's state capitol complex dedicated to the display of resident artists' work.

Similar to New Mexico, Florida established a permanent state art collection for the capitol back in 1997 and has acquired twenty-five pieces so far. Artists in both states who would like their work included in the respective collections submit slides for consideration by a panel that includes members of the state arts agencies and outside art experts. Also, like New Mexico, Florida budgets no money for the purchase of this art but actively solicits donations from artists. On the other hand, Wyoming, which inaugurated its Capitol Art Collection in 2000, appropriates funds for the purchase of art, paying up to $2,500 per piece ("The legislature has learned through this that artwork doesn't just magically appear—it costs money," said John Coe, administrator of the program).

The benefits for artists having their work included in a state art collection tend to go beyond hard cash. "It's an opportunity to have their work continually on view," said Sandy Shaughnessy, arts administrator for Florida's state arts agency, the Division of Cultural Affairs, which runs the program. "Nothing is in storage." She added that artists who donate their work to the state collection are featured in a page on the agency's Web site and that the Division of Cultural Affairs is regularly contacted by "curators and collectors" who are interested in a particular artist's work.

Donating work with an eye to finding dealers and buyers is no sure bet, however. John David Hawver, a painter in Islamorada, one of the Florida Keys, donated a $5,000 painting entitled *New Intensified Low Tide* to the state's art collection in 1998, following a show of thirty-five of his works in the Capitol Building. The donation was a form of thank-you for the exhibition, "and it certainly looks good on my résumé, 'in the collection of the State of Florida,' " but he noted that "no one has tracked me down after seeing the work in the state capitol." Sarah Bienvenu, a painter in Santa Fe who in 2001 donated a $3,600 watercolor entitled *The Field in Spring* to the New Mexico state art collection, noted that since the piece has been on display in the state capitol "I have had so many calls from people." Those people, though, are friends congratulating her, rather than buyers or gallery owners. Similarly, Berkeley, California, painter Elizabeth Hack, whose work was selected to be part of the Art in Embassies program, has had little response from collectors, perhaps because the embassy is located in Fiji.

Art Workshops

Wolf Kahn teaches painting workshops because "I have a didactic vein. I really love to teach." Janet Fish, on the other hand, will teach a workshop "in a place I don't know so well. I get paid to see somewhere new," while Tony Couch primarily teaches "to make a buck or two."

There are many reasons why amateurs take workshops and artists teach them. As a style of teaching, a workshop is brief, potentially quite lucrative, and filled with often worshipful students. In contrast, art classes at community centers, museums, and public or private schools and colleges may seem more bureaucratic and endless. Janet Fish, who has also taught at art schools, noted that workshop participants are frequently more eager to learn and make use of the small amount of time. "These people have paid for it and committed valuable time to the workshop," she said, "and so they may be more open to the experience. In a college, students may be taking a class for credit and are not always so happy to be there."

Participants in a workshop are also more likely to be older (retired and widowed in many instances) than those enrolled in art schools; they have more knowledge of the world and more money, both of which may make them attractive to some artists. "I've had it with kids," Wolf Kahn said. "They are so filled with self-importance that you can't talk with them. I like adults, because they have had more life experiences, and they can understand and appreciate what I'm doing."

The appreciation comes from the fact that, in most cases, people pick a workshop based on the teacher, and they look for artists whose work they admire. At the very least, workshops are a warm and welcoming moment for the artists who lead them. They also may be quite lucrative moments. Artists usually earn between $300 and $450 per day, even as much as $5,000 for the week, and their travel expenses, accommodations, and food may or may not be paid for by the workshop sponsor. In addition, workshop participants will often buy the demos—the demonstration paintings that the artist-teacher creates in front of the students every day—and other works that the artist brings. This is a clear benefit of teaching to older and more financially established admirers.

"I sell most or all of my demos, selling them for $450 per demo," Tony Couch said. "The same size work in a gallery would sell for $2,000 or so. I usually bring other completed works from my studio to the workshops and sell them for $1,000 apiece—that's what I'd get from the dealer minus the commission, anyway." Couch also has published three books and four videocassettes of art instruction, and brings ten copies of each to the workshops, on the average, selling half the videos and three quarters of the books. The extra earnings are in the thousands of dollars—perhaps exceeding the workshop fee he is paid. Multiplied by the fifteen workshops Couch regularly teaches annually, it becomes a substantial amount of money.

"I sell during the workshops without ever having to frame or mat the things," painter Frank Webb, who teaches between twenty and twenty-four workshops per year, said. "At a workshop, you are ulti-mately directing attention to your own work, because you are telling people and showing them what has worked for you.

Whenever I am teaching a workshop, everything I say goes. You can't have that at an art school."

Not every artist is able to sell as much during workshops, and workshop participants do not necessarily become buyers of the artists' work afterwards—those who enjoyed seeing the artist create a demo and receiving instruction from that person are more likely to sign up for another workshop with the artist rather than to become a collector. One reason for this is that workshops (and demos) cost in the hundreds of dollars, while the framed and finished pieces are priced in the thousands. "I'm a comparatively high-priced artist," said Jack Beal, a painter who teaches a handful of workshops per year, "and my work is bought by wealthy people who live in large apartments in New York City. I get very few wealthy people in my workshops."

Not all artists are able to earn as much as Tony Couch at workshops. Artists are usually paid a certain amount—between $150 and $200 per student—and a low turnout means less money for them. Artists who set up their own workshops without third-party sponsors may have a variety of costs that eat away at the potential profits. Chris Unwin, who teaches workshops and sponsors others through her company Creative Art Workshops in West Bloomfield, Michigan, said that "I charged $300 per student for a workshop I led in Taos [New Mexico], and I got sixteen students, but there are a lot of expenses. There are the rooms, the food, and the cost of a party for everybody. The party itself costs $700–800." Jack Beal, who with his wife, Sondra Freckleton, has offered workshops out of their studio in Oneonta, New York, noted that their largest problems are last-minute cancellations and the amount of time spent planning and talking to people on the telephone in advance. "You burn the candle at both ends trying to teach workshops and paint," he said. "In order to run a workshop so as to make some money, you have to put off painting, which also earns money."

In addition, not all workshop participants and sponsors want artists who see workshops as an opportunity to sell their work. Many prefer artists who focus on teaching and helping each student learn new skills. "I personally like the teachers who paint more than the painters who

teach," said Eliot Dalton, director of Hudson River Valley Art Workshops in Greenville, New York. "The people who take these workshops want these teachers more than the artists who are accomplished at marketing, who come looking to sell demos, videos, and other paintings."

"Custom" Artists

There is no one way in which artists work or show their art. Some produce alone in their studios, while others work collaboratively with others. Some create works for exhibits at galleries, while others prepare for juried shows or look for commissions. Custom or decorative artists generally work in homes and offices, hired to paint a mural on a wall or ceiling, perhaps even a tabletop, and their work is seen by the people who live, work, or visit there.

"Almost all of my work is in powder rooms, lavatories—bathrooms without showers," said Jeffrey Damberg of Cos Cob, Connecticut, noting that the steam from a shower would damage his paintings. One of his powder room wall creations was a picture of an outhouse with a forest around it. Another was a mural of a group of men, all well dressed. "You don't see their faces, only their backs," he said. "The homeowner wanted me to paint it that way, as though the men were turning their backs to give her privacy."

Judith Eisler, a New York City artist, also has been hired regularly to paint bathrooms and bedrooms. "People feel they can go wild in their bathrooms," she said. "They feel hidden there, and so they let loose and want lots of different colors that they'd never allow elsewhere in the house." However, she has painted murals in every other room of a house, as do most decorative artists, Damberg included.

A growing number of homeowners are becoming interested in bringing artists into their homes to create custom works, according to several interior designers. "Clients are getting more cultured, more knowledgeable about art, and they like to tell an artist what to do," said Lourdis Catao, an interior designer in New York City. "It makes them feel like artists, too."

One of Damberg's clients, Marian Hvolbeck of Greenwich, Connecticut, commissioned him to create a composite of famous landscapes, including Thomas Cole's *Oxbow*, Vincent van Gogh's *Cypress Trees*, and Claude Monet's *Water Lilies*, as well as images from Corot, Cezanne, and some others. Damberg was an ideal choice for this project as he specializes in art copies, and most of his murals are replicas of the work of other artists, such as Grandma Moses, John Singer Sargent, Albert Bierstadt, and various nineteenth-century French painters. "I have a whole lot of art books," Hvolbeck said, "and I opened to pages in my books and told Jeff, 'Put that in, and this one, too.' Jeff made photographs of the paintings in the books and enlarged them, so he could work from them." The ability to direct an artist made Hvolbeck feel as though she were collaborating in the process. "Paintings are interesting. I enjoy paintings and have a number of paintings in my living room, but here I was part creator. The final work is very personal to me because, while some of the copied paintings are well-known, some are not and I am the only one to know the reference."

Decorative artists encompass a wide group of talents and techniques, some straddling the fence between fine and purely decorative art, while others are more like artisans. Some, such as New Yorker Raymond Bugara, specialize in trompe l'oeil, creating realistic images that fool the viewer into believing they are three-dimensional, such as book shelves filled with classic tomes. Others, "faux artists," create simulated finishes on surfaces, such as the look of marble on a stair-case or gold leaf on molding or clouds on the ceiling. Yet others add pigment to plaster or give a wall the look of Italian colored stucco. Certain artists do both murals and wall finishes.

Decorative artists are generally found through interior designers or architects (many architectural firms have in-house designers) or by word of mouth. All of Damberg's newer clients have come as referrals through past clients, "as someone comes into the house and sees my work and asks 'Who did that?' " Bugara, whose jobs all come through interior designers, on the other hand, said that "word of mouth isn't all it's cracked up to be. People don't want the same painter in their house as their friends; it's like two

women wearing the same dress at a party. They get competitive and want a different artist."

It is rare that an artist places an advertisement in a magazine or newspaper ("an ad might bring me too much business," Damberg said), although some are listed in the Yellow Pages. However, many artists and craftspeople have joined the American Society of Interior Designers (608 Massachusetts Avenue, N.E., Washington, D.C. 20002-6006, (202) 546-3480, *www.asid.org*) as "industry partners," a category of membership for people providing products and services that interior designers can use.

When a homeowner contacts an artist individually, it is usually to paint a mural in a particular room of the house; however, when an interior designer hires the artist, the mural is part of a larger redecorating job for which the artist is one of the subcontractors. Some artists enjoy the one-on-one relationship with the homeowner, while others prefer having a designer handle the financial and technical arrangements with the client. Frequently, it is the designer who suggests to the client the idea of bringing in an artist to add accent colors or an entire mural. "Artists are basically problem-solvers," Catao said, "and the problem here is how to fill a commercial or residential space. In a small room, the question is how can an artist give the sense of three dimensions."

"I like to have the designer as a buffer," said Katie Merz, a New York City artist who creates cartoony imagery for homeowners. "It's a nightmare to deal with the owner all the time. So many of them want to make suggestions while I'm working. Some clients have a kind of neurotic way of communicating—they feel that the only way they can talk to me is to find something wrong with what I'm doing."

Merz noted her greatest fear, once the mural has been completed, is that the client doesn't like it ("You hold your breath until you hear someone tell you it's OK," she said), but the process of determining what will be painted on the walls usually includes sample designs and renderings for the client's approval. Eisler, who is both contacted by homeowners directly and hired by interior designers,

meets repeatedly with the client to ensure that they have the same imagery in mind. "Someone will say to me, 'I want it to be sand-colored, you know what I mean?' and I say, 'No, I'm not sure I know what you mean.' I ask people for visual clues as to what they want in a picture. I tell them, 'Let's find that color on a Benjamin Moore color chart.'"

She added that interpreting what potential clients want from their descriptions can be trying, as they themselves may not be certain. "You have to be a psychiatrist sometimes." she said. "One woman told me at the end of a job that she didn't really like what I had done. I told her, 'You approved the samples,' and she said 'Yes, but that's because I didn't want to hurt your feelings.' I told her that this is a service industry—it's not about feelings." Clearly, this defines the difference between a gallery artist, who creates personally motivated artwork for a more generalized audience, and a decorative artist who is being commissioned to create a very specific artwork for a parti-cular client. The final artwork may be the same in terms of imagery and style, but there are far more personal entanglements in the decorative arts field.

Graduates of art schools, both Eisler and Merz are active as gallery artists, occasionally selling their paintings to the same people who hired them as muralists. Charles Gandy, an interior designer in Atlanta, Georgia, noted that many of the artists he uses are "right out of the galleries here, and some of them sign their murals." Gandy added that he regularly looks in at art galleries to find artists who might be suitable for custom work in someone's home.

Not every gallery artist will find the transition to decorative work so natural, according to Laura Richardson, president of Miller-Richardson Galleries in Washington, D.C. Some of the challenges are technical ones, such as painting on a wall instead of on a canvas (requiring different preparation and media), and the scale is usually larger. "Some artists feel constricted by a commission, because of the desire to please, and they may not like to make changes," she said. "You're also not painting in your studio but in a public area, with an audience all the time. A lot of artists aren't aware of what they're in for."

The letters of agreement or contracts that artists and homeowners sign are similar to those for public art projects, with paragraphs detailing the requirements of the homeowner (specific wall, for instance), the medium, palette and artist, the creation of a maquette and the nature of the approval process, the manner in which the final work will be delivered or installed, the cost of the project, and a payment schedule.

Although the price will be subsumed into the overall cost of the project if the client accepts, many artists charge for their renderings (between $100 and $700, on the average, depending upon the intricacy of the maquette). Artists establish fees for an entire project in a variety of ways. Some charge by the square foot, while Damberg prices murals by the job, estimating the amount of time it will take, multiplied by a $55-per-hour wage. His average mural costs $4,000. Both Eisler and Merz charge between $350 and $600 per day (Bugara's fee is between $400 and $800 per day), and they also estimate how much time the work will require. All of the prices include the cost of materials. One of Eisler's biggest jobs was painting murals on the walls of an entire Manhattan apartment, a project that went on for several months and for which she charged $25,000. Like most other contractors, decorative artists receive a deposit of either one-third or one-half at the outset and the remainder at the completion.

Prices are often higher when middlemen are involved, as gallery owners who arrange commissions take a percentage of the artists' fees (between 10 and 30 percent) and interior designers customarily include a 15–25 percent additional charge.

chapter

5

Web Sales

During the summer of 2003, Houston, Texas, artist Douglas Hamilton said, "lightning struck"—not literally, but perhaps just as randomly. One of his paintings, entitled *Sydney II,* was bought from the Internet site ArtQuest (*www.artQuest.com*) that features the work of Hamilton, as well as 500-plus other artists, on the site's own separate Web pages. It was Hamilton's first and only sale on ArtQuest.com, and the painting was purchased by husband-and-wife authors Kenneth and Julie Kendall who were looking for a new cover design for the sixth edition of their co-written book *Systems Analysis and Design* (Prentice-Hall). The cost of the painting and the limited reproduction rights came to $2,200.

This was good news for Hamilton to be sure, and perhaps typical news for the still small but burgeoning online art market. The Kendalls are not art collectors, and the amount they spent for both the actual artwork and the reproduction rights was quite modest, but it was a sale nonetheless and probably would not have taken place without the intermediary services of an art Web site, online search engines, and the Internet in general.

ArtQuest is but one of numerous "mall" sites on the Web where potential buyers can peruse the work of a variety of artists. (ArtQuest is based in St. Louis, Missouri, a point of information that hardly seems relevant anymore, because Web sites exist more as code than as physical establishments and conversations take place in the form of e-mail.) Other, similar art sites also report lower end sales of emerging

artists' work, or at least house a collection of artists who are excited about the prospect of buyers from anywhere in the world finding them and perhaps purchasing something.

Andrea Miller, an artist in St. Louis Park, Minnesota, "figured it would be worth a try" to put her paintings on the Web—she has a page on ArtCrawl (*www.artcrawl.com*)—and was "bowled over" when someone from Los Angeles contacted her about buying her work. He didn't ask much about her, and she didn't inquire about him, although Miller "got the impression that he was a novice collector. He didn't seem to know much about art and what you talk about with art." Their initial conversation actually concerned whether or not Miller offered any discounts, and she agreed to take 10 percent off because the buyer was purchasing two paintings, $650 apiece less the 10 percent discount. Again, modest prices were paid by someone who does not appear to be a regular art collector, but actual sales took place through the medium of the Web.

More and more artists have tried their luck on the Internet, reporting varying degrees of success. Daniel Clark, an information systems manager for the City of Los Angeles and off-duty painter, sold four works in 2003 for a total of $3,000 through AbsoluteArt.com, all to one person in the Midwest who "got turned on to me and kept buying and buying." On the other hand, Ted Hess, a painter in Scottsdale, Arizona, and Saranac, Michigan, painter Karen Challender, both of whom have pages on the art Web site Art from the Source (*www. artfromthesource.com*), report no sales of art. "I've talked with other artists who are experiencing the same thing," Challender said. "It's hard to sell art over the Web. People need to see it in person." Douglas Hamilton may have been one sale removed from saying the same thing, since only that one work sold through ArtQuest.com and his own stand-alone Web site (*www.dghgroup.com*) has not produced any sales.

Every method of online selling of artwork has its benefits and drawbacks. The mall sites charge fees for the creation of an artist's home page. For instance, ArtQuest charges $10 per image for a renewable period of six months or a sliding scale commission for artworks selling for more than $1,000 (between 7 and 20 percent); Art from the Source asks a monthly "hosting" fee of $19.95 per month; ArtCrawl requires

a $250 annual fee; and a portrait painters Web site, A Stroke of Genius (*www.portrait.com*), charges an annual $600. Amounts charged on these malls may increase with the number of images on the site and the frequency with which they are changed. The owners of these mall sites do not handle the artwork listed for sale, nor act as dealers in making a pitch to would-be buyers; in fact, it is unlikely that a buyer would have any communication at all with the owner. The artists' pages include information on how to contact the artists directly (by e-mail, telephone, or postal address) to discuss prices, shipping, and availability.

These online malls, however, promote themselves to potential collectors through advertising, reciprocal links to other relevant Web sites, and efforts to elevate their ranking among the major search engines, such as AltaVista, Ask Jeeves, Google, Lycos, Vivisimo, and Yahoo. For any number of general searches made, there may be thousands of Web sites found, listed in order of greatest relevance on individual pages that contain no more than twenty sites. According to several studies of Web use, most people using search engines don't examine beyond the first forty sites, which makes getting into that top tier a source of great competition and strategy for all companies and individuals hoping to be found by an online browser. If successful, these efforts result in a considerable amount of traffic through the entire site by Web users who have come to them by one means or another. Kathy Kahre-Samuels, owner of ArtQuest, noted that the Web site receives between 3,000 and 5,000 "unique visits per day"—a "unique visit" differs from a "hit" (which Kahre-Samuels doesn't count and calls "misleading") in terms of quality time at the site—that lead to "hundreds of artworks sold every year," at least in the $1,000 and up range. There may be hundreds or thousands or no works sold in the under-$1,000 range but, because these transactions take place solely between seller and buyer, Kahre-Samuels has no knowledge of them, except, perhaps, anecdotally. The same is true at all of the other mall sites, limiting the ability of anyone to gauge the true size and nature of the online art market. ArtQuest, like many other art mall sites, is not limited to artists-as-sellers but also allows collectors (including dealers) to sell artwork.

Art mall sites have their own mini-search engines, allowing browsers to select particular areas of interest, such as colors, subject matter, style,

medium, size, and price range. (For the benefit of potential buyers, ArtQuest has a color palette behind every image on its site in order that they might find the correct shade of their walls at home and predetermine how a given artwork would look.) Besides a wide range of styles and media represented on almost any given mall site, there is also a great variety in the quality of art on display. "There are diverse buyers out there," Jody Reeb-Myers, owner of ArtCrawl said, "and so we don't turn any artists away. Nobody is juried in or out." The same sentiment was voiced by Art from the Source co-owner Bette Meritt ("Art is very subjective") and all other mall site directors contacted, who only draw the line on taking artwork that is viewed as hardcore pornography, violent, or derogatory. The open-ended policy may prove beneficial to artists who have found themselves cut out of the traditional commercial gallery field and juried show system, but it could irritate other artists who believe that others on the site bring down the level of art.

The obvious online solution to the problem of guilt by association is for artists to create their own stand-alone Web sites, and many have done just that. As at the mall sites, some artists report sales (usually at the lower end), while others can only describe inquiries or "hits" (if they purchased hit-o-meter software to count them) or nothing at all. Unlike the mall sites, no one will take on the responsibility for promoting the artist's site or providing it with headings that will attract search engines other than the artist him or herself.

Internet Marketing

Hundreds of millions of people go online every day, but there are also billions of Web sites vying for their attention. The law of probability suggests that a certain percentage of these Internet users have an interest in, or collect artwork, but ferreting them out takes a fair amount of effort. A variety of ways exist to bring traffic to an Internet site, which includes the most obvious of all—telling people one's Web site address, which may be accomplished orally or by including the information on any printed material that an artist distributes (postcard, business card, brochure, and bio, among others). Any advertisement an artist places should also list contact information, including the Web site address.

An advertisement in an art magazine moves into the area called "targeted marketing," finding the particular audience for one's own art, or just art in general. A newspaper circular, on the other hand, is a less selective way to find potential buyers. Another type of targeted marketing is sending printed material or e-mails to people on a mailing list compiled by list sellers. The numerous lists of museum curators, art galleries, art book and greeting card publishers, corporate curators, interior designers, architects, art critics, and others in the art world offered for sale by World Wide Art Resources (*www.wwwar.com*) contain hundreds of names and addresses, costing between $40 and $140. Caroll Michels' Artists Help Network (*www.artistshelpnetwork.com*) and Art Network (*www.artmarketing.com*) also sell similar types of lists at similar rates. The quality and up-to-dateness of these lists are difficult to judge in advance: Some "galleries" are actually frame and poster shops that rarely show or sell original art, and furniture and gift shops sometimes call themselves galleries. In other instances, the information may be accurate—the curator works at this museum at this address—but the individual's specialization is not noted (would a photography curator be interested in a landscape painting?), nor if the recipient has any interest in learning about new artists this way.

All marketing is inherently impersonal, as sellers look to find potential buyers who don't already know them and their products. Asking friends to talk to their friends certainly adds a more personal touch, but that type of networking only goes so far, and it may take a long time to develop a client list this way. Unheralded artists who aim to sell a lot of work *this season* are likely to find themselves quite frustrated. Direct marketing—through mailings (announcements, catalogues, postcards), advertising, direct response television or "infomercials," newspaper or magazine "blow-ins," telephone calls, and the Internet—reaches a wider audience and larger group of people more quickly, although the rate of success is quite varied. According to a 2005 survey conducted by the New York City–based Direct Marketing Association, the average response rate for telephone solicitations is 8.55 percent (the percentage soars to 24 percent for charity fundraising by telephone), while magazine advertising was only 0.17 percent. E-mail marketing averaged just under a 2.5-percent response rate, with

solicitations for health care and professional services ranging from 4 to 6 percent while retailers and publishers averaged only 1.5 percent.

Artwork sales is not one of the categories measured by the Direct Marketing Association. Apparel and computers top the list of items purchased online, followed by books, music, and a large grab-bag called gifts where collectibles and art might fit. Based on this hierarchy, it would seem that most online buyers are seeking mass-produced merchandise with which they are already familiar but at a better price than offered locally. Yet, Internet shopping encompasses more than just the bargain hunter, and some people do look for the more exotic item, which might be a rare antique map or an original contemporary painting. Anecdotes abound, but no one really knows if the Internet is or will become an alternative art market; however, going to the trouble of designing and setting up a Web site makes no sense if it cannot be found by would-be collectors, critics, and dealers.

Targeted marketing online involves making one's Web site findable in a search (through a process often called "search engine optimization") or just a click away (through advertising or links), and often both. Anyone with even limited experience of a search engine knows that most searches result in thousands or millions of relevant Web pages. Certain generic terms, such as "artist" or "painter" or "landscape," will call up too many Web pages to be useful in any search.

Artists may choose to hire a company or individual to help them with Internet marketing, which includes identifying the most useful keywords by which a Web site will be found, or take on the job themselves. The membership of the Wakefield, Massachusetts–based Search Engine Marketing Professional Organization (*www.sempo.org*) is one source of companies that work to promote Web sites, although there are many others that do not belong to this or any other industry association—ask for references. Do-it-yourselfers will want to do their own keyword research to determine how often certain words they might use to describe who they are, and when they do come up in Web searches. While the word "artist" is apt to appear countless times, the phrase "Cape Cod artist" probably has less competition. The more specific one becomes in selecting appropriate keywords, using the

type of words potential collectors are likely to use (and using them in the Web site's title and description), the more apt a site will be found in a search. A Yahoo-sponsored site, *www.overture.com*, offers those developing a Web site the chance to learn how often a certain word or phrase is used in searches—the phrase is put in quotations, more precise matches can be found.

A landscape painter whose keyword heading is "landscape painter" is apt to have a huge amount of competition and not likely to come up high in any Internet search. "You want to define with laser-like precision the subject of your art and then capture the feeling of that subject for the buyer," said Chris Maher, a painter and Web designer for artists. "You don't want just 'landscape painter' or even 'Painter of the Maine Coastline' but name the very specific cove on the Maine coast that you paint. It has a chance of coming up, and a chance of selling, if it coincides with the experience of the person making the search and if that person comes to your Web site. Maybe someone was married at that very cove, and he wants a painting of it to give to his wife." Similarly, he noted that keywords such as "Arabian horses" would be preferable to "equine artist" for someone with a passion for Arabian chargers, and car buffs are more apt to be led to one's site if its heading was "Historic '57 Cherry Red Chevy," rather than "Paintings of Antique Cars."

Such buyers are not likely to be people with art collections or who even know anything about contemporary art—and how much it may cost. "I get contacted a lot through my Web site," said Karin Wells, a painter in Peterborough, New Hampshire. "People see something they like, and they call me up." However, a number of them "stop the conversation when they hear the prices." The benefit of the Internet is that it allows people from all walks of life access to a range of goods and services that might have seemed out of reach before. Whereas traveling to an art gallery or museum might never occur to them, due to embarrassment or lack of interest or time, browsing an artist's Web site holds fewer risks and can be accomplished from their home or office. Sales may take place, and a new collector is born (or not).

The most popular search engine, Google, conducts searches based on matches of words (what you say about yourself) and the number of

links to the site (what others say about you). Links are good in themselves, because they provide a means for someone at another Web site to click onto one's own, and as an endorsement. (Even a negative reference, such as a Web site comment that one should "click here to see the work of the worst Cap Cod artist ever," earns one points in a Web search.) Artists may increase the number of links to their Web sites by asking their friends who have Internet sites to include a link, or link through one's dealer or the newspaper that published a review of one's exhibition, and they may purchase links from other sites. A link from Yahoo's directory costs $299, but others are considerably less.

Additional forms of Web marketing include buying ads on search engines (the expense is all over the board) or banner advertising on Web sites. A more updated (and more expensive) form of Web advertising, called rich media, includes animation and sound that can be very eye- and ear-catching. A click links browsers to one's own Web site.

Many portrait artists claim that they are found through individual or all sites by people with very little knowledge of artists and the art world. "The vast majority of our clients are not attached to the art world," said Marian MacKinney, director and owner of the New York City gallery Portraits, Inc., noting that the gallery's Web site (*www.portraitsinc.com*) garners "a lot of interest." That interest often leads to personal contacts. "Some corporation or university wants to commission a portrait, but they don't know where to begin and they give the job of finding out to a secretary." The secretary makes a search on the Web and soon places a call to Portraits, Inc.: " 'I have your Web site up now, and my boss loves it. Can we make a time tomorrow to come in?' "

Art galleries in general have been the greatest beneficiaries of the increased traffic and sales that the Internet promises and delivers, and a growing number of them have established Web sites. For potential buyers across the United States and around the world, the speed and ease of contacting gallery owners about certain sought-after artworks and receiving digital images of these pieces have meant increased sales even during a time of economic recession. "Our Web site produces sales on a weekly, if not a daily, basis for us," said Scott Lawrimore, director of the Seattle, Washington–based Greg Kucera Gallery, noting that "25 percent

of our sales come from people who initially found us through a Web search." Many of these are first-time buyers of art. He added that, as a percentage of gallery income, the Web-originated sales produce closer to 10 percent, since most of the sales are in the lower price realm, between $500 and $5,000, "and the average sale is well below $5,000."

Flanders Contemporary Art in Minneapolis, Minnesota, also reported that a quarter of total sales now come from people who contacted the gallery after first seeing its Web site. Carrying a mix of emerging and established artists, gallery owner Doug Flanders said many long-time art collectors have purchased works by Willem de Kooning, Hans Hoffman, and Pablo Picasso after making a Web search of available pieces to find just the right piece. "We sold a $250,000 Ross Bleckner to a doctor in Japan," he said. "He had been searching for a Bleckner, and our name came up."

Artists whose work is in demand are more likely to see the same sort of demand as galleries for works on their Web sites. Mort Kunstler, a painter of historical scenes from American history who lives in Long Island, New York, sends out e-mail announcements about new print editions to the thousands of people who have registered on his Web site as members, "and we get orders immediately," said his daughter and business manager Jane Kunstler. "A lot of selling goes on through the Web site." However, for many artists, selling is not the principal purpose of their presence on the Internet; rather, the site offers an always available portfolio of their work to which they can direct people who have purchased their work in the past or have shown an interest in buying. The Web site of figurative painter William Whitaker, who lives in Provo, Utah, for instance, displays a variety of recent images but directs inquiries to his dealer, Nedra Matteucci, in Santa Fe, New Mexico. "I don't like to sell to the public," Whitaker said. "Answering questions, sending out images, talking about myself— takes time away from my painting, and it's hard to get back to my painting after getting into this other mode, and you still don't know what comes of it: Maybe they'll buy something; maybe they won't." He added that most inquiries are at the lower price end, under $1,000, and that these conversations are "more demanding, have more hassles, and are less gracious than the high-end sales" that his gallery sees to.

For Whitaker, the Web site (*www.williamwhitaker.com*) is a "reference point" for past, present, and future buyers, and the Nedra Matteucci Gallery reciprocally refers inquiries about the artist's work to his site because of the quality of the reproduced images. The costs of maintaining the site may be considerably less than producing brochures and postcards of their work that must be mailed to all those same people. The old fashioned Rolodex itself is quickly becoming a list of e-mail addresses, by which artists may convey information about upcoming exhibitions, the availability of a new body of work, a studio sale, or anything else.

One of the biggest boosters of artists selling their own work online, painter Mark Kostabi, who divides his time between New York City and Rome, Italy, noted that he earned approximately $350,000 over the span of several years selling (mostly) drawings and paintings on eBay, the online auction company. "You don't find a lot of the major trend-setting New York City art collectors on eBay, but you do find people who are looking for a bargain," Kostabi said. "Spending $100–200 on a work of art isn't taking a big chance for these people, and I was willing to sell my artwork for less."

Some Risks in Selling Online

The benefits of presenting and selling one's art online are many— artists control the display of their work and what is said (or written) about it, prices need not be inflated to allow for a dealer's commission, and the artwork is accessible night and day to anyone around the planet who can find his or her way to the Web site—but there also are some risks at the point of sale. A worldwide industry of Internet frauds and scams has developed to pick the pockets of buyers and sellers, making both groups quite wary of each other. Art, more than most purchases, relies on a high degree of trust between artist (or dealer) and collector (Does the artist have real talent and artistic vision? Is the artist a serious person? How likely is it that the art will retain its value or even increase?), which becomes far more difficulty to build when their primary medium of communication is a picture on a computer screen. Worries about rip-offs only make the process of building a relationship all the more difficult.

For example, the credit card a buyer uses to pay for the art could have been stolen, a cashier's check might be counterfeit, and the artwork sent to some far off land may be gone for good, with little recourse available to the artist whose only fault was thinking benevolently of a collector. Buyers, on the other hand, would be loath to send a personal check or money order to someone they don't know. The same types of worries that buyers may bring to the purchase of art they do not see in person, displayed in sites that do not have brick-and-mortar facades, artists might have about credit cards that aren't physically handed to them to be swiped by someone who isn't present to physically sign the receipt. There is less protection for buyers and sellers when business is conducted through computers. However, a growing segment of the economy, currently estimated at 2.2 percent, or almost $70 billion in 2004, is transacted online, so the increased risk is borne by merchants who see an opportunity for a far larger market.

A variety of ways exist to receive payment for merchandise, some of them more secure than others. (A "secure" Web site, by the way, does not mean that all transactions are legitimate, rather that any information transmitted to it is encrypted and cannot be read by anyone with access to the site.)

Credit cards are relatively safe when the items purchased are to be shipped to the billing address; a red flag is raised when objects are to be sent to a different location. Another warning sign is a buyer seeking to spread payment over more than one credit card; above a certain dollar amount, credit card companies often become suspicious and look to verify the purchase with the cardholder. Sellers should also ask for the three-digit verification code on the back of the credit card where cardholders sign their name. That "V" code is an extra layer of protection from criminals who may have a cardholder's account number but not the card itself; that code may be verified at the same time as the account number when someone is making a purchase.

Obtaining authority to accept credit cards as payment can be a difficult process because banks, which issue Diners, MasterCard, and Visa cards, are wary of extending this authorization to individual entrepreneurs, citing a recurring problem of mismanagement and fraud on

the part of these entrepreneurs (refusing to resolve complaints from customers, going in and out of business, running into debt and declaring bankruptcy, relocating elsewhere without revealing their new addresses). American Express and Discover offer their cards and permission to accept payment by these cards directly without the intercession of a bank. There are also a number of bank brokerage firms to which sellers of all kinds—including those who work out of their homes—may apply for permission to accept credit card payment.

A number of Web sites use a third-party online payment system—PayPal is the largest of them—that verifies buyers' and sellers' financial information, providing a means by which a purchaser may pay with a credit card or transfer money through a checking account with a measure of confidence. PayPal, through which most sales on eBay take place, requires that both merchants and customers have registered with the system in advance, and it charges sellers a fee of between one and two percent of the cost of items purchased. Additionally, PayPal will indemnify a merchant who has been defrauded, although the process of notifying the service of a criminal act and proving the case is long and multi-stepped.

A benefit for artists of using PayPal is that qualifying to participate as a merchant is less complex and more accommodating than when applying to a bank to accept credit card payments.

There are other ways in which money can be transferred that provide security to both buyer and seller. These include having money wired from a checking account in the buyer's bank to the bank of the seller; the amounts banks transferring money charge for this service ranges from $20 to $40, regardless of the amount of money being wired. Western Union, which also allows customers to wire money (from one Western Union office to another), guarantees same-day service, unlike banks, although its fees are higher, from a minimum of $15 for a transfer of up to $100 to $220 for a transfer of $5,000, for example. Money orders, which may be purchased for a fee at Travelers Express, post offices, check cashiers, supermarkets, convenience stores, and other retailers, offer less security to buyers; however, since they are quite difficult to counterfeit, money orders may prove attractive to sellers.

Internet Scams

Artists and other sellers have experienced a wave of Internet scams in which someone posing as an eager buyer e-mails the seller expressing great interest in making a purchase based on having looked through the seller's Web site. A check is sent to the seller, or a credit card number is provided, but for an amount far higher than the stated price; the sellers are then asked to refund the excess money via money order, their own checks, or credit card numbers. Invariably, the buyer's check bounces, or the credit card number is from a stolen card but, by the time the sellers learn of this, their money is gone. Tracing the culprit is quite difficult, and a high percentage are overseas (Nigeria is often noted as a haven for Internet scams). Portland, Oregon, sculptor Julian Voss-Andreae came close to becoming an unfortunate victim of just such a trap, receiving an e-mail from someone who gave his name as Benjamin Mascellous with a yahoo.com return address (yahoo is a server of choice for many scammers who look to hide their identities), writing, "I saw your work via google directory, i will like to purchase an indoor sculpture for my resident i will like to know the sculptures you have available and their prices [sic]." Prices and availability were provided by the artist, and Mascellous made a selection, promising to pay the $8,500 price. However, Mascellous sent a check with a Wisconsin address ("a company that issued the payment on my behalf and not my residence my resident is located in Finland," Mascellous explained in an e-mail to an increasingly wary Voss-Andreae) for $12,579.80, asking for "excess funds" to be sent by Western Union to his "assistant" Joseph Benson in London, England, with instructions on shipping the artwork to come later. Eventually, Voss-Andreae came to the conclusion that Mascellous was attempting to perpetrate a fraud, refusing to wire any money to England or else-where and not even trying to cash the $12,579 check out of fear that whatever personal bank account information he would be obliged to provide could be used to steal from him in some other way. "Can you believe it?" Voss-Andreae said. "Of all the people to try to take money from, going after a poor artist."

chapter

Alternative Galleries

At the highest vantage point of the art trade, artists are well taken care of. Gallery owners arrange for framing, crating, shipping, and insuring of artwork, pay for exhibition catalogues and advertising, promote artwork actively to the media and collectors, and calm any fears artists may have that not everything is being done to publicize and sell their work. All that is asked of artists is that they produce artwork. Below that rarified perch is a hierarchy of relationships artists have with dealers: Artists get the show and the catalogue, but they have to pay for their own framing and shipping; artists get the show but no catalogue or advertising unless they agree to pay half or more of the costs; artists get a show, a mailing of postcard invitations, and a white wine and fruit plate opening (they must pay for everything else); artists get a show if they contribute to the costs of running the gallery.

Is This Vanity?

A generation or so ago, there was more of a boundary line between commercial art venues and what are sometimes called "vanity" galleries. Nowadays, there appears to be more of a continuum in which artists expect less and pay more. A strong sense of right and wrong has been replaced increasingly by a belief in being pragmatic, doing whatever works. Certainly, the stigma attached to paying to show has lessened, following the experience in other art forms, such as musicians who produce their own audiotapes and CDs to sell at performances (concertgoers don't seem to mind), dramatists and actors who rent

108

out theaters to stage a theatrical production (audiences don't care as long as the show is good), filmmakers who bankroll their own movies (Spike Lee's *She's Gotta Have It* and Michael Moore's *Roger and Me* made them both famous) and writers who publish their own books (readers are more likely to blame publishers for rejecting new talent).

The pragmatic artist judges every situation differently, based on his or her expectations and goals. Perhaps, achievement is measured less by sales than as a psychological boost. Rachel Von Roeschlaub, a painter in Port Washington, New York, paid Manhattan's Agora Gallery $2,000 to be included in a group show in which she only sold one work ("the least I ever sold at a show," she said), but considered the experience a success, because she is now "able to say, 'I had a show in New York,' which impresses people who look at my résumé." Similarly, Portland, Oregon, painter Kyle Evans was willing to pay $2,000 ("I can deduct it as a business expense," he said) for a show at Montreal's Galerie Gora which, "since Gora is in Canada, suddenly I'm an international artist."

There is more than just vanity to their view of themselves as artists. In the three years that Evans has been represented by Gora, five of his paintings have sold (selling for between $900 and $1,000 apiece) which, after the 40-percent gallery commission is paid, puts him at the break-even point. Von Roeschlaub has had three other shows since exhibiting at Agora—at the Broome Street Gallery in Manhattan, the Port Washington Library and the gallery of the American Association of Applied Science which may not be directly attributable to having her art displayed at Agora, but "a board member of the library said she saw I had had a show in New York."

For artists, New York is Mecca, but the process of getting one's work shown in a commercial gallery there (or in any major city) is never easy. Gallery owners and their assistants see too many hopeful artists carrying portfolios, and their brush-offs are seldom even polite. Seventy-four-year-old Eleanor Gilpatrick, a painter who lives in Manhattan, was told by one gallery owner "that I was too old and my art wasn't political enough. I didn't assume I would be discriminated against." However, having retired as an economist in the health care field in the late 1990s, she did feel too old to start a new career from

scratch—this time as an artist ("I can't look too long into the future, I may not live that long," she said)—and sought to short-cut the process of getting a gallery show, joining New York's Jadite Gallery in 2002. Jadite has three gallery rooms, the largest one renting for $4,000 per month while the others go for either $1,000 or $700 per month, and it shares the costs of other expenses. "For more established artists, no expenses are split," said Katalina Petrova, the gallery's assistant director. Gilpatrick has done well at Jadite, selling ten paintings and three drawings, putting her in the plus side of the ledger even after the gallery's 40-percent commission is figured in.

Not every artist will be satisfied with a pay-to-play approach to their careers, especially if they haven't built a collector base and expect that a for-rent gallery space will pull in art reviewers or prospective buyers. "Agora was a big disappointment," said photographer Mike Gabridge of Augusta, Georgia, who had paid $1,000 for a show back in the mid-1990s. "I got zero, nothing, out of that venture. The artist takes all the risk." He had "expected that a show—and I put that word in quotes—would lead to gallery owners, buyers, and interior designers stopping by, but attendance was very disappointing." Artists who take part in this type of venture need to recognize the difference between one type of gallery and another. The business that Agora, Jadite, Gora, and other like art spaces are in is not selling art but giving artists the chance to show their work, regardless of whether or not the owners of the gallery care for the artwork. Artists are most likely to find success at these galleries if they already have a group of collectors ready to buy but need a place to display the artwork. "If you just sit back and wait for someone else to do all the work, you really can be screwed," said von Roeschlaub. She noted that Agora's opening reception was "very bare bones, no food," and that the invitations to the show's opening "weren't very good. They told me they could do better invitations and quoted me an outrageous price; I did my own. They asked me if they could frame my work and again gave me an outrageous price; I did my own there, too."

The art world does not have an easy relationship with this realm. Commercial art dealers and gallery owners tend not to look favorably on exhibitions that artists paid rent in order to participate, and art critics look down on for-rent art galleries, cooperative art galleries, artist-curated

exhibitions, and much else that is removed from high-end traditional commercial galleries and museums: "When an artist has gallery represen- tation, it suggests the beginning of a commitment to the work by some- one other than the artist him- or herself," said *Los Angeles Times* art critic Christopher Knight. "Because art evolves as informed dialogue and con- versation, it is significant when another person—a gallerist—has begun the conversation by saying, 'I believe in your work.' A vanity gallery can- not offer that; it cannot offer more than the sound of one hand clapping." That view was seconded by *Philadelphia Inquirer* art critic Edward Sozanski, who stated that "I do not have a formal bias against vanity spaces, because the primary concern for me is always the quality of the work being shown and whether it might be of interest to readers. That said, I usually consider such shows of lesser interest, simply because I prefer to spend my time on shows that have been vetted by someone, even if only a gallery dealer. Experience has taught me that self-curated shows are usu- ally disappointing."

It can be difficult to separate the expensive opportunities from the seeming rip-offs. Complaints have been raised by artists against the Florence Biennale in Italy (each of 800 artists are to pay $2,000 in order to take part) and the Batik Art Group of Barcelona, Spain ($400 for six feet of exhibition space), as well as against *NYArts Magazine* and *ArtisSpectrum* magazine, two publications consisting principally of artist- paid advertisements whose distribution claims are not easy to verify. "These promoters are leaching on people who are going nowhere," said Robert Coane, a painter who operates the Web site Art Alarm (*www.atelier-rc.com/Atelier.RC/Art_Alarm.html*). "They offer come-ons with false or exaggerated claims, asking for huge amounts of money that lead only to more come-ons that involve a lot of money."

In most (if not all) cases, artists are "found" for these galleries, exhibits, and magazines through Web searches that are indiscriminate. Both von Roeschlaub and Kyle Evans noted that they were contacted online by the directors of Agora and Gora galleries, respectively, stating that they "loved my work and really wanted to show my work," von Roeschlaub said. The Art Alarm Web site displays an e-mail from World Art Media Director Abraham Lubelski to Robert Coane that states, "I am writing on behalf of World Art Media—a unique organization directly affiliated

with *NY Arts Magazine* and on the look out for new artists to feature in our upcoming campaigns and projects. We are based in Berlin and New York and we offer a variety of opportunities for independent, innovative, and self-motivated artists. I have looked at your Web site and I was impressed by your paintings and drawings. After reviewing it, I would like to offer you, in collaboration with *NY Arts Magazine*, a $325 annual package available to a selected group of artists and aimed at promoting you."

Opportunities for artists to "invest" in their careers are legion. Magazines such as *ARTnews* and *Art New England* periodically publish "Artist Directory" pages consisting of one after another slide-sized advertisements ($500 in *ARTnews*, $400 in *Art New England*) bought by artists who hope that a tiny image and contact information will lead to something (it rarely if ever does). Critics for prestigious art magazines regularly take on writing assignments, penning essays (at between $1 and $2 per word) for promotional catalogues for artists whose work they would never write about in those magazines. Coane, however, stated that these publications and writers are more legitimate, because they do not make false claims—*ARTnews* has a paid subscriber base of more than 84,500 art collectors, dealers, and museum curators, regardless of whether or not they bother to look at the "Artist Directory."

One man's meat is another's poison, the saying goes, for the difference between what is questionable and acceptable in the art world is sometimes a matter of perspective. Coane criticized the Manhattan-based Phoenix Gallery for overcharging the artists it represents. The gallery charges a membership initiation fee of $1,000, as well as quarterly membership dues of $520 (or $2,080 per year) for those living in and around New York City, $675 ($2,700 per year) for those living farther away. With approximately thirty artists represented by the gallery, an individual is likely to get a one-person show once every two-and-a-half years. Between joining and exhibiting, an artist may pay between $6,200 and $7,750. However, those charges are not so out of line with those of other membership galleries about which Coane had no complaints. For instance, New York City's oldest cooperative gallery, A.I.R. Gallery, demands a $500 initiation fee and $150-per-month dues (or $1,800 per year) for its twenty New York–area members

($1,000 per year for the twenty out-of-town members), with oppor-tunities to have a solo exhibition once every two years. As a result, the price of exhibiting for new A.I.R. members ranges from $2,500 to $4,100, less than at Phoenix but still a considerable amount.

"The amount of money is not an issue to me," said St. Paul painter and art gallery owner Joseph Brown, adding that his one show at Phoenix Gallery did not result in any sales. "My work doesn't sell there or here, but I think it's still worth it. I relate more to New York than to Minnesota."

The Artist as Curator

"If an artist can't show his work to the public, then he doesn't exist. How long can you go without existing?" said Philip Sherrod, a New York painter, who has actually shown and sold his work quite a lot. Still, a lot is not quite enough for him, since he organizes—or curates—other shows, including an annual exhibition of what he calls "street painters" at the Cork Gallery at Avery Fisher Hall of Lincoln Center, viewed by the very un-street people coming to see the philharmonic, opera, or ballet. The show includes his own artwork and that of a dozen or so other artists. "We're artists who went to the street and try to match the energy and sense of time in the city with technique."

And so, to present and promote his work in the context of a theme shared by a particular group of artists, Sherrod became a curator. He's not the first artist to come up with the concept of staging his own show, rather than waiting for a gallery or museum curator to put together a display—the French Impressionists, the Ashcan School, the Blue Rider group, the Surrealists, and even some Pop artists all staged their own exhibitions and events, bringing attention to otherwise ignored developments in the arts—but part of a growing trend. Instead of passively hoping for someone to discover them, leaving their careers in other people's hands, more and more artists are looking to take con-trol of how, where, and when their artwork is seen. They are contact-ing the managers of arts centers, as well as sites that are not nonprofit or arts-focused, such as hospitals, naval yards, and office complexes, to offer a presentation of artwork for public display. "There are a lot of

nonprofit art galleries in North Carolina," said Jim Moon, a painter and president of the Lexington, North Carolina–based Asolare Foundation, whose whole purpose is to stage exhibitions of the work of emerging artists. "It's not difficult to get shows in them. They don't schedule very far in advance, and most don't have curators on staff."

These nonprofit art centers also exist primarily to show the artwork of emerging artists. Since they do not need to sell art to pay their rent (like commercial galleries) or bring in large numbers of visitors to generate revenue (like museums), they offer an opportunity that is more concerned with exposure than commerce. "As an artist, you're always looking for new venues, you want to be seen," said Chicago sculptor Terry Karpowicz, who has curated more than thirty exhibitions in various nonprofit art spaces since 1982. "And, it's not just about showing your work but defining your aesthetic to the community. I do that by choosing other people's work that I respond to."

Karpowicz and Sherrod both identified the goal of these shows as being shown and getting seen rather than selling art, because, while sales do occur, they are not predictable. The New York City–based Organization of Independent Artists sponsors a series of artist-curated exhibitions every year, holding them in various locations, including public spaces at the New York Mercantile Exchange and at New York Law School. According to organization president Geraldine Cosentino, "often, there are more sales at the law school, where people don't have much money, than at the Mercantile, where they do have money." In both locations, she added, hundreds of people walk by the displays every day, and artists "all think they're going to hit the jackpot. When they don't, they can get pretty unhappy. I try to give them a realistic picture beforehand, that it's about exposure and experience; don't expect to make a bundle."

Nonprofit art centers are generally not competing with commercial art galleries, although they may serve as a substitute when no galleries are nearby. They are places "to explore and experiment with things that aren't necessarily commercial," said Laurie Lazer, co-director of the nonprofit Luggage Store Gallery in San Francisco, referring to installations, wall drawings, and other less saleable objects. As a result, artists have not been overly disappointed if there aren't any or many

sales. However, Lazer said, expectations are changing; they are making "work to sell and they want sales." More than once, prospective buyers have approached her about works on display, asking about prices and discounts. "I have a hard time dealing," she said. "If you went to a commercial gallery, they deal."

Selling may not be the point for artists curating or participating in these shows. Artists in academia need periodic shows of their work in order to obtain a raise or a promotion, or perhaps an exhibition of current artwork is a stipulation of a grant-funded project. "Shows can bring you academic success, not necessarily commercial success," said Paul Hertz, a digital artist and faculty member of the art department at Northwestern University in Evanston, Illinois, who has organized and curated several shows that included his work and that of his peers. "The goal is to provide documentation of artwork and artists who are underrepresented."

Sales only take place occasionally at the Boston Center for the Arts, and most of the artists whose work is exhibited there "are more concerned with press coverage," said gallery director Laura Donaldson. "They get upset if they don't get enough coverage, or what they think is the right kind of coverage." Otherwise, artists look at exhibitions as a stepping stone toward other chances to have work exhibited. A different by-product of these exhibitions is that artists meet other artists, which may lead to other opportunities to show work or just help find a community of like-mindedness.

However, art buying does take place at some of these shows. Karpowicz reported a handful of sales, as well as commissions to create site-specific work from shows he has curated at the Chicago Pier and the Ukrainian Institute of Modern Art. ("Gallery owners won't put time and energy into promoting large-scale pieces," he said, "but the artists will.") Painter Sally Lindsay, who has curated exhibitions at both the Cork Gallery and Marymount College in Manhattan, has sold between eight and ten works to collectors she did not know beforehand. "They're sales that might not have happened otherwise," she said. Lindsay also invites past collectors to these shows. "I don't have a gallery right now, and people want to see my work somewhere."

How sales are handled varies from one nonprofit center to another. Some will act as galleries, arranging for purchases and charging a commission, while others only provide would-be buyers with contact information for the artists. As a result, their ability to identify the actual number of sales or commissions taking place is limited. If any of the artists are contacted by galleries or museum curators, they are even less likely to know.

There are a number of benefits and a few drawbacks to being an artist–curator. Putting together an exhibition allows artists to create a context for their own artwork—such as, the use of similar materials or the pursuit of similar themes, which a gallery owner may not choose to see, for example—and to install the show in a way that more clearly suits the artists themselves. Even some artists represented in commercial galleries find that they become restless to show their work more frequently than the once every two or three years that is common gallery practice. Taking the lead in arranging additional exhibits maintains the momentum that the gallery shows may have begun.

Curating an exhibition is a lot of work, and that effort helps to build an artist's skills in a number of areas. Artist–curators need to be able to find appropriate artists and to work with them. The curator develops an idea for the show—something that links the artists—and presents that idea in a proposal to the director of the gallery space (research may be required to determine how to write a proposal). Other talents may also come into play, such as writing press releases and grant proposals. Karpowicz's show on the Chicago pier required him to raise $125,000 (most of which came from Sears, the rest from private contributions). The artist–curator must research which art spaces welcome proposals of artist–curated shows and which types of works or artists they favor. The Skylight Gallery of the Center for Arts and Cultures of Bedford Stuyvesant in Brooklyn, for instance, works primarily with African-American artists, while the Cork Gallery of Avery Fisher Hall at Lincoln Center focuses on groups of artists involved in community service. The selected artists may need to be prodded to submit their slides, résumés, or curriculum vitae and artists statements by a certain date. Egos also get involved, as the participating artists want the best

site in the gallery to put their work, and it takes considerable diplomacy to resolve problems and satisfy everyone.

Some spaces that look ideal for an art display may be problematic for other reasons, such as the lack of climate controls or security. Sherrod stated that a number of artworks at a show he curated at Brooklyn Law School (New York) were vandalized by one or more students, and another couple of works were stolen at a show he organized at an office building in midtown Manhattan ("There were too many doors and windows").

Not all nonprofit spaces welcome artist-curated shows, and some that accept proposals for artist-curated shows do not permit the inclusion of the curator's own artwork, believing that this raises a conflict of interest. Artspace in New Haven, Connecticut, half of whose exhibitions are proposed and curated by artists, refuses to permit artist–curators to show their own work ("We don't want artists to call themselves curators just to show their work here," said gallery director Denise Markonish), and the Newhouse Center gallery at Snug Harbor Cultural Center in Staten Island, New York, will "discourage it," said gallery director Craig Manister. "Ordinarily, it's not something you want to see," adding that there is no strict prohibition. The Boston Center for the Arts created a new policy in 2005, ending the ability of artist–curators to include their work in exhibitions. "We want to separate curatorial ideas from the desire to show one's own work," Donaldson said. Not trusting artists even to be objective about other artists' work, Joy Glidden, executive director of the DUMBO Arts Center in Brooklyn, said that "artist-curating disrespects the idea of what curating really is. Curators spend a lot of time studying art, and they try to put together shows that reflect a larger idea of what is happening. Shows put together by artists seem more like vanity, flavored by what their personal interests are, without any attempt at objectivity." It is not clear who actually objects to seeing artwork by the curator in exhibitions: visitors to the gallery haven't registered protests, and critics haven't complained in their reviews; the directors of the nonprofit art centers themselves, many of whom also act as curators of their exhibition spaces, are the ones quickest to find fault.

The directors of alternative art sites may claim the right to reject any work they feel is inappropriate or not at a sufficiently high level ("I don't pick the art, although I may veto something's that really awful," said Jenneth Webster, who runs the Cork Gallery), and they frequently take partial or full control of the show's installation. A number of gallery directors mentioned instances in which the artist–curators placed their work in the most central locations, assigning other artists' work to less convenient areas, or the curators installing several of their own works and just one by the other artists. Some directors spoke of exhibitions that were uneven in terms of quality, the result perhaps of cronyism: curators putting their friends in the show. Sherrod's New York City dealer, Allan Stone, noted that he is not interested in showing the work of the other "street painters" in his gallery.

Some nonprofit art centers provide an honorarium to the curator— even if that person's work is included in the show—although the amounts are usually not large. The New Art Center in Newtonville, Massachusetts, offers a stipend of $1,000, which artist–curators may use as they wish, while P.S. 122 in New York City provides "$100 or less," according to director Susan Schreiber. "We're very low budget; it's a labor of love." The Newhouse Center gallery used to offer a stipend but "There's no budget for that these days," said Manister. However, the gallery pays for insurance and transportation of the artwork, the costs of installing the exhibition and having gallery sitters, printing and mailing announcements, as well as a catalogue. If there is an opening reception, the gallery also covers the food and drink. Yet other nonprofit centers simply make their spaces available for shows, paying nothing to the curator nor contributing to the costs of mounting the exhibition. The Cork Gallery at Avery Fisher Hall requires any artist group to provide a sitter in the gallery when the space is open. If there are any costs involved in installing or promoting the exhibition, Webster stated, the group putting on the show "will absorb them. For our part, Lincoln Center doesn't charge for the use of the space." Adding to the other burdens of curating an art show is prodding the participating artists to chip in money to pay a variety of telephone, printing, and mailing expenses (one's time is seemingly free).

Publish One's Own Catalogue?

Artists are told regularly that they must take an active role in the development of their careers, that they must invest their time and energy in this endeavor, rather than waiting for someone else (dealer? patron? MacArthur Foundation?) to do it for them. Many of these opportunities involve artists spending their own money, which brings up the question of whether or not self-pay garners the same art world esteem as when someone else is the underwriter. (I can say, for example, that what you are reading is a great book, but it is probably more meaningful for readers that the publisher chose to publish it.) For some time, the ground has been shifting, moving the line between what is and is not considered acceptable for artists to pay for.

Being the subject of a coffee-table art book is a great benchmark in an artist's career, but the publishers of these books regularly are subsidized by the galleries of the artists and/or by the artists themselves ("One of the factors in the decision to produce a book is whether the artist is willing to contribute to the costs of publishing," said Carol Morgan, publicity director for Harry N. Abrams, the art book publisher). The means of financing these books are not revealed publicly, and readers don't inquire: They simply assume that the artist must be a big deal in order to merit the book, which is what the artist and dealer wanted in the first place. Throwing a veil over how the operations of the art world are actually paid for may help maintain older (needed?) illusions for collectors, critics, and artists, but even what used to be called blatant self-promotion does not seem as out of bounds as it once had.

A growing number of artists have taken to self-publishing catalogues of their work, complete with high quality reproductions of their work and essays by noted critics, that look for all intents and purposes just like those created by galleries and museums.

"Artists are looking for grants, new galleries, museum shows," said West Palm Beach, Florida, artist Bruce Helander, "and they need professional evidence to show that they've not just another artist in a sea of wannabes." He has produced catalogues three times to accompany shows (twice at galleries, once at a museum), claiming that the costs of creating them—averaging $12,000—were more than made

up for by increased sales that the catalogues generated. "A catalogue gets more reviews from critics and more attention from collectors," he said. "The basis of a catalogue is to transmit visual information to a consumer with a high level of design and quality. Readers then put two and two together and are more likely to form a more favorable opinion about the artist."

The first catalogue Helander published was in 1995 for his first one-person exhibition at New York City's Marisa del Rey gallery, which had no promotional plans beyond printing and mailing a postcard. He hired a designer to create an attractive presentation and commissioned Henry Geldzahler, former curator of twentieth century art at the Metropolitan Museum of Art, to write a 1,000-word essay about his work. (Part of that expense included round-trip air fare to his studio for Geldzahler.) For its part, the Marisa del Rey gallery kicked in $2,500, which went toward mailing the catalogue to collectors, critics, and other people on the gallery's mailing list. Sales were strong, and "by the end of the opening, the catalogue had paid for itself," Helander said.

The link between increased sales and a catalogue is not always direct or clear—might (some of) these sales be attributable to the prestige of the gallery itself or other behind-the-scenes work done by the dealer?—and artists may have to take on faith that the catalogues they produce is money well spent.

In 2001, Manhattan artist Barbara Ratchko self-published 5,000 copies of a sixteen-page catalogue of her pastel paintings, which she used as promotional material, sending out the catalogues around the country to museums, curators, galleries exhibiting contemporary art, "any single person who had ever expressed interest in my work", art consultants, and critics (names and addressed purchased from mailing lists). The costs broke down to $14,000 to produce the catalogue ($1,000 apiece to two designers, $1,000 apiece to two critics who wrote essays, and $10,000 for printing), $4,500 for an assistant who typed mailing addressed and stuffed catalogues into manila envelopes along with cover letters, $150 for mailing lists, and several thousand dollars for postage.

Her catalogue did produce results: Several galleries took on Ratchko's work, and ten others have scheduled exhibits. The new galleries have generated a few sales, which, considering prices for her artwork—$7,500 for smaller pieces and $24,000 for larger ones—indicated to the artist that "I've already recouped the costs. The value of my paintings justified the cost." However, Ratchko has not had a larger quantity of sales overall since publishing the catalogue than in preceding years, which she attributed to "the economy, which has been horrible." The catalogue may have helped offset a downturn in sales, or she might have generated those same additional sales through a less costly form of promotion: Who knows? "It's very difficult to quantify the dollar value of your efforts," she said. "Welcome to the art world."

Any artist who self-publishes a catalogue trusts that there will be benefits seen at some point in the future. "You do a project like this, and you don't get results in the first six months or a year, that doesn't mean it's a flop," she said, noting that "a curator or gallery owner may contact you a year or so later. You never know." Helander claimed that he does know, however: In August, 2003, he met a senior curator of the Whitney Museum of American Art, who bought one of the artist's collages for the institution's permanent collection, "and on that curator's desk was a stack of material about me, and on top of that stack was my catalogue of the Marisa del Rey show."

Self-published catalogues serve various purposes for artists. Topping that list are expanding an audience and generating sales; as much as increasing their visibility in the art world, potentially leading to exhibition opportunities, artists need to recover their costs through sales. As a result, artists need to move slowly into this realm, developing an idea of how much a catalogue will cost, how much they have to spend, and how they will distribute the catalogues (and pay for that distribution). The total costs were more than twice what Ratchko had budgeted, largely because she began to produce her catalogue and "learned what it was really going to cost me along the way."

Susan Hall, a landscape painter in Point Reyes Station, California, self-published 2,000 copies of a hardbound book of her artwork in the beginning of 2003, which cost $30,000 ("I didn't start out with a

budget," she said, "and found out what it would cost along the way"). Her plan has been to sell copies of the book—at $45 apiece—through local bookstores (she and her husband both went to store owners to convince them to carry the book) and mail order (based on brochures about the book sent out to a mailing list). Her paintings sell for between $1,000 and $6,000, and Hall hoped that the book was "a way for people who can't afford my work to have something of mine." For long-time collectors, the book presents a career overview, while for those new to her art it offers "a way for people to be introduced to my work."

Almost one quarter of the books have been sold and, perhaps, more importantly, the number of her paintings sold since publication of the book has increased by 30 percent, Hall noted. As with Ratchko and Helander, the exact link between book and painting sales is difficult to identify, but Hall claimed that the book "starts a process," with the end result being the sale of original art. At the current rate of sales, the book's publication costs will be recouped "within two years; it could even be sooner."

Among the decisions that need to be made are whether or not to tie a catalogue to a particular exhibition and who should write an essay (or if one should be written at all). It is obvious to anyone reading a catalogue that the essays in it will be positive, even laudatory. Some artists just include their own comments—an Artist Statement, for instance—and otherwise let the artwork speak for itself. The useful-ness of an essay written by the artist or by someone else is to provide whoever is looking at the catalogue with some essential facts or inter-pretation that may be quickly gleaned. "The main people who read catalogue essays are critics on deadline," quipped Phyllis Tuchman, an art critic for *Town & Country* magazine and the author of numerous artist catalogue essays. While an artist's own say-so may be valuable in understanding the creative process, an outside observer as essayist is more likely to lend greater authority and credibility to the work—it's not just the artist who appreciates it. Carey Lovelace, a critic and co-president of the U.S. chapter of the International Association of Art Critics, however, stated that a catalogue essay is "not just validating the work for the viewer. It's not just like *Consumer Reports*. Art is about

ideas, and the critic looks to find the idea that is important. That creates a bridge to the work for the reader."

Hiring a noted critic or curator also may be seen as elevating the stature of the artwork being discussed—"it adds what I call the Pope's nod," said Bruce Helander. A known critic's essay may be more likely read than that of an unknown writer, according to a number of critics who write and read these commentaries. "I guess I'd perk up if an essay is by someone I know," said Eleanor Heartney, a critic for *Art in America* and the other co-president of the International Association of Art Critics. She added that artists may also "go for the big name, because they'll assume they'll get a quality essay."

Critics, museum curators, and art historians regularly are approached by artists to write catalogue essays; for some of them, it is a lucrative sideline, because the going rate is one or two dollars per word and essayists often require a minimum of 1,000 words (critic Peter Frank claimed that there also may be "an extra charge if the writing needs to be turned around quickly"). The New York City–based artist career development company, Katharine T. Carter & Associates, has formalized this process, placing on retainer a number of New York area art critics who for two dollars per word, 600 words minimum, will write catalogue essays. "It has been helpful in my career to have written these essays," said Karen Chambers, one of Katharine T. Carter's critics-for-hire who separately wrote an essay for one of Bruce Helander's catalogues. "It gets my name out. People see that I've written about artists, and they want me to write about them." In fact, it was after Helander had read Chambers' essay in a self-published book by Seattle, Washington, glass artist Dale Chihuly that he contacted her to write about his collages.

Artists need to keep their hopes and expectations in check, when hiring a noted critic. Just because Richard Vine, the managing editor of *Art in America* and another of Katharine T. Carter's critics, wrote about a given artist does not mean that artist has any "in" with the magazine—in fact, none of the artists he has written up as part of his association with Katharine T. Carter has ever been reviewed or

profiled in *Art in America.* "You have to realize that you haven't bought this person body and soul for the price of an essay," Eleanor Heartney said, adding that "all of us who write these catalogue essays are trading on our reputations."

Both Barbara Ratchko and Susan Hall produced their catalogue and book independent of any specific exhibition, which makes them less time-bound but also removes a potential marketing event in which excitement and sales may build. Both women have needed to create all the momentum on their own, lengthening the process of generating sales. Helander, on the other hand, produced his three catalogues at the time of particular exhibitions, even placing a gallery's logo, address, and telephone number of the catalogues as though to suggest the dealers published them. Had he produced his catalogues with no exhibition taking place and no gallery to list on the back, the publication would lack "cache. It would be too much of a commercial venture," he said, "just a naked piece of promotion," produced by "a poor artist that no gallery or museum wants." He added that "it's no one's business how an artist is trying to market his work." Perhaps the real issue is whether an artist may look in control of his or her marketing and sales or if some veil over the actual operations of the art world is still needed in order to appeal to older sensibilities.

Galleries and Associations for Women

Back in 1889, when the National Association of Women Artists was formed, women couldn't vote and rarely found a place to show their artwork. (There also weren't many art academies that permitted women students.) "Women weren't considered equal in anything," said Melissa Fleming, current director of the association, which maintains a gallery to show its members' art and provides a lecture series on various topics. More than a century and a quarter later, much has changed in American society, but the National Association of Women Artists and a number of other women-only organizations and galleries around the United States remain. Are they still filling a need or just clinging to a past the rest of us are well rid of?

"Things have been equaling out," Fleming said. "There is a more level playing field." One sees that many women have joined traditionally male artists' organizations, competing with them to have their work exhibited in shows, and women have come to be represented by commercial art galleries in roughly equal numbers to their male counterparts. Organizations of women artists "aren't an anachronism yet," said painter Janet Fish, "but we hope that they would be" in the near future.

Some women-only artists groups have significantly reoriented themselves. Hera Gallery in Wakefield, Rhode Island, which started out in 1974 as a women's artist cooperative ("named after a great goddess who got really angry," according to current director Cynthia Farnell), began admitting male artists as early as 1982. "The gallery had served its purpose of providing women an opportunity to show their work," she said. Similarly, San Francisco Women Artists, which, like the National Association of Women Artists, began in the 1880s, also has taken to letting male artists join. Another cooperative, Impact Artists' Gallery in Buffalo, New York, was founded in 1993 as a women-only space but within a few years started showing the work of both male and female artists, although the gallery's membership is comprised solely of women. There are quite a few exhibition spaces in Buffalo for artists these days but, for members, Impact has evolved from primarily serving as a venue for their work to being "a comfortable place for women artists to come. It basically is a support group," said Mary Jane Luce, the gallery's director.

She noted that artists find encouragement and the opportunity to "network," meeting other artists with whom they may share information and experiences. A number of groups have evolved from being the only place for miles where women artists could exhibit their work to creating a supportive setting in which women may explore their creativity, learn the business of art and develop mentoring relationships with other women artists. "We've become a support group for many of our members," said Esther Grimm, executive director of The Three Arts Club of Chicago (Illinois), which until recently had run a dormitory housing program for women art students since 1912. "People eat meals together, talk about their problems and art together." At both Women Artists of the West (established in 1973) and the American

Academy of Women Artists (founded in 1993), the emphasis is on mentoring and networking, as well as educational programs (how to put together a portfolio, write a résumé, and create digital slides or a Web site, for instance). Male artists are perhaps no less in need of this information and help, but it is believed that women lag behind men in the basic knowledge of some of these areas. Luce noted that both men and women often must put off their art, because of jobs and families, and need to learn about how the art world works later in life. However, she stated, men may have something of a head start, because they "have contacts with moneyed people through their work. Women may have contacts but at a different level, especially if they needed to take time off to raise a family."

The art world's discrimination against women is also not wholly a thing of the past, though it may take more subtle forms these days, according to both members and directors of women-only arts groups and galleries. "Society is changing, but it is not changed already," said Gwen Pentecost, a painter and president of Women Artists of the West, claiming that the "better galleries will represent a male artist before they would a woman." She added that men who paint full-time are perceived as serious artists, whereas comparable women are more likely to be thought of as hobbyists. Dena Muller, director of New York City's cooperative A.I.R. Gallery and the president of the Women's Caucus of Art (both groups founded in 1972), found sexism in the issue of "who's making money in the art world these days. You look at the resale market and see that the work of male artists is going for much more than that of women artists at galleries and at the auctions." Others complain that exhibitions of women artists' work are reviewed far less often than shows of their male counterparts, that art history books do a poor job of representing women artists, and that the number of works by women artists in museum permanent collections is minute. Guerrilla Girls, an informal advocacy group of women artists who stage protests, disguising their faces in gorilla masks and not revealing their actual names, surveyed the modern and contemporary art collections at New York's Metropolitan Museum of Art both in 1989 and in 2004, finding that works by women artists are still under 5 percent. "Things are better for women and artists of color now than they've ever been, especially at the entry level, but there's still a long way to go," Guerrilla Girls spokesperson "Kathe Kollwitz" said.

Some juried exhibitions and professional art organizations also seem to hearken back to pre–Women's Liberation percentages in terms of their inclusion or recognition of women artists' work. Cowboy Artists of America does not allow women as members (a Cowgirls Hall of Fame exists for them), and shows that highlight Western art—such as the Prix de West, Masters of the American West, Buffalo Bill Art Show & Sale, and Western Visions—invite particular artists known to the curators rather than jury in particular works of art, resulting in exhibitions that highlight the work of male artists disproportionately. Since 1973, for instance, only two women artists have won any Prix de West awards, Glenna Goodacre and Bettina Steinke. "Shows that invite artists tend to be over overwhelmingly male," said Missoula, Montana, wildlife painter Julie T. Chapman. "Shows that jury in specific artwork are much better gender-balanced." Describing the fields of wildlife and cowboy art as "full of testosterone," Chapman said that she joined the American Academy of Women Artists because its annual show provides "a counterweight to the Prix de West for people who happen to have been born female."

Some good may result from bad: The most recent Masters of the American West show, which is overwhelmingly composed of the work of male artists, raised half a million dollars for its host organization, the Autry National Center in Los Angeles. Some of that money is used to purchase work by women artists for the permanent collection, according to the museum's curator of visual arts Amy Scott.

All organizations and membership groups—arts and otherwise—have some type of common denominator: All of the members of the National Watercolor Society are watercolorists, for instance; those belonging to the American Society of Portrait Artists create portraits. There may well be significant variations in styles (abstract or Photo Realist, for example) or medium (a painted or sculpted portrait), but members have strong links. Organizations of, and galleries showing, women artists are by nature far looser groupings, united only by the gender of the members. Some of the women may be fervent feminists, quite critical of a male-dominated art world and culture ("the last I heard, the Equal Rights Amendment hadn't passed yet," said painter Miriam Schapiro), while others retreat from the word "feminist" and

simply want to be in a community of women pursuing similar activities. The type and quality of art that members create can be all over the lot as well. This presents a greater challenge to galleries of women artists, which, unlike customary commercial galleries that present works with some stylistic or conceptual unity, must month after month seek to entice in visitors who may have no idea of what to expect. The founding members of the A.I.R. (standing for Artist-in-Residence) cooperative chose a gender-neutral name so that visitors would bring an open mind to the work on display (the gallery later removed a collection plate on the front desk and mission statement on the wall, so that some visitors may not even know that it is a co-op). On the other hand, the Austin, Texas–based Women & Their Work nonprofit gallery (founded in 1977) used to receive telephone calls from employers looking to hire secretaries and cleaning help, leading the group to discuss whether or not to include the word "art" in their name.

These galleries generally are nonprofit spaces or cooperatives, supported by the women artists themselves or by outside members who believe in the women's movement. Unlike the work of African-American and Latino artists, there does not appear to be a defined group of collectors who specialize in the work of women artists, although the National Museum of Women in the Arts in Washington, D.C., was founded on a private collection of work by women artists formed by Wilhelmina and Wallace Holladay. The Chicago-based Woman Made Gallery is a nonprofit, according to its director Beate Minkovski, because it displays "a lot of subjects you won't see in commercial galleries, artwork dealing with breast cancer, domestic violence, menstrual cycles, crafts, art by lesbians." The identification of women's art and work about women's own bodies troubles Dena Muller, who worries that many women artists have pigeon-holed themselves, fulfilling the market's expectation for what their artwork should look like. "The issue of women consenting to be sexual objects is a deep one in the art world, reflecting how the art world is entangled with the fashion and entertainment industries," she said. Muller acknowledged that many male artists have created work focusing on their own bodies, but stated that "the market is open to a wider range of styles and subject matters for men; it's narrower for women." However, the art world's acceptance and percentage of

women in all roles (artists, museum curators and directors, critics and art dealers) has expanded so greatly since the 1970s that generalizations are quite susceptible to contradiction. Some women artists are adamantly opposed to joining organizations of women artists, believing that viewers will start to look at their work in a limiting perspective. For instance, New York printmaker Clare Romano noted that she doesn't like "the segregation of artists as women," and painter Audrey Flack complained of the "break-down" of the art world into identity groups of "lesbian artists, Polish artists. I wish now that there was just a national association of artists." Both Flack and Romano, though, are members of the National Association of Women Artists, suggesting that their thinking isn't set in stone.

Keeping A.I.R. and similar galleries and groups in business, however, is a belief in their continuing value on the part of women artists. "We have a large constituency of repeat visitors," Muller said, and "we keep getting applications from women who want to join. If people weren't interested in a women-only space, we would cease to exist."

Among the organizations of women artists are:

American Academy of Women Artists
3935 County Road 250
Durango, CO 81301
(970) 375-1366
www.aawafineart.com

ArtTable, Inc.
270 Lafayette Street, Suite 608
New York, NY 10002
(212) 343.1735
www.arttable.org

Catharine Lorillard Wolfe Art Club
802 Broadway
New York, NY 10003
www.clwac.org

Guerrilla Girls
532 LaGuardia Place, Suite 237
New York, NY 10012
www.guerrillagirls.com

National Association of Women Artists
80 Fifth Avenue
New York, NY 10011
(212) 675-1616
www.nawanet.org

National Cowgirl Museum and Hall of Fame
1720 Gendy Street
Fort Worth, Texas 76107
(817) 336-4475 or
(800) 476-FAME (3263)
www.cowgirl.net

The Women's Art Center
345 Pierpont Avenue
Salt Lake City, UT 84101
(801) 577-8367
www.womensartcenter.org

Women's Caucus for Art
P.O. Box 1489 Canal Street Station
New York, NY 10013
(212) 634-0007
www.nationalwca.com
There are 26 chapters around the country.

Women Artists of the American West
P.O. Box 1644
Bemidji, MN 56619
(218) 854-7517
www.waow.org

Women in the Arts
National Women's Music Foundation
P.O. Box 1427
Indianapolis, IN, 46206-1427
(317) 713-1144
www.wiaonline.com

Women's Studio Workshop
P.O. Box 489
Rosendale, NY 12472
(845) 658-9133
www.wsworkshop.org

Among the cooperative galleries of women artists are:

A.I.R. Gallery
511 West 25th Street
New York, NY 10001
(212) 255 6651
www.airnyc.org

ART Gallery
734 North Milwaukee
Chicago, IL 60622
(312) 733-2787
www.arcgallery.org

Ceres Gallery
547 West 27th Street
New York, NY 10001
(212) 947-6100
www.ceresgallery.org

Hera Gallery
Hera Educational Foundation
327 Main Street
P.O. Box 336
Wakefield, RI 02880-0336
(401) 789-1488
www.heragallery.org

Impact Artists' Gallery
Tri-Main Center
2495 Main Street
Buffalo, NY 14214
(716) 856-2447
http://members.tripod.com/ImpactArtist

The Pen & Brush, Inc.
16 East 10th Street
New York, NY 10003
(212) 475-3669
www.penandbrush.org

San Francisco Women Artists
P.O. Box 156934
San Francisco, CA 94115
(415) 263-0705
www.sfwomenartists.org

SoHo 20 Gallery
511 West 25th Street
New York, NY 10001
(212) 367-8994
www.soho20gallery.com

Three Arts Club of Chicago
1300 North Dearborn Parkway
Chicago, IL 60610
(312) 944-6250
www.threearts.org

Women Artists Rising
P.O. Box 8247
Tampa, FL 33647
(813) 213-4444
www.womenartistsrising.com

Woman Made Gallery
2418 West Bloomingdale
Chicago, IL 60647-4301
(773) 489-8900
www.womanmade.net

Women & Their Work
1710 Lavaca Street
Austin, TX 78701
(512) 477-1064
www.womenandtheirwork.org

A number of organizations provide fellowships and grants to women artists, including:

Anonymous Was a Woman Foundation
130 East 59th Street
New York, NY 10022
(212) 836-1358
By nomination only

Astraea Lesbian Foundation for Justice
116 East 16th Street
New York, NY 10003
(212) 529-8021
www.astraeafoundation.org

Radcliffe Institute Fellowships Office
Mary Ingraham Bunting Fellowships
34 Concord Avenue
Cambridge, MA 02138
(617) 496-1324
www.radcliffe.edu/fellowships.php

The Fund for Women Artists
P.O. Box 60637
Florence, MA 01062
(413) 585-5968
www.womenarts.org

Money for Women/Barbara Deming Memorial Fund, Inc.
P.O. Box 630125
Bronx, NY 10463
Awards up to $1,000

The Kentucky Foundation for Women
1215-A Heyburn Building
332 West Broadway
Louisville, KY 40202
(502) 562-0045
www.kfw.org

The Leeway Foundation
123 S. Broad Street, Suite 2040
Philadelphia, PA 19109
(215) 545-4078
www.leeway.org

McKenzie River Gathering Foundation
Lilla Jewel Award for Women Artists
2705 East Burnside
Portland, OR 97214
(503) 289-1517
www.mrgfoundation.org
For artists residing in Oregon

National Museum of Women in the Arts
Library Fellowship Program
1250 New York Avenue, N.W.
Washington, D.C. 20005-3920
(202) 783-7366
www.nmwa.org
Provides up to $12,000 for the creation of artists books

A Room of Her Own Foundation
P.O. Box 778
Placitas, NM 87043
By nomination only

Serpent Source Foundation for Women Artists
3311 Mission Street
San Francisco, CA 94110
(415) 597-3545
http://home.flash.net/~serpents/

Thanks Be to Grandmother Winifred Foundation
P.O. Box 1449
Wainscott, NY 11975-1449
(631) 725-0323
Grants up to $5,000 to women artists age 54 and over working
in the visual arts

Women's Funding Network
1375 Sutter Street
San Francisco, CA 94109
(415) 441-0706
www.wfnet.org
An information source

chapter

Specialized Markets

The market for art is quite segmented, with different media and styles of art having their own galleries, fairs, magazines, membership organizations, and collectors, often with precious little overlap. Artists may be wildly famous in their own spheres and completely unknown outside of them. As noted in chapter 1, an artist's expectations may get in the way of a successful career if he or she is a painter of animals or marine subjects but has his or her sights set on being written up in *ARTnews* or *Art in America*. (Either the artist's work will have to hew more closely to the type given attention in the magazine, or publication in that particular venue must cease to be important to the artist.) In the realm of niche art, some of the best starting points are the membership associations of artists who work in those areas, which publish newsletters, hold conferences, and organize exhibitions. Among these are:

American Academy of Equine Art
c/o Kentucky Horse Park
4089 Iron Works Parkway
Lexington, KY 40511
(859) 281-6031
www.AAEA.net

American Society of Marine Artists
P.O. Box 369
Ambler, PA 19002
(215) 283-0888
www.marineartists.org

American Society of Portrait Artists
2781 Zelda Road
Montgomery, AL 36106
(800) 62-ASOPA
www.asopa.com

American Watercolor Society
47 Fifth Avenue
New York, NY 10003
(212) 206-8986
www.americanwatercolorsociety.org

Audubon Artists
47 Fifth Avenue
New York, NY 10003
www.audubonartists.org

Cowboy Artists of America
P.O. Box 396
Blue Springs, MO 64013
(816) 224-2244
www.caamuseum.com

Guild of Natural Scientific Illustrators
P.O. Box 652
Ben Franklin Station
Washington, D.C. 20044
(301) 309-1514
www.gnsi.org

Miniature Artists of America
1595 North Peaceful Lane
Clearwater, FL 33676
(727) 584-3883
www.miniatureartistsamerica.org

National Association of Women Artists
80 Fifth Avenue
New York, NY 10011
(212) 675-1616
www.nawanet.org

National Sculptors Guild
2683 North Taft Avenue
Loveland, CO 80538

(907) 667-2015
www.nationalsculptorsguild.org

National Sculpture Society
1177 Avenue of the Americas
New York, NY 10036
(212) 764-5645
www.sculptors.org/NSS/

National Society of Painters in Casein and Acrylic
969 Catasaugua Road
Whitehall, PA 18052
(610) 264-7472
www.bright.net/~paddy-o/art/nspca.htm

National Watercolor Society
915 South Pacific Avenue
San Pedro, CA 90731
(310) 831-1099
www.nws-online.org

Organization of Independent Artists
19 Hudson Street
New York, NY 10013
(212) 219-9213
www.oia.org

Pastel Society of America
15 Gramercy Park South
New York, NY 10003
(212) 533-6931
www.pastelsocietyofamerica.org

Portrait Society of America
P.O. Box 11272
Tallahassee, FL 32302
(877) 772-4321
www.portraitsociety.org

Society of Animal Artists
47 Fifth Avenue
New York, NY 10003
(212) 741-2880
www.societyofanimalartists.com

Wildlife Artist Association
5042 Casitas Pass Road
Ventura, CA 93001
(978) 768-7218
www.wildlifeartistassoc.com

This is certainly not a complete list, and it only includes national organizations. Almost every U.S. state has one or more watercolor societies, and there are also numerous state societies of pastel artists and printmakers. (For a more complete list, see *How to Grow as an Artist* by Daniel Grant, published by Allworth Press). Often, the members are a mix of professional and amateur artists, and some groups admit new members on the basis that their artwork was juried into a show they sponsor, indicating that level of quality is a higher consideration than whether or not the individual artists have a track record of, or an interest in, supporting themselves from the sale of their art.

In certain niche categories, there may not be a realistic option of showing works in galleries, requiring artists to take on the job of finding exhibition spaces and opportunities, as well as collectors.

Religious Art

Most of the organizations noted above focus on artists working in a particular medium, with little concern for style or—with the exception of animal, equine, and marine artists groups—content. Another association, Christians in the Visual Arts (255 Grapevine Road, Wenham, MA 01984-1813, (978) 867-4124, *www.civa.org*), has no requirements for its members to work in a particular style or medium, nor that the work they produce look biblical in some way or have some overtly spiritual content. Some of this artwork shows up in commercial art galleries, although many dealers claim that the market for this art is limited, because deeply religious people tend not to be art buyers. "Not too overly religious" is art dealer Jack Rutberg's proviso, yet that hasn't stopped artist Jerome Witkin from creating images and titles—*A Jew in the Ruin* or *Jesus (A Disbeliever's Vision)*, images that clearly describe the importance of religion in contemporary life—or stopped Rutberg from exhibiting this work at his Los Angeles gallery.

Over the past quarter century, a growing number of exhibition venues have been created for fine art that focus on religious or spiritual subjects, such as in galleries established within churches (a growing number of religious institutions have also set up "arts ministries," which are fine and performing arts programs for congregants) and smaller museums, particularly those associated with Christian colleges. "Our mission is to present the artwork of our time that represents the religious and spiritual dimensions," said Father Terrence E. Dempsey, director of Saint Louis University's Museum of Contemporary Religious Art in St. Louis, Missouri, which was founded in 1992. Exactly what that artwork looks like—two- or three-dimensional, representational or abstract, traditional or postmodern—is not predetermined. The museum looks to show artists whose work "evokes something more than what is physically viewable," he noted.

There probably is no firmer definition of religious art to be found. Unless an artist is depicting a story from the Bible or other religious text, there may be no way of knowing what is in his or her mind: A landscape may be seen as having a spiritual dimension (God's green earth), or it could just be a picture of trees and grass. When Jerome Witkin painted *The Silence*, which shows a woman at a barn, he claimed to be thinking of the mother of Jesus, but "my work is open enough that people can find their own meanings," he said. "There's no proselytizing." This also works as a strategy. Both Sandra Bowden, a painter and president of the twenty-five-year-old membership organization Christians in the Visual Arts, and sculptor Karen Swenholt, at times have disguised their more religious themes with indistinct titles that let viewers make their own interpretations. "When you enter competitions, works with religious titles don't make it," Swenholt said, noting that one work of Jesus encountering a woman about to be stoned to death for adultery is entitled *Waiting for the First Stone* on some occasions and *Drawing in the Sand* on others. "I'm out to communicate, not to irritate," she said. Similarly, a largely abstract painting by Bowden that includes the suggestion of Hebrew calligraphy has two titles, *The Book* and *Book of Remembrance*, "depending on where it is exhibited," she said. "No one wanted *The Book*, but *Book of Remembrance* has been accepted into I can't tell you how many shows."

Perhaps, the biggest show of all is the Museum of Biblical Art in New York City, which opened in 2005, offering exhibitions that take a scholarly approach, rather than proselytizing, and focuses on contemporary art. The museum's director, Ena Heller, defined biblical art as "an umbrella term used to describe art that draws from the text of the Bible or from Bible literature. Much of the art we will show at the Museum of Biblical Art does not draw directly from the Bible, but would not exist had it not been for the original book." She added that the museum's aim is not to "celebrate religious practice, we're not saying, 'My religion is better than yours.' "

The number of qualifiers in her description of the new museum reflects the degree to which religion and art have been perceived as mutually exclusive and even antithetical since the dawn of Modernism. Gordon Fuglie, director of the art gallery at Loyola-Marymount University in Los Angeles, stated that "Modernism has a secular theory, that art is the new religion and religious art is something that will just wither away." Putting the case more bluntly, James Elkins, a professor of art history at the School of the Art Institute of Chicago, noted that "there is virtually no way to break out of the 'religious art' stigma and into the mainstream art world."

Bruce Herman, a painter of religious images and director of the art gallery at Gordon College, a Christian institution in Gloucester, Massachusetts, stated that he has learned to take derogatory statements by museum officials about his type of artwork ("religious ideas are passé," "Christian content too overt") in stride, recognizing that the content and titles of his paintings "have limited where I can show and sell my work. Sincere religious imagery is never going to be a serious focus of collecting." That mix of defiance and resignation doesn't sit well with everyone, though. Many artists themselves look to make clear distinctions between their religious faith and artwork, fearing a backlash from collectors, critics, curators, and dealers who identify religious art as second-rate illustration of stories from the Bible and also see overt expressions of religion as expressions of intolerance (for other religions) or extremism. Tim Rollins, who runs an arts ministry at the Memorial Church in Harlem (New York City) and creates installations of text and images with an ever changing group of adolescents whom he calls Kids

of Survival, stated that "when the secular community hears that you are a Christian, it assumes that you are a member of the 700 Club or a Jesus freak, and it terrifies them." Rollins said that he is "open about my religious beliefs" but doesn't "advertise" them and, besides, the art community doesn't assume that artists are devout about anything but their art. Painter Makoto Fujimura, who claimed that "I am an artist who happens to be a Christian," said that "I worry that collectors would not look upon my work with favor anymore were I known as a Christian artist." Similarly, installation artist Tim Hawkinson said that "I'm a bit shy about letting the art world know my religious beliefs. It's not always politically correct, and the art world isn't always welcoming to issues of spirituality." He noted that his wife, Patty Wickman, who is also an artist and teaches in the art department at the University of California at Los Angeles, had told him that hiring committees at UCLA regularly "pass over the applications of teaching candidates whose artwork address issues of faith."

Several art dealers noted their hesitation at displaying overtly religious artwork, because religion doesn't play a large part in the life of intellectual people and is not part of their intellectual identity. In addition, religious imagery and symbols in art are also more likely than almost any other subject matter to offend someone. Controversy spreads out in all directions: Edward Knippers, a figurative painter of biblical subjects and long-time member of Christians in the Visual Arts, stated that "one major Washington [D.C.] dealer said to me, 'Ed, I've liked your work for years, but I don't want to mark my gallery with your subject matter.' " However, one of the most notable complaints about his work came at a Christian school, Union University in Jackson, Tennessee, where a work by the artist in a group show at the college's art gallery irritated a security guard who brought his concerns to a university administration official who was also irritated by the work. "There's a window in the gallery," said the gallery's director Michael Mallard, "and we were told to close the blinds." The reason? "The figure in the painting was naked." Knippers stated that his problem is threefold, that his paintings are "too nude for churches, too large for homes, and too religious for museums."

Over the years, a growing number of colleges and seminaries have created graduate programs in theology and the arts, which have

resulted in arts ministries and new opportunities for artists to exhibit their work within churches. These include:

Fuller Theological Seminary
Brehm Center for Worship, Theology, and the Arts
135 North Oakland Avenue
Pasadena, CA 91182
(626) 584-5498
www.fuller.edu
M.A. in religion and the arts

Drew University
36 Madison Avenue
Madison, NJ 07940
(973) 408-3000
www.drew.edu
Ph.D. in Liturgical Arts

Graduate Theological Union
2400 Ridge Road
Berkeley, CA 94709
(510) 649-2400
www.gtu.edu

Regent College
5800 University Boulevard
Vancouver, B.C. V6T 2E4
Canada
(604) 224-3245
www.regent-college.edu
Christian Studies in Religion and the Arts

United Theological Seminary
1810 Harvard Boulevard
Dayton, OH 45406
(937) 237-5817
www.united.edu
Doctoral program includes a focus in the arts

University of St. Andrews
Institute for Theology, Imagination and the Arts
Fife KY16 9AJ
Scotland, United Kingdom
011 44 1334 476161
www.st-andrews.ac.uk

Wesley Theological Seminary
Center for the Arts and Religion
4500 Massachusetts Avenue
Washington, D.C. 20016
(202) 885-8600
www.wesleysem.edu

Yale Institute of Sacred Music
409 Prospect Street
New Haven, CT 06511
(203) 432-5180
M.A. in religion and the arts
(may have visual arts emphasis)

Sports Art

If painting or sculpture with religious or spiritual subject matter is an art that dare not speak its name, sports imagery has even fewer people to speak on its behalf. Sports are not thought of as a serious subject for art, and the vast majority of sales are to non-art collectors at non-art venues, and what they buy are not original canvases but poster reproductions. The largest of these venues is the National Sports Collectors Convention (P.O. Box 35200, Las Vegas, NV, (702) 515-0636, *http://natlconv.com/national/*), although there are other, smaller sports and memorabilia shows throughout the year all over the country (*www. signingshotline.com* is a good source of information on what is happening where and when).

Certainly, recent art history has had its share of sports subjects, from Thomas Eakins' paintings of scullers and George Bellows' renowned boxing painting *Dempsey and Firpo* to the images of baseball players by Elaine de Kooning. Since 1997, the George Krevsky Gallery in San Francisco has staged an annual "Art in Baseball" exhibition, featuring paintings, prints, and sculptures with baseball themes, which has included the work of such artists as Gregory Gillespie, Elaine de Kooning, Ben Shahn, and Saul Steinberg. "The foot traffic for that show is the highest for any exhibition we mount during the year," gallery owner George Krevsky said. Sales are brisk, many to people who don't ordinarily collect art, but the show never has been reviewed in the city's major newspapers or magazines. In 2001, the *San Francisco Chronicle* included a sort-of review on its sports page and, for the 2004

exhibit, pre-game radio shows for the Oakland Athletics and the San Francisco Giants described works on display. "Sports art is not seen as serious art," Krevsky said. "I'm battling that problem."

It isn't a battle he is waging very hard, however, because the gallery doesn't show sports imagery except during that one summertime exhibition. In effect, "Art in Baseball" may represent a break from serious art, which is its appeal and limitation. One of the artists in the most recent "Art in Baseball" show, painter Arthur K. Miller of York Beach, Maine, noted that he is represented by the O.K. Harris Gallery in New York City and has sold many original works through that gallery. However, "a one-man show of my work at O.K. Harris doesn't make sense, because my audience is so targeted," Miller said. "People coming into O.K. Harris would see half the gallery is images of baseball, and that may turn a fair number of them off."

There are a number of sports museums around the United States that highlight original artwork, such as the American Sports Art Museum & Archives in Daphne, Alabama, (which names an annual Sports Artist of the Year), and the National Art Museum of Sport in Indianapolis, Indiana, which collects artwork representing 40 areas of sports. Richard Johnson, curator of the Sports Museum of New England in Boston, which also displays sports art, noted that balancing sports and art interests is a "tricky issue. The sports crowd thinks that art is wearing French berets and drinking cappuccino on a veranda, while the arts crowd thinks we're hanging smelly jock straps up for view."

As opposed to other, perhaps more timeless art subjects, sports themes need to be tied to something topical, such as a current player or a recent major event (U.S. Open championship or Super Bowl win, for instance). Sanford Holien, a painter in Olympia, Washington, who began his career as a commercial illustrator, took a great leap into the sports art field in 1986, producing a limited edition print image of Seattle Seahawks wide receiver Steve Largent, who at the time was en route to setting a National Football League record for consecutive catches and was a local favorite. Holien obtained permission from Largent (through his agent), the Seahawks, and the NFL, produced a brochure, and bought newspaper advertisements. All 1,500 copies in the edition sold out, and he soon

made sports figures the focus of his art career, largely giving up the commercial illustration work. Steve Largent's record-setting catch was news in 1986, but it would not be twenty or more years later. Holien's depiction of Largent's achievement was popular in Washington State but probably would not be in other regions of the country where sports fans root for their local teams and players.

In the regular art world, it is important for artists to sign their prints, but in sports art it is often equally if not more useful for the depicted athlete to autograph the copies. An autograph, Holien said, "adds cache, and it creates a personal link to the athlete" for the fan. It also indicates that the depicted athlete approves of the work—another non-art criterion—which comes at the end of a sometimes lengthy process of obtaining permission to use the image. It took months for Holien to gain the rights to portray former Seattle Mariners outfielder Ken Griffey, Jr. (from his agent, the ball club, and the league office) and a full year to do the same for former Portland Trailblazer basketball star Clyde Drexler. (With basketball players, one also needs the OK of the players union. If the depiction is based on a photograph, the artist may also need to obtain licensing rights from the photographer.) That permission is also costly, Holien said, adding up to 20 percent of the estimated retail sales for the print edition, payable as royalties.

Some sports artists circumvent this problem by focusing on athletes of the past, around whom there is a sentimental aura, rather than those who are still active or even still alive. Current professional athletes are far better paid than those in the past, but there is much less romance about them, and too many of them end up on the police blotter. "Players in the fifties drank some beer, they didn't take steroids," said Andy Jurinko, a New York City sports artist, said. "Players tended to stay on the same team for a longer period of time. Now, it's rare if someone is still on the same team after three years. Fans end up rooting for logos." Arthur K. Miller noted that his portraits of pre–World War II ballplayers Carl Mays and Johnny Vander Meer, whom he thought were relatively obscure figures in baseball, sold quite quickly, while his painting of former Yankee star Reggie Jackson "I can't get rid of." Picking the right athlete to portray, he added, is "sort of a knuckleball."

In this realm in between real sports and real art, artists often have to predict what the buying public is likely to want when selecting a particular athlete to portray. Sports art isn't "just a valentine to some athlete," Richard Johnson said, but most artists in this field would disagree (at least in practice). "The image better be flattering," Holien said, and it is difficult to imagine a sports image that did not make the subject(s) look heroic in some way. Timely, of purely local interest, endorsed, and flattering are not easy boundaries for artists to work within, and many (if not most) of the collectors may not even see the works they purchase as art at all but as photographs (or composition photographs) by other means. Such strictures and assumptions can lead artists to lower their standards and work in a formulaic manner. "I'm an artist without ego," Valrico, Florida, artist Greg Crumbly said, "but I do have standards. People look at my works and are drawn to them without knowing why. They think it's just because of the athlete, but I know it's because of the composition and color arrangements and the way I create the figures."

Entering the Print Market

"If all the stars lined up, and I painted a little gem," said Kerry Hallam, "all I could do is sell this work once, and that's that." That might be enough for many artists, but Hallam, who lives and paints full-time in Nantucket, Massachusetts, found that merely painting and selling was not getting him ahead in the world; it just paid the bills. Back in the 1980s, he began to notice how certain artists, such as Simbari and Leroy Neiman, "were making gigantic amounts of money selling silkscreen prints," and the idea of creating an edition of prints from his original paintings began to take hold.

A lot of artists, galleries, and print publishers were thinking a lot about print editions in the 1980s, catering to a growing art market that saw prints as both an entry into art collecting—acquiring works for a far lower price than originals—and an investment. Perhaps, too many artists, galleries, and publishers decided to get in on this trend. Certainly, print edition sizes ballooned to, in some instances, thousands of copies, and resulted in a glut on the market. By the end of the decade, print prices were in a free-fall (and many prints were simply

unsellable); many of the galleries that primarily sold prints went out of business, and publishers retrenched in order to stem their losses.

Making and selling multiples based on paintings never faded away—although some of the frenzy did—as many artists continue to try to widen their audience, increase their exposure, and generate more income from the sale of prints. In 1989, Kerry Hallam "raided the cookie jar" for money to rent a booth at Art Expo, the annual late Winter fine-art print show held at the Jacob Javits Convention Center in New York City. He brought along twenty-five of his paintings, hoping to attract the attention of a print publisher. A number of publishers expressed interest, and Hallam signed a contract the following year with Chalk and Vermilion Fine Arts, the Greenwich, Connecticut–based publisher with whom he continues to work to this day.

Wanting to earn more money is a perfectly good reason for an artist to look into the print market but, as the experience of the 1980s showed, success in this venture takes more than greed. Sylvia White, an artists' career advisor in Los Angeles, noted that "artists most suited to making a line of prints need to satisfy three requirements": The first is a strong market for the originals, "when one specific painting could have been sold ten times. A lot of artists think, 'I'm not selling my paintings, so I'll try to sell prints.' That's a backwards way of looking at it; you need to have a market for the paintings first." The second requirement is that "the original paintings have appreciated in value to the point that the artist is losing former buyers." In that case, offering prints allows these past collectors to continue to purchase the artist's work "at a lower price point." The third requirement is that the art is "targeted to a particular niche, so that the very people you want to buy your work know about your work."

Creating print editions based on paintings today offers more choices to artists than in the past. Twenty years ago, the principal options were offset lithography (a transparency made from the original is scanned and transformed onto a printing plate) and photo-serigraphy or silkscreen printing (a photo-sensitive film is placed on the screen), producing paper prints. Digital technology has more recently allowed photographs of paintings to be scanned into computers, where colors

may be changed and enhanced on the monitor and then printed by large-scale printers onto a variety of substrates, including watercolor paper and canvas, which offer the look of the original painting rather than a photographic version of it. These are usually called digital prints (or Iris prints) or giclees. Meeting the competition, many newer offset lithographs and serigraphs have been produced on canvas, adding to their production and selling costs but again providing the look of original art.

Digital prints generally cost more to produce than the lithographs and serigraphs. However, the entire edition of lithographs and serigraphs are customarily printed at one time, requiring artists and publishers to determine in advance what size the edition should be and perhaps creating a storage problem of dozens, hundreds, or thousands of unsold prints. On the other hand, just one digital print may be produced at a time to test the market (it does not add significantly to the cost to print the remainder of the giclee edition, since all of the information is stored within a computer).

In 2001, Sally Swatland of Enfield, Connecticut, whose paintings sell for between $7,000 and $9,000, tested the market for prints by producing offsets on paper and giclees on canvas for three different images. The production costs for each paper-based print were between $100 and $150, and they were priced between $250 and $700 framed; the same images on canvas cost $175–200 apiece to produce and were priced at $800–1,500, also framed. She found that there was much greater interest in the digital prints "among buyers who can't afford an original but want the feeling of canvas. They were willing to spend more for the print if it seemed more like an original painting." Canvas-based prints generally need to be mounted and framed, whereas in many instances those on paper may only be shrink-wrapped and stacked with other paper prints, allowing them to get "lost in the crowd."

Other artists have also found that they can earn more for prints that seem like original paintings. The paper-based prints of Kerry Hallam's paintings are priced at $1,150, while the same images on canvas cost $2,600. Hallam also adds to these canvas prints' look of originality by lightly painting on top of certain sections; another painter who

creates prints from her work, Barbara McCann of Bradenton, Florida, produces editions of giclees that are priced up to $2,000 apiece, $2,800 if she "enhances" them with some brushwork. This practice has become so widespread that a number of print publishers have artists on staff to add hand-painted highlights.

These higher end prints have proven popular with many private collectors and companies, especially those businesses that operate on a strict budget but want to purchase a lot of artwork for their money, such as hotels and motels that look to decorate hundreds of rooms. "I've been told by one corporate manager, 'We have $1 per square foot to spend on art,' " said Cecily Horton, a corporate art consultant and a trustee of the Museum of Fine Arts of Houston. "It doesn't sound like much, but they have projects of 160,000 square feet." Some companies may seek original works, perhaps even commission artists to create specific pieces, in their lobbies and reception areas (Horton calls these works "trophies to impress the world at large"), but less publicly accessible areas—such as hallways, conference rooms, and cafeterias—are ripe for multiples. She noted that there are some areas where it does not make sense to place original art, because of a lack of protection against theft or the unlikelihood that anyone will check that the art remains in good condition. However, corporate buyers have shown greater interest in giclees and canvas transfer prints than the poster-type offset lithographs: "I could sell giclees up the wazoo," Horton said. "In an increasingly technological world, the touch of the human hand is more and more valued, and anything that approximates that will be more sought after."

The purpose of creating the prints is to provide an artist with an additional (sometimes called "passive") source of income, and the multiples may also increase the number of potential collectors who become aware of the artist and eventually seek to purchase the original paintings. A problem may arise, however, if the prints seem so much like originals that buyers only opt for the less expensive multiples. Curtis Ripley, a Los Angeles painter whose originals (priced in the $2,000 range) and multiples (priced between $500 and $600 apiece) are sold through a nearby fine art publisher, noted that an increase in sales for his prints has come at the expense of his paintings. As a result, he now

believes that artists may need to have their originals and prints sold at different venues. "Iris prints have replaced one-of-a-kind things," he said. "It's a double-edged sword."

Artists who are considering creating prints must also decide whether they will make open or limited editions of images—open editions generally mean a lower price, while limiting edition involves research-ing the market and strictly obeying the print disclosure laws in effect in many states around the country. In addition, once artists decide to go into prints, they also need images to print from, requiring them to make high-quality photographic images of their originals. "I have slides of every painting I've ever made," said Linda Kyser Smith, an artist in Santa Fe, New Mexico, who is under contract with the El Segundo, California, print publisher Marco Fine Arts, "and they are all available to the publisher."

Various options are available to artists looking to create prints from their work. Among these are self-publishing and seeking a publisher, and there are benefits and drawbacks to each. Publishing one's own edition allows an artist maximum control over the quantity and qual-ity of the prints, as well as the marketing, promotion, and advertising of them, and it puts all profits in the wallet of the artist; however, it also entails considerable costs (production expenses, advertising, postage and shipping, mailing tubes for unframed prints and crating for framed ones, storage, market research, framing, and dealing with possible returns) and a lot of time attending to all these administrative tasks that take away from actual creating. Relying on a publisher removes the non-art jobs from the artist, yet it also means that the lion's share of profits go to the middleman–publisher rather than the artist and requires the artist to vigilantly watch over the publisher.

Publishers are distinguished from printers in that they may simply con-tract out the printing; however, they do take charge of distributing the prints to a network of galleries, as well as pay for advertising, promo-tion, shipping, framing, and other expenses. Some printers have mar-keting consultants on staff who advise self-publishing artists with basic information on what to do with the prints they are ordering. "When and how should you enter the print marketplace, and should you enter

the print marketplace at all, are three separate questions that I frequently find myself talking about with artists," said Sue Viders, the marketing consultant for Color-Q printers, which is based in Cincinnati, Ohio. "It can cost a lot of money to make an edition of prints, and it doesn't do the artist or Color-Q any good if the artist then can't sell them."

Sheila Wolk, a print consultant in New York City who works with Katherine T. Carter and Associates, an artists' career advisory agency, noted that "there are a lot of minuses to publishing yourself, unless you have guts of steel and big bucks," but some artists fit that description. The biggest bucks, however, are not generally spent on printing an edition but on shipping, and especially advertising, which also involves the additional expenses of four-color separation and (frequently) the services of a designer. "People don't contact the artist unless they see an ad," she said, and those advertisements may need to run a number of times before readers begin to remember the name of the artist and the look of the artwork. In addition, these ads should be placed in a number of different publications that one's targeted audience reads— all of which can add up to the tens of thousands of dollars.

All publishers are not alike, and ten artists represented by one publisher may sign ten very different contracts. Some, such as Somerset House Publishing in Houston, Texas, and Wild Apple in Woodstock, Vermont, limit their endeavors to producing and distributing print editions, although Somerset has a licensing division. Chalk and Vermilion Fine Arts, on the other hand, takes on the job of managing an artist's entire career, marketing and selling both multiples and originals. "I can't sell a doodle on a restaurant napkin without them giving me permission," Hallam said. He noted that the publisher also suggests particular subjects for him to paint and the particular mood that the picture should convey. "They have a better overview of the market than I have."

"We put a lot of effort into our artists," said Eric Dannemann, chief operating officer of Chalk and Vermilion. "We're the publicist, marketing arm, production arm, agent, salesman. The word 'publisher' sounds like we only make an edition of prints. The word should be 'manager.'" A number of publishers are moving in this all-encompassing direction.

Marco Fine Arts is somewhere in between Somerset and Chalk and Vermilion, since it publishes print editions of Linda Kyser Smith's paintings and also has contracted to purchase ten of her paintings every year ("at market value," she said) that are resold to the galleries carrying Marco prints. While these galleries also sell her originals, "the paintings are there to promote the prints," Smith said. A difference between Hallam's agreement with Chalk and Vermilion and Smith's contract with Marco is that Smith may sell her other paintings however she chooses, and she has arrangements with six other galleries.

Print publishers find the artists they sign to contracts in different ways. Most of Wild Apple's artists came to the company's attention through unsolicited submissions, according to Julia Brennan, the marketing manager, where a four- or five-member art development team evaluates slides, photographs, or e-mail submissions once a week or more. Chalk and Vermilion, on the other hand, "rarely signs" artists that the company has never heard of before, Dannemann said, preferring to recruit painters whose work they see by going to galleries or looking through art magazines: "We sign a new artist every one or two years."

There are various sources of information about distributors, suppliers, printers, framers, and publishers: The classified sections of art magazines generally include advertisements for these companies and occasional calls for submissions; the annually published *Artists' Market* (F&W Publications) contains detailed listings of companies; *Art Business News* (Advanstar) contains numerous advertisements by publishers and suppliers, as well as articles on trends and practices in the fine art publishing industry. Every year, *Art Business News* publishes its *Buyers Guide*, which contains reference information for the print publishing industry, and Advanstar hosts the five day-long Art Expo where artists, publishers, and suppliers rent booths and show their products.

Art Expo is the top of the line for fine art print shows, attracting much of the trade and thousands of fine art collectors. It is also one of the most expensive shows for exhibitors, costing thousands of dollars for a booth. For artists without considerable experience in producing and selling prints, and rather than spending thousands of

dollars to rent a booth, it may make more sense to do one of the following: Visit the show in person, admission is free to members of the art trade and $12 for other visitors, including artists; visit the show's Web site at *www.artexpos.com*, click on ArtExpo New York and then the Exhibitor List; or buy the Art Expo catalogue (only $30, and it contains one or more full-color displays by each of the show exhibitors, (888) 322-5226), or the *Buyers Guide* (available through the $65 subscription to *Art Business News*, One Park Avenue, New York, NY 10016). There are also numerous other arts fairs around the United States where artists can sell their originals and prints, and information on these may be found in a variety of art publications and at a variety of Web sites; see the listings in chapter 2.

Whereas Kerry Hallam entered the print world at Art Expo, Carl Hoffner of Fayetteville, New York, worked his way up during the 1980s and 1990s, installing a booth at between eighteen and twenty-four fairs and festivals per year (the booth fees averaged $250–$400) and using the remainder of his time to print, frame, mat, and ship his work as well as keep up with the paperwork of applying for admission to all these shows. "It's hard work to do these shows," he said. "It takes a lot of stamina to stand around talking to people and being friendly, listening to them, and seeming interested in what they have to say." Sales skills are rarely taught in art schools, and Hoffner learned by doing and by listening to audiotapes that describe how to sell to people while he is driving to one fair or another. After enough of these fairs, Hoffner became comfortable talking to strangers, learning how to be his own advocate while responding to collectors' questions. "They're all looking for something for their homes. You simply have to identify what their needs are and satisfy them."

By the mid-1990s, Hoffner decided to concentrate on the high-end shows, such as the annual Art Expo in New York City. "I worked for a year and a half to make the work for the 1995 New York Art Expo," he said, producing eighteen editions of 110 prints each. "The cost of doing that show and the cost of printing the work for the show came to $50,000. It's like betting your house: The 10′ × 10′ booth was $4,000 alone, and then there's the hotel and food costs, but the years of doing the festivals had taught me to have confidence and to invest

in myself." The show turned out to be a positive experience, as Hoffner sold almost 60 percent of his work from his booth. By the end of 1995, he had sold 90 percent of his work. In subsequent years, he said, he has done "even better."

Remarques

When a new print edition, based on one of his historical battlefield paintings, is released, Don Troiani gets really busy. Depending upon the size of the edition—sometimes, there are as many as 1,000 prints—he will spend the better part of a week making small pencil sketches on the margins of some number of the prints, "to personalize the work." These sketches, often called "remarques" or embellishments, are sometimes his idea or they may be requested specifically by a collector, such as the Southerner who wanted a drawing of a dead Union soldier even though the print image itself did not show any war dead. These sketches, noted Troiani, who lives in Southbury, Connecticut, "are not my favorite thing to do, I'd prefer to work on new paintings," but $350 extra for a fifteen-minute drawing exercise seems too good to pass up.

Collectors have been a driving force in prompting artists to create remarques on their reproduction prints, seeing these works as more valuable, because they are no longer just mechanical creations but reveal the actual hand of the artist, and artists usually are happy to oblige, as their brief work on the margins doubles a print's price. It all seems so win–win. The reality is a bit more complicated.

Certainly, a remarque increases a print's price, but it is less easy to assess the long-term value, because no printer, print publisher, or gallery association has ever documented the secondary or resale market for reproduction prints. (These works never appear to come up at auction, so there are no published prices.)

Paying Artists in Proofs?

A longtime fixed structure of the art world has been that artists' proofs should be no more than 10 percent of the size of the edition. So what does one make, then, of the thirty artists' proofs supplied in 1996 to

artist Gerhard Richter by Edition Schellman in New York City for an edition of only 60 prints? What's more, the artists' proofs were his entire payment—there would be no royalties on Schellman's sales. Unusual perhaps, but the relationship between artists and print publishers has become far less fixed, more "everything's negotiable."

"There are no rules written in stone," said New York City dealer and print publisher Diane Villani. "It's whatever makes the artist and the publisher happy." Sometimes, she noted, it makes artists happy to simply divide the print edition with her, both sides going off to sell works, rather than paying artists a percentage of the sales she arranges. "Some artists don't want to be involved for years, keeping up with all the bookkeeping and waiting for works to sell. They're happy to take a portion of the prints and go away."

At other times, Villani will be responsible for all sales, although she will negotiate whether to pay a percentage of the sales (at wholesale prices if sold to other dealers, retail prices if sold directly to collectors) to the artists from the very first sale or after she has recouped her costs as publisher. The percentage to the artist is likely to be higher if he waits until her costs are recovered.

Percentages may range widely, depending also on the stature of the artist, the size of the print edition, the cost and complexity of producing the prints, expense of promoting and marketing the works, and the prices at which the prints will be sold. The Long Island, New York–based Universal Limited Art Editions pays artists between 30 and 50 percent of the net sales from the very first works sold, while Pace Editions in Manhattan establishes royalty arrangements starting at 20 percent and going as high as 70 percent, all contracted individually. At times, Arion Press in San Francisco sets up "partnerships" with artists, whereby the artists pay for the costs of printing an edition that the Press will then market and sell; in that case, artists receive more than the 50-percent royalty that they would otherwise be paid if Arion was responsible for the printing.

There are a number of reasons for the more open-ended relationships between artists and print publishers. In part, it reflects changes

in what publishers are willing to do. Traditionally, a publisher initiates a project with an artist, pays for printing, marketing, and sales, awarding the artist an agreed-upon percentage of the sales. The high cost of some editions and the over saturation of the print market in the 1980s and 1990s have led some publishers to pull back on their initial outlays, lowering their royalty payments to artists, paying only after the publishers have recouped their expenses (Judith Solodnik, director of the New York City print publisher Solo Impressions, Inc., referred to this plan as "profit-sharing"), seeking a financial contribution by the artists and paying in actual works rather than with cash. Crown Point Press, a publisher in San Francisco, no longer prints all of an edition at one time as a cost-cutting move. In addition, "we try to keep our inventory down, because that affects the amount of taxes you pay," Cathan Brown, Crown Point's director, said. Print buyers, however, will still be sold the works with numbering based on the full edition size. Brown noted that the fact that the edition is not yet complete will be disclosed: "Collectors have to assume that we will print the rest."

Paying artists in prints—artists' proofs or a percentage of the actual edition—also benefits publishers, because it is the lowest cost way of compensating them; paying in prints takes an operating cost off the publishers' books, and the artists will have to do more work—distributing and selling the prints—in order to be financially compensated. "If you're going to sell the works yourself anyway, why go to a publisher in the first place?" said Joshua Kaufman, an attorney in Washington, D.C. "If you know how to sell and have a ready market, you might as well just self-publish." He added that "most artists can't or don't want to sell," and being paid in prints doesn't work to their advantage.

Some artists, however, may benefit from payment in kind. They "may have a lot of assistants working for them whose main job is to sell work," said John Szoke, a print publisher and dealer in New York. Other artists regularly work with a variety of galleries in the United States and elsewhere, and they will consign the prints to locations where they already have collectors. Cathan Brown noted that European artists prefer to take prints back to their own countries rather than "pay income taxes on sales in the United States" that Crown Point Press has generated.

156

Other dealers and print publishers dispute the idea that artists are put at a disadvantage when they are paid in works, claiming that prices for prints are often raised as the edition begins to sell out. Holding on to the actual works, artists are able to realize, in the words of one dealer, "the increased value over time in its entirety."

The key may be holding on to the works. Publishers, of course, do not want to find themselves in competition with artists in the selling of works from a print edition, or the accompanying artists' proofs. The contracts that artists and publishers sign usually stipulate that the artists will not offer works for sale until all or most of the publishers' stock is gone, that the prices offered by the artists are at least 80 percent of the publishers' retail value, and that the artists may only sell in different markets or geographical areas than publishers (Europe and not North America, for instance). These agreements also frequently state that the artists have the right to purchase prints from the publisher at a favorable wholesale price.

The number of artists' proofs created is yet another area of negotiation. While many artists offer their artists' proofs to friends as gifts or donate them to charity auctions—the artist Christo orders scores of artists' proofs of his lithographs, which are later given to the myriad of people (engineers, lawyers, photographers, and other assistants) involved in his giant projects—others seek a large quantity to sell. These proofs, which may not be as clean and precise as the works in the final edition, are prized by collectors for being closer to the artist's hand, revealing aspects of the artistic process. "Most of our artists' proofs are between five and fifteen in number," said Bill Goldston, president of Universal Limited Art Editions, "but if an artist says he wants twenty-five, that's OK. We'll do twenty-five."

The market for proofs has led to a wide range of proofs that may be sold to the public, also including printers' proofs (they get several as a gratuity), publishers' proofs (usually, half of the total number of artists' proofs), presentation proofs (usually given to institutions), B.A.T.s (bon-a-tirer, or final working proofs), and *hors de commerce* (not-for-sale proofs, which sometimes are put up for sale anyway). Noting that "prints are often used as a cash cow nowadays," Goldston said that

many proofs are made during the process of creating an edition, "and nobody likes to throw away a proof."

Tourist and Second Home Art

"All politics is local," the old politican said, and perhaps all art is, too. Walter Gonske of Taos, New Mexico, found that out when he placed his paintings of the American Southwest in galleries in California and Hilton Head Island, South Carolina. There were no sales. After six months, the gallery in Hilton Head Island, a resort vacation destination, recommended that Gonske "come on out and paint some scenes there." Eventually, a few of his paintings that he had painted of the coast of California and included palm trees and commercial fishing boats, "which could be from the area," sold in Hilton Head, "but no adobes." All of this led him to the conclusion that "works sell best if they're of the area where the gallery is. Paintings of New Mexico and Colorado sell in New Mexico and Colorado."

Fortunately, they sell very well in Santa Fe, New Mexico, and Vail, Colorado, where tourists flock and the well-to-do buy second homes. When the out-of-towners come, they often buy art that will remind them of where they have been. Gonske creates approximately 100 paintings per year—half scenes of Santa Fe in the summer and the other half Vail in the winter—and sells the majority of them. "I'm not free to just paint at my own pace," he said. "I prefer working on large canvases, and I can just get lost in my work and forget the time, but then one of my dealers calls, wanting a certain number of paintings by a certain date, so I have to drop everything to paint a bunch of smaller works for him."

Vacationers and second-home owners are a major source of collecting for a great many artists who paint or sculpt regional scenes. Often too busy during the rest of the year, the out-of-towners devote a day or two to shopping (in many instances, it is the last day of the vacation), leisurely visiting stores and art or antiques galleries, feeling freer with their money than they might back home. "They have more time to do things that they don't allow themselves to do in their own cities," said Arthur Rogers, a gallery owner in New Orleans, 60 percent of whose buyers are from out of state. Looking at art is something that perhaps

they were too busy to do back home, but now they have the time. "When you're on a holiday, you'll break your rules a little bit. Buying art is one more fun thing to do that they might not do otherwise."

In addition, husbands and wives on vacation shop together a rarity the rest of the year—which allows them to purchase artwork more quickly, because the one doesn't need to check with the other before buying. Sometimes, there is a helping hand in the process of generating art sales of out-of-towners. The San Francisco Chamber of Commerce, for instance, sets up gallery tours for spouses of convention goers, busing in people to the gallery-rich Union Square district. "People find it pleasant to shop when they're on vacation," said Leah Edwards, marketing director of HANG galleries, half of whose sales are made to tourists and those in town at a convention. "They're not on a schedule."

There is no one style of art, or one subject matter, that is bought by vacationers and second-home owners, but the predominant realm of sales is realism that clearly conveys a sense of a particular place, or corresponds with the collector's feelings about the place. Shirley Rabe Masinter's (of Covington, Louisiana) paintings of old cemeteries and once-grand neighborhoods in New Orleans "have an old world feeling; they seem very exotic to people from Ohio," while Alan Flattman's (of Madisonville, Louisiana) paintings of the bars and restaurants in New Orleans' tourist-drawing French Quarter are "popular, because the particular places are popular." On the other hand, Ed Dwight, a sculptor in Denver, Colorado, whose work features noted jazz musicians through a negative and positive space mix of head, horn, and hands, is also popular among New Orleans visitors who associate the city with its musical legacy "People go to New Orleans to be transported," he said. "They get enthusiastic, drink some of that crazy juice down there, and want to bring something home with them that reflects their experience. Buying my work is an extension of their trip."

"My buyers want something that says Cape Cod," said Sue Carstenson, owner of Birdsie-on-the-Cape, a gallery in Osterville, Massachusetts, that sells three quarters of its artwork to second-home owners or their guests. "They don't want scenes of Venice." Tight

realism tends to be the most favored style of painting, but some buyers prefer whimsical work that is done in a primitive or naïve style. "They've bought this house in order to have fun, and they want fun art in it." It may be the fate of realist art to be viewed almost exclusively in terms of subject matter rather than its formal or plastic qualities. For a show at the museum of Bowdoin College, the curator stipulated "all paintings should be of Maine." He believed that this "is more interesting to the people in Maine and that people are more attracted to what they are familiar with."

Second-home art is taken less seriously than what they might purchase for their primary residence, Carstenson noted, and "there is a price point of $5,000 at the top end. No one is going to buy $25,000 art for a summer home." She keeps close tabs on her buyers and frequently passes on information on what does and doesn't sell to the artists whose work she represents. "Sue tells me that people don't like orange-y sunsets," said Neil McAuliffe of Centerville, a year-round Cape Cod resident and the gallery's top selling artist. "She also tells me not to do things that are yellow-y, because people can't match it with their decor. The main colors should be pink, green, and blue—hydrangeas, water, and sky." "Blue and rose are colors that always sell," Carstenson said. "Put in the beach roses, it'll go; put in the hydrangeas, it'll go."

Success in reaching and selling to a particular market, however, also has the potential of placing artists in a bind: Selling principally to nonresidents, they often do not receive direct feedback on their work from collectors and only find out what sells from dealers—those dealers may only want more of the same rather than an evolving artistic vision; they probably do not want to paint the same image— or variations on it—again and again, but low prices require them to be prolific, working from a formula; they also don't wish to lose sales and incur the wrath of a gallery owner by finding different subjects. McAuliffe, for instance, traveled up to Acadia National Park in Maine, where he painted a number of scenes, but Sue Carstenson's response to those works was a clipped "Don't you bring me paintings of Acadia National Park. That's for galleries in Acadia to sell," the artist recalled her saying. McAuliffe looks forward, he noted, "to branching out, but right now I'm just doing what people want."

Working Small

In the art world, as in other arenas, size matters. Some artists prefer to work small, but their dealers tell them that large is priced higher and is taken more seriously by critics, collectors, and curators. Other artists choose to work on a larger scale, but their dealers inform them that few collectors have room in their homes for such big stuff and that they need to make art that is more affordable and portable. Quite often, art is judged by non-art criteria.

There are many reasons that artists create works in different sizes or, perhaps more pertinent, make small pieces when they are best known for larger ones. William Beckman, a painter in Millford, New York, may "spend months on one big painting, but I can do a small one in a day." During that day, he may go outside to paint a landscape; a large canvas is apt to be blown about by the wind, so by necessity he must limit the size to under two or three feet. "If you're carrying it around outside, it also has to be able to fit under your arm," he noted.

Working smaller also affects his attitude toward the work. "I don't ponder every brushstroke, so I feel freer when I'm painting." Changing his technique allows Beckman to experiment, and the results eventually may wind up on a larger painting, or maybe not. "I don't think of my small paintings as seriously. They're expendable; I call them 'throw-away paintings,' because it doesn't matter so much if they don't work." Works that he produces in his studio—and he only creates three large paintings per year, on the average—"I think of more as commodities. They're more expensive, and they have to be right."

Other artists also note that smaller works feel different than larger ones and "allow a lot more freedom to make mistakes, and also some happy accidents that lead to exciting new developments," according to Burlington, Vermont, painter Peter Arvidson. For Scott Prior, a painter in Northampton, Massachusetts, his method doesn't change when moving from big to small, but he "may try out different subject matter" that will be expanded at some other time on a larger canvas. In that regard, the small painting could be seen as a preliminary artwork, except that there hadn't been a larger one in mind when he started.

Completing one large work and then moving on to the next large work can make art seem like an endless chore. "Big paintings are hard work," Prior said. "They're a leap of faith when you're beginning, because you look at the canvas and see days and days of work ahead, and you have to hope that it all comes out alright. After I have finished one and step back to look at it, I'm impressed that I have accomplished this thing, but I need a break before I begin the next one." With a small painting, "I can finish it in a day and think, 'Hey, I can take tomorrow off.' "

What smaller works may lack in finish they perhaps make up in a level of intimacy, both for the viewer and the artist. One generally backs up to take in a larger work of art, limiting the ability to see all at one time what the image is and how the artist created it. There is none of that with smaller works, which usually are viewed at arm's length. It is not always the case that smaller works take less time than larger ones (although "most galleries price works by size, which means that smaller is always less valuable, which is really unfair," Beckman said) or that artists change their techniques based on scale. More often, the subject may be simplified—fewer figures in a painting, for instance, or a head instead of a full body—but the small scale requires the artist to focus more intently.

"There is something magical about a small work," said New York City painter Jacob Collins. "It seems very modest, because it's so small but guilefully announces itself the more you look at it. Big paintings are never really modest. They announce themselves immediately as big paintings."

Big artworks also announce an artist's career, while smaller pieces simply let people know that something is for sale. Very few artists are known for their diminutive pieces, regardless of how much larger a percentage of them may be sold than more floor-to-ceiling works. In fact, giantism has taken out whole segments of the contemporary art world: Big really seems to be better. "Typically, I recommend that my artists work larger," said Manhattan art dealer Kathryn Markel. "My clients have large walls, and they won't be able to see a work if it's only 20-by-20 inches." The fact that larger works cost more than smaller ones is another reason that dealers press artists to work on a

larger scale. Sarah Hatch, a painter in Decatur, Georgia, was told by her New York City art dealer, the late Monique Goldstrom, that "it wastes her time having to deal with smaller pieces, she can do the same amount of work to sell a larger pieces."

For many dealers, in fact, it takes more time to sell smaller and less expensive works than larger ones. San Francisco art dealer John Pence noted that "when people want a big work, they can afford it. There's no scraping of pennies and thinking of what they might have to give up. With smaller works, the client is often not so wealthy and will have to think long and hard whether or not he or she can really afford it." With gallery rents reaching tens of thousands of dollars per month in a number of major cities (Pence's gallery costs $50,000 per month to run), artists would need to produce a lot of work and dealers would be required to sell them in significant quantities when the individual pieces are small and modestly priced.

Large, sprawling artworks—huge canvases, monumental sculptures, room-sized installations—sometimes provide an inaccurate impression of an artist's actual body of work. Far more of Mark di Suvero's tabletop (28″ × 16″) and medium-sized (from 4 to 10 feet in height) sculptures sell in any given year than the larger outdoor works that are assembled with cranes and for which he is better known. In fact, di Suvero told one of his studio assistants, Zachary Coffin—who lives in Atlanta and is a full-time sculptor in his own right—that "the key to keeping everything flowing is to have small works to sell." Coffin has also gained a reputation for his massive public art pieces, weighing up to ninety tons and costing $200,000, but he, like di Suvero, additionally produces smaller works of only thirty-five to forty pounds that cost $5,000 to $25,000. Dealer prodding pushed him in that direction. "Gallery owners have told me, 'People love your work, but we can't move it,'" Coffin said. "'Collectors want the work in their houses; our customers don't own sculpture parks.'"

At times, however, galleries may seek smaller works by an artist, or at least a balance of small and large, to give potential buyers a choice. Smaller and less expensive pieces provide a safe entry point for new collectors and those who are being introduced to an artist's work for

the first time. "Smaller works are easier to sell, ship, and store," said Julie Baker, an art dealer in Grass Valley, California. She noted that one of the artists represented by her gallery, the San Francisco painter Nellie King, is known for her 8′ × 8′ paintings, whose average sale price is $6,000, but "I've specifically asked her for smaller pieces." King has brought in both "painting strips" that measure 9″ × 8′ and 12″ × 12″ paintings that are priced at $600. Those have sold well, Baker said, to both budget-conscious collectors and others who "don't have to worry where an eight-by-eight foot painting is going to go. People love her work, but many don't want to spend $6,000. They get the flavor without making a huge commitment."

This area of the art market has been accorded its own forum with the AAF (Affordable Art Fair) Contemporary Art Fair, which takes place annually in New York City in late October and features art priced under $5,000. Almost every two-dimensional piece in the fair could be carried out under the arms of the buyers. Approximately 13,000 visitors came to the 2003 fair, making 2,500 purchases whose average price was $1,300. According to the organization that sponsors the fair, half of the buyers were new to the galleries that had set up exhibition booths; most of them were also new to art collecting. Lower priced artwork doesn't need its own event for dealers to have pieces on hand, however. "It's nice to have things that sell for $200 or $300," Kathryn Markel said. "Gifty, present-y things."

Collectors may not be the only reason that a dealer suggests the artist create smaller pieces. "We can't show paintings that are bigger than six-by-nine-feet," one New York City gallery owner stated. "Larger than that, the painting won't fit through our front door or in the elevator. With sculpture, too, there is a storage problem, especially for very large works."

part

2

Starting an Art Business

chapter

Practical (and, Perhaps, Ethical) Considerations

As any experienced artist knows, no one becomes rich and famous simply by creating superlative art. The artwork has to be put out into the world for people to see, and this requires the artist to gain expertise in marketing (finding the proper audience), promotion (creating press releases and brochures), and sales (developing relationships with prospective buyers).

Photographing Art

The artist also may need to become an expert in photography, since the first introduction to one's art for many of the art world's middlemen (critics, curators, dealers, art show jurors) is through photographic images. Their first impression of someone's artwork may be formed while holding a slide up to a light bulb (perhaps on a light box or through a projector onto a screen) or, if the image has been digitized, on a computer screen. A great work of art, if not photographed well, might be rejected as second-rate. "A poor slide tilts in favor of declining the work, if there are any questions," said Frank Webb, a painter in Pittsburgh, Pennsylvania, who has frequently served as juror in many art competitions.

There are myriad problems in badly photographed slides: the artwork is crooked, colors are off, glare from too much light or shadows that obscure portions of the piece, background distraction, the whole thing is out of focus. These problems are not always apparent to the

artist, who "lives with his work in his head" and may not see it as objectively as a professional photographer, according to Edouard Duval Carrie, a painter in Miami. "An artist and a photographer may have very different concepts of what the work looks like. A professional photographer only sees the work through the camera viewfinder, and he photographs just what he sees, not how he imagines the work looks like. I may like the fact that one part is more lighted than another, but it looks terrible when it is reproduced."

Carrie had shot his own slides in the past, but his Miami dealer, Bernice Steinbaum, told him that he had to hire a photographer in order to create better images to send out to the press or to show collectors. The artist agreed and now only photographs his work for his own archives. "I don't have all the equipment to take photographs properly. I'm usually too rushed or too rattled to do it the right way."

There are three main ways in which artwork is photographed: The artist does it; the artist hires a photographer; or, the artist's dealer hires the photographer. Painter Jack Beal's New York City dealer, George Adams, arranges for someone to photograph the artist's work—he does that for most of the artists represented by the gallery—bearing the expense himself. ("I don't have the equipment, I don't have the know-how, I don't have the time or interest," Beal noted.) Bernice Steinbaum, on the other hand, often brings a photographer into the gallery to shoot images of the artworks on the walls, passing on the cost to the artists. "Artists under contract to the gallery are obligated to provide two transparencies for every work," she said.

There is no association of photographers of artwork, but many are listed in the Yellow Pages or, through a search engine, on the Web. Word-of-mouth references also leads artists to photographers, and some hunt up a photographer whose work they have seen in a catalogue or book (through the publisher, for instance). The costs for this service range widely, depending upon the size of the artwork, the number of pieces to be photographed, the number of exposures of each work and whether the photographer will shoot the artwork in the artist's studio or if the art needs to be transported to the photographer's own studio. Some photographers set their rates by the

hour—Peter Shefler of Gibsonia, Pennsylvania, for instance, charges $70 for the first hour and $60 per hour after that—while others charge per image. "It costs us between $47 and $100 per image to hire a photographer," said Patrick Weathers, director of Bryant Galleries in New Orleans, Louisiana, (the artist is likely to reimburse the gallery for the full amount, unless the gallery wants to reproduce the image for a catalogue or print).

Hiring a photographer has its drawbacks. Carrie spends hundreds of dollars for each photo session, and "it's a hassle to get a photographer to come when I want him," he noted. "I don't like to wait around." Still, the results now are uniform and good. In addition, photographing his own artwork "wastes my time and materials. I'm not really saving money doing it myself."

The art of photographing art can be a time-consuming and expensive pursuit, and it may also take up a fair amount of space in one's studio or home. Many artists who regularly photograph their own work dedicate some area solely for this purpose—Frank Webb, for instance, uses a third-floor room in his house exclusively for shoots—for a good reason: The setting up of a photographic shoot tends to take the most time; once lights, background, camera, and tripod are in place, different works may require only small adjustments in the equipment before they are photographed. (That is why, unless an artist works in a variety of media and at vastly different sizes, paying by the hour is often a better deal than per image.) It makes sense, therefore, to keep the photo studio permanently set up, rather than clearing out a portion of a room again and again, arranging afresh all the equipment for a shoot.

There are certain (almost) universally recommended rules of photographing a work of art. For two-dimensional pieces, the camera lens should be placed parallel to the work (in order to reduce distortion and blurriness), aimed at the center of the piece, and the alignment should be checked by a small level on both the camera and the artwork. When looking into the camera, the artwork should fill the viewfinder, eliminating extraneous material, such as the wall of a living room where it was hung or the easel on which it was

photographed. Usually, the artwork is flat to a wall: wire-hung works often lean forward slightly, but a shim between the bottom and the wall can compensate for this; if the work is in a frame, screws may attach the entire piece to the wall, and works on paper may be tacked. A somewhat different approach is taken by watercolor artist Tony van Hasselt of East Bay, Maine, who places his painting on the floor, attaching his camera to a shelf and pointing it downwards. "I like to shoot the picture as soon as I'm done," he stated, noting that "I don't want to wait until the next day, because I lose the mood." He added that "if I hung up the painting, the watercolors might drip." Laying the artwork flat on the ground solves the dilemma.

Whenever possible, protective glass should be removed from in front of the artwork, because it reflects natural or artificial light as a form of glare; mats and frames also should be removed, because they add a rim of shadow around the artwork and may present a distraction. Because duplicates, or second-generation, slides are often not as clear as the originals, artists often take between three and six frames of the same artwork; some also take close-ups as details.

Photographing artwork requires a 35 mm camera that is "fully manual," allowing one to control the shutter speed and lens aperture (the f-stop), with a 50 mm lens or larger. One may only get as close as 2 or 3 feet away from the artwork with a standard 50 mm lens, which may create difficulties if the object is quite small or only a detail of the work is to be photographed. Lenses up to 85 mm or 105 mm may be helpful, as they compress distances and do not distort objects near the camera (as a wide-angle lens may), or one may use a 50 mm lens equipped with a "macro" or "micro" (the term differs with the manufacturer), which will allow a small object to fill the camera viewfinder or frame. A tripod upon which to place the camera is also valuable, in order that no small movements in one's hand (while holding the camera) affects the image; similarly, a cable release permits one to take the photograph without the possibility of jarring the camera while pressing the shutter release button. The variety of available films is wide: Slide films are all called "-chromes" (Ektachrome, Fujichrome, Kodachrome), and one usually purchases a slow speed (50 or 100) to allow for greater color saturation and sharpness of detail.

The quality of the mega pixel images produced by digital cameras has been sharply improving, and "macro" elements are usually built into the basic 50 mm lens. A clear benefit to using a digital camera is that an artist may examine the photographed image immediately, rather than wait for days until the photographic prints or slides come back from the developer. (Slides themselves are only of limited value to artists, few of whom are likely to own a projector and so see what their image actually would look like to a show juror.) Digital files may also be converted into slides by film processors, usually costing $1 per image.

The list of possible accoutrements goes on: When shooting indoors, one needs at least two lamps designed for flash (strobe) or incandescent (tungsten or halogen) bulbs, placed at 45 degree angles from the piece and aimed at the center of the artwork. Bulbs need to be treated very gingerly—handle them only with a clean rag or cotton gloves, since the oils from one's skin may cause the bulb to heat unevenly—and one also better work quickly. These bulbs have a life span of six or eight hours of use, and the spectrum of light they produce diminishes as they near the end of their life. Because artificial light may create glare, polarizing screens or filters for the lens can be necessary. All natural light should be eliminated from the room so that the setup is the only light source, requiring curtains over any windows. Even better is shooting at night.

While cameras contain their own built-in light meters, measuring reflected light (light bouncing off the object being photographed), a separate handheld light meter placed next to the artwork determines the relative brightness of the light shining on the piece, or incident light. A Kodak product called a "gray card," which will reveal the average mix of light, shadow, and color on the artwork, should be held up to a corner of the piece, and the camera's light meter set to the reading on the card. For background, one can purchase a roll of plain photographic paper (available at most photographic supply stores) or black velvet (sold at fabric stores), which eliminates any distractions and absorbs light.

"It's definitely more expensive to take photographs indoors," said Robert Burridge, a painter in Arroyo Grande, California, who generally places

his artwork outside in direct sunlight when taking a picture. He places a painting onto black velvet glued to a board, angling the board 45 degrees from the sun, making slight adjustments in that positioning if there is too much glare.

The cost of equipment is not the only factor involved in determining whether to photograph artwork indoors or outside. "Sunlight is the perfect color temperature to use with film," said Chris Maher, a professional photographer (of artwork), craftsperson, and artist Web site designer in Lambertville, Michigan. However, he noted, "variability is the problem, because the light is changing all the time. You may find that it is impossible to repeat what you have done." Where an artist lives may also affect the ability to take photographs of their work outdoors on a regular basis. Southern California has a lot of sunny days, while the northwest is often overcast and rainy. Wintertime snow on the ground would likely reflect a considerable amount of light onto the artwork, creating the problem of glare. As a result, some artists set up photo studios inside where they work for the times that they cannot take pictures outside.

Artists may simply need to find out what works best for them: Some prefer the more diffused sunlight at 10:00 in the morning or 4:00 in the afternoon, shooting in direct light or in the shade, while others become frustrated that outdoor light is naturally filtered differently at different times of the day—there is more blue in the morning and red in the evening. Alexandria, Virginia, painter Nancy McIntyre takes photographs of her work at mid-day on her patio, but only when there is "a little bit of sun and haziness. Overcast with light sun works perfectly with me." (Made-to-order climate conditions is not easy to come by but, perhaps, Alexandria has a lot of that type of weather.) Some artists report that slightly underexposing their photographs creates more saturated colors, while others prefer a faster shutter speed.

"Artists need to try things out to see what works for them," Maher said. "The difference between an amateur and a professional photographer is that a professional makes tests, while an amateur will just assume that everything will work out the first time."

Are Artists Responsible for Their Art?

Art is long and life is short, according to the old Roman saying, but sometimes art doesn't hold up its end of the bargain. The canvas warps, the metal bends, the paper turns brown: New artworks may look like old works in a short period of time, leaving their buyers perhaps feeling as though they have been had. One such collector brought back to New York City gallery owner Martina Hamilton a painting she had purchased there by the Norwegian artist Odd Nerdrum that looked as though the "painting was falling off the canvas," Hamilton said.

Art doesn't come with warranties, and state consumer protection statutes only cover utilitarian objects, such as automobiles and toasters, rather than art, which is sold "as is" by galleries or directly from artists. Still, dealers hope to maintain the good will of their customers, and artists don't want to develop a reputation for shoddy work. It is not fully clear, however, what responsibility artists bear to their completed work, especially after it has been sold. It is particularly the case for artists who purposefully use ephemeral materials in their art (bee pollen, banana peels, lard, leaves, mud, moss, and newspaper clippings, to name just a few examples)—isn't it the buyers' responsibility to know what they are getting?

Nerdrum, who is known for formulating his own paints (and constructing his own frames), was contacted by Hamilton about the deteriorating painting, and he directed the dealer to offer the buyer her choice of other works by him at the gallery in the same price range. The collector, however, didn't want any other Nerdrum painting in the gallery, so the artist rehired the same model he had used originally and painted the entire image anew. The entire process took a year to resolve.

Nerdrum is not the only artist who will try to make amends for work he or she created that doesn't hold up, although few others have gone to such lengths. Many others simply look to do restoration work. Painter Susan Norrie, who is represented by New York's Nancy Hoffman Gallery, was "absolutely willing to restore the piece," gallery director Sique Spence noted, after wide cracks appeared in the work,

173

the result of incompatible drying times of the paint layers. All was not totally well with the collector, Spence said, as some buyers view a restored painting as having a "stigma." As a result, the gallery offered the buyer a credit for any comparably priced work in the gallery by any artist. When Norrie finishes her restoration, the gallery will own the painting and not ask the artist for its money back. "The artist bears some responsibility to his or her art," Spence said, "but we bear more responsibility to the client."

If they are alive and physically able, should artists be counted on to repair damage—caused by their own workmanship or a collector's mishandling—or is the job of creation and that of conservation so disparate that no one person should attempt both? Artists look to correct problems, such as repainting a section of a canvas, whereas conservators aim to slow the process of deterioration, repairing holes, filling in cracks, but not using any materials that could not be completely removed by another conservator. It is more often the case that collectors will take damaged artworks to a conservator, perhaps directed to someone by the dealer from whom they purchased the piece, and the conservator may or may not contact the artist. "I always contact the artists," said independent conservator Len Potoff. "I ask them if they want to be involved in conserving the work, what they would recommend I do, what they think about my plans for conserving the piece, and also their feelings about the work—what were their intentions when they created it." He likes to know what artists did and how they did it, "but I may not follow their formula. I don't want to recreate the problem that caused the work to deteriorate."

Some artists, however, welcome and solicit the conservation role. Long Island City, New York, artist Tobi Kahn stated that he wants to maintain an ongoing relationship with his work, even pieces from twenty or more years earlier, "and I tell my collectors, 'If there is any problem with the work, bring it to me and I'll be your restorer.' I want the painting to look exactly as it did when it was first painted." He added he sees how many paint layers he had done and "will recreate that exactly. When someone brings me an older painting that needs repairs, I'm not Tobi Kahn the painter, I'm Tobi Kahn the restorer."

An artist's sense of obligation to his or her work sometimes may be time-limited, contractually at times—public art commissions usually contain a clause in the agreement stipulating the artist's responsibility for "patent or latent defects in workmanship" for between one and three years—or based on evolutionary changes in the artist's life and work. Artist Frank Stella said that he may be willing to help repair one of his works if "it's not more than two or three years old." He uses different materials for specific works and, "after two or three years, I don't have any of the materials left over. I don't have the expertise to deal with it; if I were to attempt a repair, I'd make a mess of it."

Stella refused to take part in the restoration of a twenty-five-year-old sculptural painting that had been brought in for repairs to Len Potoff, who had contacted the artist as a matter of practice. "He said that he couldn't do it," the conservator said. "He's not where he was twenty-five years ago, and he couldn't put himself in that zone. At the time, I was really pissed, but now I find that point of view commendable."

Potoff stated that his change of mind was a result of seeing artists take their work from decades earlier and make brand-new pictures out of them. "Artists evolve over time," he said. "What they were thinking about, how they handle a brush, how they mix a specific color changes over time. There is one artist I can think of who took a 1950s painting, which was historically important and artistically great, and made a 2000-something painting out of it. The picture was altered for the worse and looks like a reproduction." That is a matter of personal opinion and taste, of course, but extensive reworking raises the question of veracity, if it is still dated from the 1950s. Tobi Kahn noted that when his restoration work is extensive, he has considered redating a painting something like 1983–2004 in order to make clear his ongoing involvement. (The approach, however, suggests that he worked on it for twenty years, not that it ever needed to be repaired.)

An example of this issue from the field of photography occurred after New York's Museum of Modern Art in 1996 purchased the complete set of Cindy Sherman's 1979–1980 untitled film stills, some of which

had been processed carelessly (resulting in severe color shifts and fading). "When people bring in an early work that's technically all wrong—it's turned silver or something—we print out another one," said Janelle Reiring, director of Sherman's gallery, Metro Pictures. For the Museum of Modern Art, Sherman herself had a photo lab reprint from negatives the entire set on better quality paper and with more conscientious processing. While the newer prints may look better, the older ones are considered "vintage" and worth more.

The question of which artwork expresses the original inspiration becomes even more poignant in the art world category of digital art and new media, in which operating systems and programs are bound to change. "We tell artists that works must be upgradeable, compatible with newer technology," said Tamas Banovich, co-owner of Manhattan art gallery Postmasters. New media, which is viewed as anti-object, suddenly becomes very material when seen as updatable hardware and software.

Artists are not chemists and may not be knowledgeable about the chemical properties of the materials with which they are experimenting. Nowadays, they are unlikely to learn anything about mixing their own paints, or even what is inside a tube of paint, in art school. Still, many artists will experiment with their materials to the potential detriment of their work's ultimate longevity. A large number of Andrew Wyeth's paintings developed considerable flaking, for instance, because the artist made mistakes mixing gesso and egg tempera. There have also been many problems with paintings by Willem de Kooning because of the artist's mixing of safflower oil and other materials with his paints. De Kooning wanted to make his medium buttery and sensuous, but that combination made it difficult for the paint layers to dry.

In addition, many artists do not see themselves as creating works for posterity, which is more a concern of the marketplace than the studio. The work reflects the moment of experiment and creation. Mexican muralist David Alfaro Siquieros and French cubist Fernand Leger both painted on burlap sacks. Chagall made designs on bed sheets, and Franz Kline, chronically short on cash, used house paints

and occasionally worked on cardboard. Their intention was to achieve different textures without regard, it seems safe to say, for future conservators and collectors. Robert Rauschenberg is one who "didn't take any particular pains with a lot of his earlier pieces. He just stuck things on with glue," his biographer, Calvin Tomkins, said. "At that time, he felt that the work itself is ephemeral, and that it's the process that is important. I don't think he feels that way now. He has a lot of people working for him now who make sure things are put together right." Among the more problematic Rauschenberg pieces are a silkscreen painting called *Sky Way* (created originally for the 1964 World's Fair and currently in the Dallas Fine Arts Museum) whose screening has flaked off, and the stuffed goat in the inner tube called *Monogram*—probably his most famous piece—which has attracted (among other things) lice.

Experimental use of materials and haphazard techniques tend to be the province of younger artists; eventually, those with longer careers look for more stable processes of art making. "It is not very pleasant to always be confronted with clients coming back with artworks needing repairs," said conservator Christian Scheidemann. He noted that part of his work on contemporary art involves visiting artists' studios to learn how they have worked and to "consult with the artist to improve his technique, if he is interested."

Framing and Matting Artwork

The subject of framing works of art—whether or not to frame, what kind of frame to use, how much to spend on frames, and who pays for them—occupies a lot of time for art dealers and even more for artists. As a financial fact, they are a significant element of overhead, yet there is no denying that frames serve a variety of purposes: They protect works of art from light bumps; they distinguish art from everything else around it; they make the work appear complete and help collectors imagine how the art will look in their homes. It is rare to see a drawing, print, or watercolor on display anywhere that doesn't have a frame around it, and often a mat and glass on top, although some galleries occasionally have tacked a series of drawings onto a wall and placed a large protective piece of Plexiglas over them.

Seemingly, the battle of framing has been won, although who should declare victory is not as clear.

Two issues face artists and dealers in exhibiting drawings, and they are sometimes treated as mutually exclusive: The first is how to use frames in such a way as to present drawings as substantial and complete-in-themselves works of art—like paintings—which can become a particularly perplexing problem when these often pale and delicate works are displayed in the same room as frequently larger and more colorful paintings; the second is how to mat and frame drawings in a manner that will protect them from moisture, excessive light, and a host of airborne pollutants.

From an Exhibition Standpoint

"In general, I don't put works behind glass next to paintings," said Louis Newman, director of David Findlay Jr. Fine Arts, a New York City art gallery. Drawings and other works on paper generally "recede" in the presence of painting whose colors are more likely to "jump out" at the viewer. When a big canvas is nearby, a drawing will often be taken as a preliminary study for the larger work, sometimes regardless of the content of the two pictures. Still, sometimes it happens that a drawing and canvas share a wall, which may take place for a variety of reasons (part of a single installation, each provides context to the other, a simple lack of separate space in the gallery, among others), and Newman stated that in this case the gallery might paint the wall blue "to neutralize the effect, basically putting both works on a neutral playing field." The benefit of painting the walls is to keep the white drawing paper from seeming to dissolve into the wall itself but stand out.

The Nancy Hoffman Gallery in New York City has also painted the walls when exhibiting drawings, even when no paintings are present, also to "offer a little bit of contrast to the paper," according to the gallery's director, Sique Spence. The wall paint is apt to be a shade of gray—"just a bit of contrast. Red would be overly dramatic." However, that kind of drama is regularly found in the works on paper galleries of major museums, where walls may be green or violet or some other color that contrasts sharply with white paper, especially

because the lights are often much lower in these galleries than in the regular painting and sculpture rooms.

Hanging drawings also poses dilemmas for artists and galleries. It is not uncommon to see a single large painting on a wall of a commercial art gallery—a visitor's attention is immediately focused from afar—but "you don't want one drawing, unless it is absolutely enormous in scale, holding up a whole wall," Spence said. "The drawing is likely to get lost in scale that way." The more customary approach is to group a number of drawings together, drawing the visitor up close in order to get a better view. Drawings amidst other drawings force the viewer to forego looking for the finished larger piece and concentrate on their specific artistic qualities. The obvious drawback in this type of exhibit design, however, is that it suggests that the individual pictures are not substantial works of art in themselves and need others around them to fill them out.

Galleries seek to solve that problem by displaying drawings on smaller walls or in smaller gallery rooms. In that context, "the eye can rest on it, instead of going beyond it," Spence said. Additionally, as collectors are likely to hang a drawing in a smaller space, "they will get a better sense how the work might actually look in their home."

Finding the most appropriate mat (if there is to be one) and frame also takes considerable care. Overly thin frames might not be strong enough to hold everything together, while very ostentatious ones can be an unattractive billboard for how much the drawing cost. Jill Weinberg Adams, director of Lennon, Weinberg Gallery in New York, noted that she prefers a "straight-forward presentation. I don't take a small drawing and put an enormous mat and frame around it to make the drawing look more substantial"—an approach with which most dealers agree—but there are certain mats and frames that heighten the drama of looking at the picture. Louis Newman uses a deep bevel mat, eight-ply rather than four-play, because "eight-ply gives the image more of a presence," as opposed to the standard four-ply in which "the image looks like a poster." Fillets, or spacers (usually wood, rag board, or plastic), between the frame and glass also have the effect of deepening the image, drawing one's eye in. He avoids metal

frames, which he associates with posters and finds do not enhance the image, choosing instead lightly stained hardwood frames that seem to be more commensurate with original fine art. Newman also eschews black frames as "funereal, and they pull the eye away from the work." His worst case display for a drawing is "a thin cardboard mat with a black frame on a white wall, because this makes for a sterile presentation." In addition, he has applied fine linen or silk on the mat itself in order "to soften the color of the cardboard mat and it gives a halo effect without distracting from the image."

Mats are not always used in the framing of drawings. While their main function is to keep the drawing flat and not drifting toward the glass, many artists, dealers, and collectors prefer to show the edge of the paper itself, especially when it has a rougher, handmade quality. In these instances, the drawing is attached to the backboard and simply "floats" within the frame; fillets are often used to create the extra space between the paper and the glass that the mat would otherwise provide.

A novel use of mats has been made by Bill Richards, a New York City artist who exhibits drawings at the Nancy Hoffman Gallery. The mat covers the perimeter of a drawing, but the mat itself is floated within the frame; that is, the edge of the mat can be seen three quarters of an inch in from the frame. The mat is secured in place either by hinges at the top (more on hinges later) or simply by the pressure of the glass.

Mats are also a source of decoration, adding or offering contrast to the central image. At times, the mat will be a different color than the paper, and the mat may contain designs and colors complementing the drawing. Graydon Parrish, who creates drawings and oil paintings in Amherst, Massachusetts, and exhibits at Hirschl & Adler Galleries in Manhattan, uses a framer that draws in borderlines on the blue-gray mats, and some of these lines are filled in with pastel-colored dry pigments, applied with a watercolor brush. There is a considerable amount of back-and-forth between Parrish and the framer, as the two experiment with different line thickness, mat, and pigment colors, and the extra work figures into the price: between $800 and $900 per frame and mat on drawings that sell on the average for $20,000.

(Parrish pays for this service out-of-pocket, noting that "it's the one problem I have with Hirschl & Adler, they will not pay for matting and framing and just take it off the top when they sell a work.") Framing and matting charges that run 4 or 4.5 percent of the entire cost of the artwork is within the norm of the gallery world. Louis Newman's rule of thumb is "no more than 10 percent of the work's price for the frame."

From a Conservation Standpoint

On the face of it, art dealers and art conservators should have a lot in common—both groups want art to look good, if for somewhat different reasons. Badly illuminated, matted, and framed drawings will not be appealing to potential collectors, and those same factors are likely to cause long-term damage to the artwork itself. The two groups sometimes part company when it comes to the actual business of finding the right mats, frames, and lighting for drawings. The reasons certainly are economic, but also the result of a lack of a clear understanding about how to actually protect drawings. Everyone is quick to repeat the mantras of products labeled "acid-free" and "archival," which suggest proper care and an artwork's longevity, but these terms are to art what "all-natural" and "organic" are to food—well-intentioned, higher-priced, and ultimately meaningless because there is no federal standard for what these words are required to mean.

Ronald Jagger, director of the Phyllis Kind Gallery in New York City, noted that he spends "a great deal of time" thinking about frames and mats for the drawings that are periodically put on exhibition, but those thoughts often run to "how to keep the costs down." Framing and matting costs between $100 and $175 per drawing, an expense shared equally by the gallery and the artists, and there may be forty-five works in a single show. "We think about what kind of frame—metal or wood—would best enhance the drawing, we think about UV"—ultraviolet light—"glazing, and we know to use archival materials, but the fact is that most of our clients take off the frames and mats we put on. They have their own framers." Cheaper frames and mats seem to solve one problem, but they also may lead to others.

Drawings not matted and framed to exacting museum standards may result in significant damage to the artwork. The paper is stained by acids in the mat or frame (or both), even by the tape used to hold the drawing in place. The paper buckles and puckers because of moisture, perhaps even bulges out so far as to come into contact with the protective glass (which no longer protects it at that point). These types of damage are not uncommon in private homes, although quite rare in major museums where the price of high-end matting and framing small drawings start at $500 or more. The gap between what professional conservators recommend doing and what many artists and dealers end up doing can be wide. The Lennon, Weinberg Gallery may spend as little as $75 per frame, according to Jill Weinberg Adams, who noted that she works "on a short timeframe; I have to get a lot of frames in a hurry. While I look for the best balance of care, I don't always have the time and budget to get everything properly framed. I may have eight weeks and $3,000 to spend. Sometimes, I have to go with a less expensive framer just because they're the fastest."

Conservators speak not just about framing and matting but about the entire "frame package." That package typically consists of backing material (acid-free corrugated cardboard or polystyrene-cored board, often called Fome-Cor), a backboard that may be called "conservation board" (high-quality cardboard and paper made of chemically refined wood pulp) or rag board (made of cotton or linen stock), the drawing itself, a window mat (again, rag board, buffered rag board, or conservation board), covering glass (including regular glass or acrylic glazing materials, such as ultraviolet shielded Plexiglas, Lucite, and Acrylite), and the encompassing frame (wood, metal, plastic), which can—but need not—be made airtight when sealed on the back with polyester film (Mylar), metal foil, or other impermeable materials. "Airtight" does not mean, however, that a work of art can be placed in any environment, such as a humid bathroom, and remain protected.

Many of the materials that framers use are described as acid-free, but that may not offer sufficient protection to artwork. It is not uncommon to see, for instance, a brown core just under the top

layer of a so-called acid-free window mat, where the window has been cut out. "If the mat board has a core that has wood pulp, it won't remain acid-free," said Leslie Paisley, head of paper conservation at the Williamstown Regional Conservation Center in Massachusetts. That wood pulp core contains lignin, a type of natural glue that holds the wood fibers together but turns brown and more acidic as it ages. That acidity will reach through the surface of the mat to the paper, causing it to darken in spots.

Hazards lurk all over. A mat that is perfectly acceptable to conservators may turn acidic from backing material that contains harmful wood pulp or if it is in direct contact with a wood frame, absorbing acids from the wood. Some types of wood are more acidic than others—poplar and ash are less likely to cause conservation problems than oak, for example—but it is often the case that some buffering material between the mat and frame is needed. Artists need to go beyond claims of "acid-free" to ask specific questions of those who would mat and frame their work about what these products actually contain.

Some framers simply do not carry the highest quality conservation materials. "Framers are profit-driven and know that they can't charge exorbitant prices," said Karen Pavelka, a professor of paper conservation at the University of Texas Graduate School of Preservation and Conservation Studies. "So they don't use mat board with good quality fibers, for instance, or they will mount the artwork using pressure-sensitive tape, which isn't very strong, doesn't let the paper expand and contract, and is very difficult to remove. There is a lot of damage that framers can cause."

Acidity, which causes paper to become stained and brittle, is the most common long-term problem with improper matting and framing materials. A less visible but no less problematic area is adhering the artwork to the backboard, using what is referred to as hinges. (At times, drawings are held in place with corners, made of sturdy acid-free paper or Mylar folded into triangular shapes and adhered to the backing.) A variety of materials are used as hinges, including archival (not Scotch or masking) tape and linen with

a type of envelope glue; what makes them archival are the claims that they can be removed without damaging the artwork.

Those claims, however, are not accepted by all conservators, who often look beyond the issue of getting the picture matted and framed to a time in the future when the drawing will be removed from the mount. "You may be able to take off archival tape within a few minutes of applying it without any real damage but, if it has been on for some time, it will not easily come off without taking some of the paper with it," said Margaret Holben Ellis, director of the Thaw Conservation Center at the Morgan Library in New York. Additionally, while the paper expands and contracts with changes in humidity, the tape does not have that flexibility, causing the paper to buckle where it comes into contact with the tape, sometimes leading to tears. The linen hinges have more—although not exactly the same—elasticity to "breathe" with the paper, but its glue has the potential of staining the paper, "and you have to use a lot of water to take it off. It's like steaming a stamp off an envelope, and that water can damage the paper."

The preferred method is long-fibered Japanese paper, which is adhered to the paper and the backboard through a wheat or rice starch that is applied with a brush. "It is very strong and entirely reversible with not that much water," she said.

The materials used in conservation matting and framing are somewhat more expensive than ordinary frame shop supplies, but what one actually pays for is the increased amount of time and labor involved, especially in cooking up an adhesive paste, brushing it on, and waiting for it to dry. Artists who are do-it-yourselfers may be able to learn these techniques through organizations' Web sites (such as the Northeast Document Conservation Center, 100 Brickstone Square, Andover, MA 01810-1494, (978) 470-1010, *www.nedcc.org*), through books (among them *Matting and Framing Works of Art on Paper*, published by American Institute for Conservation, 1984; *Curatorial Care of Works of Art on Paper* by Anne F. Clapp, Nick Lyons Books, 1987; *The Care of Prints and Drawings* by Margaret Holben Ellis, Altamira Press, 1995; *Caring for Your Collections*, edited by Arthur

Schultz, Harry N. Abrams, 1992; *Matting and Hinging of Works of Art on Paper* by Merrily A. Smith, Library of Congress, 1981; *The Care and Handling of Art Objects* by Marjorie Shelley, Metropolitan Museum of Art, 1987; *Preservation of Library and Archival Materials*, edited by Sherelyn Ogden, published by Northeast Document Conservation Center, 1994; and, *How to Care for Works of Art on Paper* by Roy L. Perkinson and Francis W. Dollof, published by the Boston Museum of Fine Arts, 1985) and at workshops offered by the Professional Picture Framers Association (4305 Sarellen Road, Richmond, VA 23231, (804) 226-0430 or (800) 556-6228, *www.ppfa.com*) and the American Institute for Conservation of Historic & Artistic Works (1717 K Street, N.W., Washington, D.C. 20006, (202) 452-9545, *www.aic-faic.org*). The types of materials used by conservators are available at certain art supply stores, book binderies, and library supply outlets. Conservation supplies are also sold through catalogue companies, and many can be searched online (for instance, through the Smithsonian Institution, *www.si.edu/ scmre/supplier.html*) and through links at the Web sites of the Professional Picture Framers Association and the American Institute for Conservation of Historic & Artistic Works.

One area in which art dealers and art conservators would clearly find themselves at odds may not matter all that much. Gallery lighting is much brighter than that used in the rooms showing drawings in museums. The dim lighting in museums preserve the paper but it makes getting a good look at the work a bit more difficult, and gallery owners want prospective collectors to see the work clearly. "If you can't see it, it won't look very good," said Frederick Baker, an art dealer in Chicago. "A dark room would make me crazy." The galleries in museums devoted to works on paper are usually illuminated to scientific measurements of between five and eight "foot candles," Margaret Ellis said. To determine whether or not a room is brighter than that, she recommended using a photographic meter, which is built into many 35mm cameras. Setting the ASA scale to 100 and the f-stop at 5.6, the indicated shutter speed will be equal to the number of foot candles. If that number exceeds eight, the room should be dimmed or the artwork moved elsewhere. It is rare, on the other hand, that a gallery director has any idea how much wattage is lighting up an exhibition.

"Objects are made up of molecules," Margaret Holben Ellis explained, "and light energy may cause molecules to separate. When that happens, it releases acidity, which is a product of the reactions, and that eats away at the canvas and paint, causing fading." She suggested placing drawings away from wall areas that will receive strong direct sunlight as well as away from lamps.

In addition, ultraviolet filters might be placed over the windows, or ultraviolet Plexiglas in front of the work itself, to shield it from the most harmful effects of the light. Among the benefits of Plexiglas are that it is lightweight and almost unbreakable; however, it holds a static charge that may lift the paper or bits of the drawing material. Larger pieces of paper (40″ × 60″) have more movement than smaller ones, and they are more apt to be pulled toward the Plexiglas, requiring a larger fillet (perhaps a three-quarter-inch spacer as opposed to the standard one-quarter inch) to keep the paper and gazing material separated.

There also are ultraviolet coatings that one can apply to windows, retarding the most severe effects of strong sunlight, as well as certain types of accordion-shaped blinds that allow a certain amount of light and heat to enter a room while reflecting high heat. Hardware and home decorating stores will have many of these products. If not, call a local museum to find out where to get them. Darkening the walls with paint, by the way, adds a certain drama to a room and may reduce some of the glare that takes place in galleries where the light bounces off the white walls. However, it does nothing about reducing either ultraviolet rays or the overall amount of light in the room.

Fortunately, exhibitions in galleries only last a few weeks, after which the drawings would go back into storage or into someone's private home where the longer term problem of preservation actually begins.

Juried Show Etiquette

There is no "Miss Manners" for the art world, but there is an unspoken etiquette for juried shows and art fairs, which is brought up whenever an artist is found to have broken one of the rules.

Sometimes, it is the artist who is clearly at fault, knowingly dis-obeying a rule that the show sponsor has set; at other times, show sponsors create rules that may force artists to choose between fol-lowing the stated guidelines (causing them to act against their own best interests) and dishonesty. The fact that there is no standardiza-tion among the thousands of shows and fairs annually taking place around the United States means that artists themselves must tailor their own practices (and ethics) to conform to the rules of this or that event.

One rule on which there is general agreement is that artists should not substitute another work for the piece that was submitted to a jury. The desire to make a substitution may come about when an artist sells a juried piece before the show begins. Not all collectors will allow the works they bought to be part of a show (the piece may be damaged, for instance), and this puts the artist in a bind: Should the artist hold off on a sale, withdraw from the show, or see if the show sponsor will accept something else? Artwork is not interchangeable, however; a work that is submitted for an exhibition should be available, and sales may have to wait.

Another point on which most agree is that the same work should not be submitted to two or more different shows, taking place at the same time, in order for an artist to see which show is the best in which to participate. If the artist's work is accepted into more than one show, it means that another artist who applied was rejected, and the show spon-sors may also have to scramble to fill an empty space. Artists should learn about a show before they enter their work, not afterwards, and commit themselves fully to the event.

Artists should also not fudge the issue of medium, which sometimes comes up in shows of watercolors. Some watercolor shows accept acrylics and gouaches, even pen-and-ink drawings with a watercolor wash, while others are adamant about only transparent watercolors. The Midwest Watercolor Society has been so concerned about what is called a watercolor that it tests accepted entries to see if their medi-um is truly transparent. Artists who are in doubt about what is allow-able have every right to ask; however, they should not knowingly

submit work that goes against a sponsor's stated aim. If you don't like the requirements for entering a show, don't enter.

Some gray areas in show etiquette may also arise. Certain show and fair sponsors require that participating artists donate a work—perhaps, for an auction or as a door prize or for the sponsor's permanent collection (when the sponsor is an art institution)—but which work? Should a painter contribute a painting or a print or even a sketch? Must the donation be representative of the artist's best-known work or just anything? Often, the prospectus does not indicate what the donation should be, and artists are left with an ethical decision—to give away the type of work that got them into this show or donate just something small or inexpensive (or both) with their name on it. Probably, the latter option makes the most sense, especially if a donated piece is to be used as a door prize. Some artists create a line of less expensive pieces—for instance, prints or small sculptures—and one of these would fulfill the requirements of the sponsor.

Must an artist stick to the prices that he or she originally placed on a work? The length of time between when an artist submits a work to a juried show and when it is accepted may be months, and significant changes may happen in the artist's career in the meantime. Awards may be won, works sold, rave reviews published. Frequently, show sponsors require that artists put a price on work they are submitting for jurying; by the time of the actual show, an artist may want a much higher price, which could be accommodated in a gallery situation but is likely to cause hardship to a show sponsor who has printed up hundreds or thousands of brochures with prices noted in them. The sponsor would have to reprint the entire brochure with the correction or pencil in a change on every brochure or leave the brochure as it is and hear from annoyed visitors to the show. Price hikes cause hard feelings on the part of the sponsor, while artificially low prices will irritate the artist. Presumably, sticking by one's word means adhering to the price originally set.

Little is cut-and-dried: Some shows require that every work on display be for sale, which may be attractive to visitors but not to artists. Must artists sell simply because show sponsors say they have to?

Artists may not want to sell works with personal meaning to them, or they may have a ready buyer (or have even sold the piece already). They may want the piece available for another show. A not-uncommon solution for artists is to give the piece a very high price ($10,000, whereas it otherwise would go for $1,500) in order to discourage sales and get around the Not-for-Sale problem. Other show sponsors set price limits for works on display, which is again appealing to visitors but cause hardship for artists who could charge more at other shows. Just as in the required donation problem, show sponsors place artists in an ethical bind: irritate the sponsors or hurt their own career opportunities. Certainly, it is wisest to read a prospectus carefully and simply not enter shows and fairs that make unpalatable demands. However, these requirements are not always described (or described fully) in the prospectus, leaving artists to discover after they have already committed their time and money to a show what is expected of them.

Artists who have entered works for "plein air" exhibitions similarly have come up against rules that change from one group to another. Plein air, which refers to painting done outside, may mean done totally outside, or just largely outside—last minute changes or corrections done in the studio. The Plein Air Painters of America defines the field as 90 percent outside, while the Genesee Valley Plein Air Painters (in New York State) permits 85 percent and the Ohio Plein Air Society allows just 60 percent. Different judges of these exhibitions have their own ideas of what makes a painting plein air—including an Impressionist style of brushwork (that's how the first plein air artists painted), no hard edges (that suggests the use of photographs), not too much detail (again photographs or extra time in the studio), no wet on dry paint (it should all be done in one outing) and no interior views (plein air means outside)—but there are many artists who honestly could call themselves plein air painters but violate one or more of these tenets. Artists may need to challenge the set beliefs of judges, or the groups that employ them, or simply look to a more agreeable place to exhibit their artwork.

Some conflicts between artists or between artists and show sponsors may not be avoidable. An artist may choose to enter the same work

in a great many shows, which will likely irritate other artists (and show sponsors) who are unhappy at seeing the same piece again and again. However, is there something inherently wrong with it? The public does not travel the show circuit as artists do and are unlikely to see the work repeatedly; artists create works for potential buyers rather than for other artists or show sponsors, but they still may need to choose between doing what is right for them and what others want them to do.

An artist may look to submit the same favorite work to juries for years, which may also annoy fellow artists who only send in slides of their newer work. Many show sponsors require that all work submitted has been created within the past two years, in part because they want annual shows to have a different look every year for the public. Newness, of course, is not an artistic criterion, but good etiquette in the art world is often a mixture of strong principle and the assumed needs of the market.

chapter

Talking about Art, Talking about Money

Marketing and selling one's own artwork takes a lot of courage, and it also calls for qualities that might in other circumstances be called bad manners: You have to talk about yourself, and do a lot of it— what you do, what you have done, why you are doing it, why what you are doing has some value. It is so much easier when someone else does that talking, such as an art dealer, but most artists cannot rely on some third party to make their case. The Artist Statement is often where this case is made, but knowing what to say about oneself or one's art—and saying it in concise, grammatical, typo-free English— is rarely easy.

The Question of Artist Statements

Artist statements regularly are found as part of materials (slides, résumé, news release) sent out to the press or to juried art show sponsors or to gallery owners. The public comes into contact with these one- to three-paragraph (usually) commentaries at exhibitions, where an artist statement may be displayed on the wall or table near the artwork. These statements are, according to Jeremy McDonnell, associate director of the Barbara Krakow Gallery in Boston, Massachusetts, "an educational tool, not just a sales tool. Young collectors, or those unfamiliar with the artist's work, want a way to step into the work and see what the artist is all about. The artist statement is an access point for them."

Not every exhibit at the Barbara Krakow Gallery will include an artist statement; the more established artists represented by the gallery "don't bother," McDonnell said. "Their thinking is, 'If after exhibiting for twenty or thirty years you still haven't heard of me, four or five sentences aren't going to help you much.' Artist statements are more for artists on the way up." When statements appear, they are "never on the wall" (posing a distraction to visitors), but can be found at the front desk, next to the price list and any published reviews. Other galleries place them to the side, such as on a table or in a portfolio that includes images of the artist's work, prices for individual pieces and a résumé or brief narrative biography. Yet other galleries of contemporary artists don't want these statements at all.

"I'm way better at putting into words what an artist is doing," said San Francisco dealer John Pence. "I have a broader view, and I'm more succinct." An unspoken debate has developed in the world of art galleries over the purpose of artist statements and what to do with them. Many dealers, like Pence, believe that it is their job to talk up the art on display, tailoring their remarks to fit the level of understanding and interests of the individuals to whom they are speaking. The other primary concern with artist statements is the quality of the writing of them. "When artists are asked to write an artist statement, you usually find the results are spur-of-the-moment affairs, or they're too long and labored," Pence said. Even gallery owners who believe in the value of an artist statement in creating a bond between reader and artist note that a high percentage of the statements they put on public view are not well written. Chicago art dealer Douglas Lydon likened some artist statements in his gallery to "bad poetry," while Santa Fe gallery owner claimed that artists she shows "create verbiage." On a more positive note, Sally Troyer, owner of Troyer Gallery in Washington, D.C., noted that "most visitors to the gallery don't even look" at the artist statement and those who do "don't expect a painter to be a good writer."

These and other dealers don't try to make themselves feel less uneasy by doing anything to turn the statements they sometimes request of artists into more readable prose. "We don't edit what they say," said Marissa Gianno, a gallery associate at Jenkins Johnson

Gallery in San Francisco. "We may just clean up punctuation." Douglas Lydon also stated that he would "never edit the content" of an artist statement, even when "the artist writes something crazy." The statement is treated as though it is a work of art in itself, available for framing but not for alteration. The DeCordova Museum and Sculpture Park in Lincoln, Massachusetts, which focuses exclusively on New England regional artists and hosts an annual summertime exhibition of ten emerging artists, provides two separate comments for the work of each artist—one written by the artist and the second penned by a curator. DeCordova curator Francine Weiss claimed that including "two viewpoints" allows visitors broader opportunities for understanding the artwork on display, but it may also help solve the problem of readers not following what the artist is talking about. Here is an example of the two-label approach from an exhibit at the museum:

THE DECORDOVA ANNUAL EXHIBITION
Dave Cole

I want my sculpture to be as approachable as an all-night diner. The kind of place that you swing by after work; you want a quick cup of coffee and you're willing to drop in there because it's simple: It doesn't matter if you're tired, worn out or not dressed for the occasion. Then you stick around for another refill, and before you know what happened, you've eaten dinner and you're waiting for a slice of blueberry pie. It's not that you weren't hungry—you just didn't expect the meal.

I make sculpture because I love the work of physically meditating on a material until it becomes something. Repetition allows the work to become a metaphor for itself. Labor: meticulous and calculating; frenzied, repetitive and driven. Familiar materials and benign analogies become recklessly violent absurdities. Innocuous objects, seemingly playful in their clumsy obviousness, suddenly bare their teeth.

Dave Cole

And the curator's commentary:

Dave Cole's sculptures play with our expectations. As the treasured possessions and icons of childhood, his teddy bears signify security, suggest softness, and even invite tactile engagement. Yet these seemingly innocuous objects are made of hazardous

and uncomfortable materials–Fiberglas™ or lead. Caught between attraction and repulsion, yearning and rejection, we feel a sense of frustration that reminds us of our unmet childlike desires and the loss of innocence that accompanies adulthood. Simultaneously, we are also made to feel the artist's frustration as he undertook the arduous and ambitious work of knitting sculptures, on small and large or absurd scales, from unyielding and dangerous industrial materials.

By joining the process of knitting to the materials of industry, Cole merges a tradi-tionally female activity—and its associations of femininity and domesticity—with materials symbolizing masculinity and male labor. In *The Military History of Knitting*, Cole reverses the paradigm of women knitting for soldiers with humorous results. But these military knitting sets also question the idea of authenticity. More importantly, they function as metaphors for history itself, which is as constructed as Cole's objects.

Francine Weiss
Curatorial Fellow

Two questions arise: How should artist statements be written? And do they need to be written at all? Among the reasons that some gallery owners appreciate these statements is that they offer infor-mation that may be used in a press release or as part of the discus-sion that the dealer will have with the perspective buyer. Collectors, as well as those doing research on an artist, welcome insights into the artist's frame of mind, the sources of artistic inspi-ration and technical information about the artmaking process that a statement may reveal. However, there is an equal likelihood that writing that "reads like James Joyce or is full of artspeak, designed to confuse people" will turn off those otherwise disposed to show an interest in the artist's work, according to New York City art dealer Stephen Rosenberg. "There are artists who can't put two words together. People coming into my gallery may start to think that I represent a bunch of idiot savants."

"Most artist statements, 99 out of 100, are not useful, and they're often ludicrous," *Philadelphia Inquirer* art critic Edward Sozanski said. "A poorly written statement has turned me off an artist's work. Being a literary person, I am influenced by the way people speak and write. A badly written or poorly conceived statement

pushes me in the wrong direction. It shouldn't, but a bad statement makes me say, 'To hell with it. That person doesn't know what he's talking about.' "

Many museums include didactic, or educational, labels, brochures or wall text with individual works of art in the permanent collection or for entire temporary shows, in order to provide useful information about an artist or a trend in art history, for instance. Gallery directors generally don't do this sort of educating; if they are presenting historical works for sale, it might seem presumptuous, and, when they are showing the work of contemporary artists (especially, younger artists), it may seem absurd to offer a museum treatment. Instead, they publish press releases and make available reviews that others have written. Manhattan art dealer Andrea Rosen stated that any statement about the art that she or an artist writes is "anti-democratic. The audience has the right and responsibility to its own point of view. Increasingly, I have come to see that the printed word is more powerful than the art itself. When you have something in writing, people presume they know what the work is about, whereas that knowledge may be detrimental to the larger viewing of the work."

She added that "my gallery is about the power of the people to be subjective," adding that "the sign of being a good artist is having confidence that the art is successful and doesn't need explanation."

A growing number of art schools currently offer workshops and whole courses on how to write an artist statement, which may improve the writing of them but not help the artist gain confidence in evaluating whether or not their work needs their words of explanation. Dave Hickey, an art critic in Las Vegas, Nevada, called these art school classes "insane" and "a profoundly silly idea. Art is not a literary practice. I always assume that professors ask their students to write artist statements in order that they might have some way of evaluating a student's work." He added that, when reviewing an art show, "I never read an artist statement. They're trivial. They don't matter. They identify the artist as an amateur. They're a covert plea for sympathy. I deal with consequences, not with intentions, and I always

presume the artist said what he wanted to say in his art and that the artist may not know why he did what he did." Not every critic is as harsh, however. Even while he also found art school artist statement courses "ridiculous," Hilton Kramer, art critic and editor of *The New Criterion*, said that "if I'm interested in an artist's work, then certainly I'm interested in what that artist has to say about it. It might influence my thinking, or it might not." Kramer added that he would "never base a judgment on an artist's work on the quality of his prose. That's not an appropriate standard."

Defending her school's business of art courses that includes instruction in how to write an artist statement, Deborah Dluhy, dean of the School of the Boston Museum of Fine Arts, stated that a statement "is not intended to explain the work. Its proper function is to offer insight into the artist's process and to provide a window for the viewer to enter the work and experience it in his or her own way."

It has been long intoned that "a picture is worth a thousand words" or that "art must speak for itself," but artwork and language have long been intertwined. For much of art's history, images served as illustrations for pre-existing texts (the Bible, for instance); more recently, critics and historians have provided a running commentary on artwork, artists, and the vicissitudes of art movements. Critic Harold Rosenberg's aphorism on conceptual art, which he did not like, was "the less there is to see the more there is to say." Deconstructionist critics, for their part, have announced that art itself is simply "text," which needs to be deciphered by a critic in order to be rendered intelligible by the public. Increasingly, artists themselves have taken on the twin jobs of creating art and commenting upon it. Their aim as writers may be threefold: as a form of education, they look to offer information about their work and the creative process; as a marketing tool, they seek to encourage the interest of onlookers in their art particularly; and, in a sea of language, artists aim to reestablish control over their work through words of their choosing.

For Ariane Goodwin, the author of the self-published *Writing an Artist's Statement* (*www.artist-statement.com*), who also works individually with

artists in preparing these statements, the essential purpose of the artist statement is "to create a level of bonding between the reader and the artist. If art isn't connecting us to each other, what's the point? Artist statements persist in our culture, because they are so needed; words add another layer of connection, revealing an artist's relationship to his work."

The importance of an artist statement first occurred to her at an art gallery when she found herself "bowled over looking at a painting. The gallery owner came over and handed me a résumé of the artist, which was filled with a bunch of dates and shows and lists of collectors, and my heart sank. This didn't tell me anything about the artist. I didn't even know at the time that such things as artist statements existed, but that's just what I would have wanted."

Perhaps the proliferation of artist statements reflects not only the prompting of art schools but also the recommendations of artists' careers advisors, who, like Goodwin, assist artists in their preparation. "An artist statement exists in another dimension than just the art itself, that is, the psychology and personality of the artist," said Calvin Goodman, the artists' advisor. "The statement is directed at the purpose and not just the appearance of the art." He added that "it is important that an artist makes a statement that is different than every other artist statement." Obviously, artists must now compete, not only with images, but with their commentaries.

Certainly, there are occasional instances when an artist statement is not only helpful to the artist, but important in itself. Henri Matisse's likening of his art to a "good armchair" in a 1908 journal essay, entitled "Notes of a Painter," established a way for contemporary collectors and future art historians alike to appreciate his painting: "What I dream of is an art of balance, of purity and serenity, devoid of troubling or depressing subject matter, an art which might be for every mental worker, be he businessman or writer, like an appeasing influence, like a mental soother, something like a good armchair in which to rest from physical fatigue." An even more oft-quoted artist statement, this by Robert Rauschenberg, was included in the catalogue of New York's Museum of Modern Art's 1959 "Sixteen

Americans" exhibition: "Painting relates to both art and life. Neither can be made. (I try to act in that gap between the two.)"

With both Matisse and Rauschenberg, their statements describe an approach to making art. Matisse's essay reveals his method of capturing sensations of form and color within a composition, noting his indebtedness to Paul Cezanne and his differences with the Impressionists; Rauschenberg's comments are Duchampian without ever mentioning Marcel Duchamp.

As much as he may revile some of the writing, Stephen Rosenberg stated that he has included artist statements in exhibitions because visual literacy is not always high with the public, and visitors to galleries need—and are often grateful for—any help they can get in understanding what an artist is doing and why the artist is doing it that way. In general, it is those visitors with less knowledge of contemporary art who are more apt to seek out a statement. Certainly, no evidence exists that people become collectors through reading artist statements, but statements—good, bad, or indifferent—do not seem as troubling to gallery visitors and collectors as to dealers and critics.

Artists should probably consult with the dealer or gallery owner about what might be the most appropriate information to include in a statement. Perhaps describing the technical process is appropriate in certain instances where a viewer's first reaction may be "How did the artist do that?" For artists who have had significant events occur in their lives, such as living in a particular foreign country or being taught by a noted artist, biographical information may be most pertinent. A discussion of an artist's thought process is also often useful, as the visual language of art may be more difficult for viewers to understand than the specific ideas behind an image, as well as how the artist's ideas (and works) have evolved over time.

"Sometimes, art needs an explanation," said Salt Lake City painter Jason Wheatley, who described his realism as "just organizing objects, and people make their own interpretations. My art is accessible to a

lot of people, but it can also be confusing." To dispel that confusion, he wrote this statement for an art exhibition:

I have approached this new body of work in the opposite manner than my previous work. I began working narrow vertical surfaces with no composition in mind, only broad mark making and surface qualities as my initial priorities. With my previous work, I would compose first, by setting up the still-life and then make a canvas according to the composition. Composition is decided not by a preconceived idea, but from a constant interaction with the layers of paint and process. It is as if the unconscious finds its way to the surface and manifests through non-deliberate thinking and counterintuitive reactions. I titled this show "Vertical Manifestations," because as I layer these new paintings onto narrow vertical supports objects begin to emerge from an unintentional, unplanned process. Vertical is for the format which I see as a representation of a river cutting through the landscape. Manifestations, because I am looking to this river for revelations and new reflections of myself.

People often make the same mistakes over and over. Artists tend to paint the same painting over and over. I found myself guilty of both and started trying to rethink my approach to both (paint and living). So as I stirred up chaos into paint and life, I tried to react to the chaos counter to my primary urges. Hoping to push past the barrier and break through to uncharted water I am finding it hard to bypass thirty years of conditioning and survival, still water runs deep and what I profoundly need is flow. Evaporation will rob the reservoir with out it. The levies must be lifted, and the dam demolished. The river must run free. When the dust settles and the water washes over, hopefully I will emerge a little fresher and slightly truer. Hopefully the river will bring new life to parched places.

To my thinking, this is a bit ethereal in places ("... I stirred up chaos into paint and life"), and the water analogy is anything but clear. Perhaps, most or all of the second paragraph could be eliminated (as an editorial note, I fixed some noun–verb agreements and added needed punctuation). To his credit, however, Wheatley is attempting to describe how he approaches a traditional subject, attempting to give it a new aspect. Whether or not viewers gain any greater appreciation of his work from the statement is another question.

Figurative painter Wade Reynolds of Newport Beach, California, noted that he tends to "avoid writing about myself and my work as much as possible. I want people to make up their own minds," adding that "if I were as good with words as I am with oil paint, I'd be an author." The titles of his paintings—*Figure as Landscape I* or *Figure as Still Life IV*—also promotes that desire not to tell viewers what to think. However, when asked by the Jenkins Johnson Gallery for an artist statement, Reynolds stated his approach to painting concisely but without limiting his work to a simple idea.

Throughout my painting career, the figure has been of major interest along with portraiture, landscape and still life. In portraiture I have endeavored to capture the essence of the subject through mannerisms of hands and the conversational face.

My efforts with the figure have been a complete dichotomy. I have consistently tried to remove any sense of the individual, and deal with the beauty of the form and its reaction to the light applied. Part of the strategy resulted in the turned away or hidden face, and in a large number of earlier works the face was not only turned away or hidden, but in a compositional ploy, the head itself was partially cut off by the picture plane.

A somewhat different but effective piece of writing to accompany an art exhibit may be seen with the New York City artist Matthew Ritchie, whose work includes whimsical maps, alongside which he writes Surrealistic, sometimes fictional stories that parallels the art imagery. Below is an excerpt from a 2003 exhibit:

Please imagine that you are sitting in a classroom in Greenland, a country that has been radically changing in size and shape since the invention of standardized world maps. Gustavus Mercator's map of 1569, the first complete spherical projection on to a flat surface, and still the most used map in the world, shows Greenland as being nine times larger than South America. On the Van der Grinten projection—the Mercator map's successor—used by the National Geographic Society until 1988, Greenland is 554 percent larger than actual size. On the Robinson projection of the world, currently in use, it is now only 160 percent larger than it should be.

As you look around the classroom you can see that the pale yellow walls are bare except for three objects: a four-color map of the world labeled in Swedish, using the Van der Grinten projection; a round twenty-four-hour clock with black Arabic numerals on a white face; and a blackboard with the letters of the English alphabet in upper and lower case, neatly painted by hand in script at the top ...

Please remain seated. Look at your hands, your skin. Look closer at the ridges, the channels, the pores and scars, the landscape of experience. You are a walking continent, unfurled like a sail. As you are looking at your hands, one of your citizens, too small for your eyes, is fleeing for its life. A brown and white egg shape with no discernible head or tail, desperately escaping across your surface, anchored only by thousands of tiny hooks. Behind it staggers its pursuer with the eager air of a debt collector. This one resembles the insides of a human being, disemboweled, dipped in amber, and then reassembled in the wrong order, six scaled legs drunkenly carrying a semi-transparent sac, where dark green and brown forms can be seen, squirming against an infinitely complex web. Bobbing on its head, tipped like the crown of a demented potentate, rides a violet and green helical cone. A tiny, flea-like extension from the rider burrows into the yielding skin of its victim, scrabbling and scratching. The pieces come away in a hundred bloody places, falling like autumn leaves, on to the furrowed landscape of your skin.

To some gallery owners, an artist statement is a type of "filler," taking the place of reviews and profiles that have not been written at that point in the artist's career. Later in a career, artists may feel less of a need to explain themselves. That does not eliminate the value of artists providing insight into the development of their ideas and manner of working, all of which may provide inspiration to other artists and documentation for collectors, critics, curators, dealers, and historians. The literary shortcomings of certain artists need not condemn an entire area of art history. A related approach that certain dealers have tried is creating a video that runs continuously in the gallery during an exhibition. The video shows the artists at work and/or answering questions about themselves or their art. As many artist statements are written as though answering questions that the artist would hope someone might ask about his or her art, this alternative to the written statement may be quite useful if done well.

Pricing Art

In 1973, Robert Scull, the owner of a New York City taxi fleet, sold off the bulk of his noted Pop Art collection at Sotheby's, in the process earning $85,000 for a painting by Robert Rauschenberg entitled "Thaw" that he had bought fifteen years earlier for $900 from the artist's dealer. Rauschenberg, who had attended the sale, came up to the collector at the end, shoving him and saying scornfully, "I've been working my ass off for you to make that profit?" Scull did have a reply to the artist: "You're going to sell now, too. We've been working for each other." But Rauschenberg's anger did not abate, and he became an advocate of what are called "resale royalties," a policy of requiring collectors to pay to the artists (or their heirs) a percentage of the profits they earn when they sell artwork.

It is not difficult to understand the artist's anger at collectors who buy cheap and sell dear, and perhaps his prices were too low. On the other hand, sculptor David Smith felt himself undervalued for much of his career, raising prices when there were no sales. In fact, most of the seventy-five works that were sold during his lifetime occurred in his last two years (he died in 1965 in an automobile accident), when he began to receive considerable acclaim, leaving behind a studio in Bolton's Landing, New York, that held more than 4,300 unsold sculptures and an estate tax problem for his heirs of monumental proportion.

Artists, especially at the outset of their careers, are unsure how to put a price on their work, and for good reason. The existential problem of art is that it has no specific use and has value only to the degree that other people are willing to pay something for it. An artist's say-so doesn't make anything art; collectors do, and they determine its importance as art through the amount of money they are spending, but collectors still look to artists to set the price. Certainly, artists would like some formula to help them, and some advisors to artists recommend deriving a price using some equation. A typical bit of advice in this category was offered in 2005 in the magazine *Sunshine Artist*, which published an article on the subject that claimed "Your prices should be based on your overhead

combined with the costs of the time and materials that went into each piece. Period." The article goes on to describe what someone's time might be worth—total yearly art business expenses divided by the number of weeks one works divided by the number of hours one works per week (hourly wage) times the number of hours it took to create the artwork times two (wholesale price) times two (retail price)—arriving at a figure that would seem sensible, scientific. The only problem is that such a formula has no bearing on either a collector's level of desire for the artwork or the prestige of the artist, and that no fine artwork in modern history has ever been priced in such a way. "Just after the Second World War Picasso bought a house in the South of France and paid for it with one still-life," the author John Berger wrote in his book on the artist, but the transaction only took place because the artist was Picasso. Supply, and the length of time it takes to create the supply, are meaningless without demand.

A simpler, and more realistic, approach to determining a price is to find similar artwork by artists at a similar point in their careers, using those numbers as a guide. An unknown artist's work that has a strong resemblance to that of Jasper Johns would not be priced at that same level.

Discounts?

Early on in Barbara Ernst Prey's career, a man came up to her where she was selling her paintings. "He looked me straight in the face and said he would pay me $1,000 less than the listed price," she said. "I said no, and he said to me, 'So, you're going to walk away from a sale?'" As it turned out, Prey eventually sold that painting for the full price, but the situation she faced is one that, in one form or another, many other artists have encountered—a buyer who wants, and expects, a discount.

Bargain hunters exist in the art world as elsewhere, and the phenomenon is not new. Algur Meadows, the Texas oil man and art collector, boasted of his ability to get artworks at half or less of the going price. He once told a newspaper reporter in the 1960s, "They'd come down

here with a Modigliani for $100,000, which I knew was the selling price anywhere. The next day they asked $75,000 and I told them to take it away. ... Two or three weeks would go by. They kept telling me they had to leave town. Well, I said, I haven't asked you to stay. If you want to sell it to me, I'll give you $45,000. They took it." The laugh was on him, however, since the majority of the Old Masters he bought turned out to be fakes.

Getting something for less is well established in the art trade, with dealers regularly offering 5 to 10 percent discounts to prospective buyers as an inducement to take a work. The practice of discounting prices has become institutionalized, as certain dealers provide specific price breaks to different collectors: 5 percent to a first-time buyer, 10 percent for a long-term collector (Komei Wachi, director of Gallery K in Washington, D.C., noted that he may go up to 15 percent when buyers purchase three or four pieces at the same time), 20 percent for significant private or public collections, up to half off when major museums are in the market (in those instances, some dealers simply swallow their commission in order to raise the stature—and thereby the prices—of the artists).

Discounts, however helpful they are in generating sales, have a draw-back: They blur the question of the actual price—and value—of the work involved and potentially make those who pay full price feel like chumps. The process of selling artworks does not want to be likened to car buying, in which dickering and mistrust have taken on greater importance than the actual thing being sold. More and more, collectors on all levels of buying are taking the view that the stated price is not the real price and begin a process of haggling. Barbara Krakow, a dealer in Boston, noted that many galleries "raise prices for works in order to accommodate requests for discounts," adding that "it all becomes a game. Some people seem more interested in the discount than in the artwork. Some people ask for discounts because their friend got one. The discount seems to have a meaning in itself."

As the economy slows and prospective buyers worry more about making mistakes with money, it is likely that these negotiations over

price and the expectation that buyers deserve a discount will continue and, probably, increase. During the last recession, in the early 1990s, "things seemed to get out of control in terms of buyers' expectations around discounts," said Arthur Dion, director of Gallery NAGA in Boston. "There was a sense of a price behind the price, and that the stated prices weren't real. We decided at that point that we wanted to establish that these were real prices, so we stopped allowing discounts."

Individual artists who sell works out of their studios or at art fairs regularly face customers who aggressively look for, or demand, steep reductions in the price of given works, and they must develop their own policies for when or if to allow discounts. The largest challenge may be to stand their ground, whatever they decide to do. Painter Robert Sadlemire of Myrtle Beach, North Carolina, said that dealers often approach him at art fairs and ask for discounts ("it's brutal"), and "I'll go with it if they plan to represent me in their galleries. If they just want my work for less, I'll say no." At times, an artist's policies may appear to be whimsical. Liv Marinoff, a painter in Jersey City, New Jersey, who called price negotiations "assaultive," claimed that she will lower the price (by 10 or 20 percent) for works that "don't have as much personal meaning for me." West Indian painter Daniel Jean-Baptiste said that he won't permit discounts on one-of-a-kind pieces but will for his prints: "They're photomechanical reproductions. If they cost me $2 apiece to print them up, I just use them as a form of promotion."

Baton Rouge, Louisiana, painter Rolland Golden has allowed discounts of up to 20 percent to buyers who purchase "ten or more works," but he prefers to offer other incentives, such as framing, packing, and shipping—costs that the collector usually bears. Frank Webb, a painter in Pittsburgh who frequently offers watercolor workshops and sells works to students attending them, said that he reduces the price of his pictures based on the fact that they are not framed or matted and because "they're often demos, which I wouldn't sell at full price in a gallery, anyway."

The form that requests for discounts take can be varied. Certain buyers ask directly what types of discounts are offered (or what do they

get for paying in cash), while others state the discount they want. Some artists report that prospective buyers will simply name the price they will pay for a work ("I'll give you $2,500 for it"), disregarding the list price entirely. Not only private collectors but members of the art trade—gallery owners and dealers—also play hardball with artists, probably nowhere as openly as at art fairs, especially at the end of the shows. "It's very predatory," said Alan James Robinson, a watercolor artist in Easthampton, Massachusetts, who has been an exhibitor at Art Expo in New York City. "Dealers see someone from another country or from across the country, and they go to that artist at the end of the show, saying, 'Give me an extra 10 or 20 or 30 percent off, and I'll take the whole wall.' When an artist considers the cost of packing and shipping everything home, he may go for that deal. I'm ashamed to say that I've taken deals like that in my life."

The belief that artists will eventually cave in to demands for lower prices causes many other dealers to frown on artists whom they represent also selling their work privately. If an artist will sell his or her work less, what incentive is there for a collector to buy from the dealer? "I don't necessarily mind if one of my artists sells privately," Barbara Krakow said, "as long as they don't undercut me. They have to sell at the stated price." When establishing a relationship with a gallery owner, the question of private sales should be discussed and agreed upon by both the artist and dealer in order to prevent friction later on. Many artists whose work is represented by one or more galleries avoid the potential tensions with their dealers and the problem of haggling with discount-seeking buyers by simply refusing to sell private, referring inquiries to their galleries. Certain artists agree to pay their dealers all or part of the regular commission when they sell their art privately out of the belief that collectors have come to them as a result of the dealers' work on their behalf.

To some artists, it seems unfair that their dealers may offer discounts but they may not. Artists and their dealers periodically have opposing views on this subject. Painter William Beckman, noting that, "dealers wouldn't have a job, wouldn't exist without artists," stated that "it is just as viable for the artist to sell work with a discount as the dealer." On the other hand, Gilbert Edelson, administrative vice president and counsel of the

Art Dealers Association of America, warned that "artists offering discounts jeopardizes their relationship with their dealers, even if the discount and the final price is the same as what the collector would get at the gallery. Collectors talk to each other, 'Don't buy from the dealer. You'll get a better price from the artist'—this hurts the dealer and eventually the artist after the dealer decides he no longer wants to handle the artist because the artist has become his competitor."

He noted that the only kind of discount he recommends for artists is what is known in the art market as a "trade" discount when they sell work to their dealers, which may be as large as 40 or 50 percent—in effect the regular gallery price minus the regular dealer commission.

When they are represented by a gallery, the price of a work of art is set by the artist in conjunction with the dealer; dealers don't tell artists what they will charge. The amount of the discount, and to whom a discount may be given, also should be discussed and agreed upon by the artist and dealer. In most cases, when a dealer offers a discount, that amount comes out of the dealer's commission, although on some occasions the artist and dealer split the cost of the discount. Establishing a sense of integrity in the art market, or in just one artist's market, may mean being consistent in prices—only offering discounts in certain, narrowly defined circumstances or not permitting them at all. Sales may be lost to buyers who need to wheel-and-deal, but other collectors are likely to appreciate the fact that no one else is getting a better dealer than themselves. Sticking to one's guns also has a self-affirmative element. "Everybody wants a dealer," Barbara Ernst Prey said, "but after making a living as an artist for all these years, I know there is always someone who will buy the work. I don't have to deal with people who seem more interested in a good price than in the art I'm making. I can afford to hold onto my work."

Giving Artworks a Name

In 1871, James McNeill Whistler painted what would become his most famous work, which he titled *Arrangement in Grey and Black* and submitted the following year to the Royal Academy of Art

in London for its 104th Exhibition. Both members of the Royal Academy and the British public were unhappy with the work—the Academy came close to rejecting the painting (Whistler never again submitted a work for approval to the Academy) and the public was uneasy with a portrait described solely as an "arrangement" of colors, wanting more of an explanatory title. As a result, Whistler appended the words "Portrait of the Artist's Mother" to the "Arrangement" title just for this exhibition, although that name stuck and the painting has come down to us by the more popular *Whistler's Mother*.

It is rare that an artist is so demonstrably thwarted in the attempt to describe and title his work ("Take the picture of my mother, exhibited at the Royal Academy as an *Arrangement in Grey and Black*," the art-for-art's-sake Whistler wrote in his 1890 book *The Gentle Art of Making Enemies*. "Now that is what it is. To me it is interesting as a picture of my mother; but what can or ought the public to care about the identity of the portrait?"). However, the incident shows the degree to which a name matters to people who will see and perhaps buy the piece.

Most titles tend to be quite straightforward. "I name the subject matter, if it's a still-life or a landscape," said painter Sondra Freckleton. "Its name is what it is. It's like naming puppies: You see how they behave, and that's what you name them." Most representational artists do the same with an occasional exception of a title that alludes to some event (for instance, Manet's *The Execution of Maximilian*, which was indebted to Francisco Goya's earlier *The Third of May, 1808*) or line from a poem (the titles of African-American artist Whitfield Lovell's paintings are often fragments from jazz songs, which may have inspired them) or one that is witty, such as Debra Bermingham's 1992 painting within a painting of two human figures with a landscape in the background amidst images of a butterfly and a postcard titled *You Might as Well Choose Your Wife with a Buttercup*. "I always try to impart to the viewers something more than just a literal transcription of what they can see," Bermingham said. "The title asks them to free-associate."

Representational art would appear to have far less need of a descriptive title than most forms of nonobjective art; there seems little need for a landscape to be titled *Landscape*. From an aesthetic point of view the title seems redundant. However, viewers generally seek some idea of what is going on from the title in ways they do not when the work is abstract. "If the title is obscure or there just is no title, people often ask what they are looking at," according to Bridget Moore, director of New York's D.C. Moore Gallery. Abstract art, on the other hand, often employs a wider range of title possibilities, from *Untitled* and numbering (Robert Ryman's *Classico III* or Sam Francis's *Untitled, No. 11*) to a physical description of the artwork (Dorothea Rockburne's *Drawing Which Makes Itself* or Ellsworth Kelly's *Orange and Green*) and titles that may mean something only to the artist (Brice Marden's *The Dylan Painting* or Frank Stella's *Quathlamba*). Regardless of the style or subject matter, the length, obscurity, or descriptive nature of a title does not seem to make a difference to collectors, Moore stated. "It's how it looks on the wall that counts."

Titling art establishes an artist's control of it, yet giving a name to a work of art is, historically, a relatively recent phenomenon, and it is even more recent that artists provide the title. For instance, Giorgio Vasari, in his *Lives of the Artists*, published in 1568, makes reference to a variety of paintings and sculpture by their creators, subject matter, location, and patrons, but the actual artworks have no separate names. Titles may not have been deemed necessary when biblical or mythological scenes were depicted—*Madonna and Child* or *The Resurrection*—that everyone knew, or when the work was a portrait: Leonardo da Vinci never referred to *La Gioconda* or, as it better known in the English-speaking world, the *Mona Lisa*.

No one actually knows when titles by artists became standard practice. It may be assumed that artists would begin furnishing their own titles when they started producing artwork independent of patrons or sold by art dealers, a situation that developed in seventeenth-century Holland. However, according to several European art curators at the Metropolitan Museum of Art in New York, there was basically no such thing as artists giving titles to their works in Holland at this time.

Inventories gave descriptions of what the compiler saw, and the titles of secular works were usually generic (such as, still-life, merry company, landscape with figures). An exception is Vermeer's *The Art of Painting* that was called so by the artist's wife shortly after his death.

Some titles refer to the location of the piece (Van Eyck's *Ghent Altarpiece*, for example) or are simply descriptive, such as Alfred Sisley's *Still Life: Apples and Grapes*, which he painted in 1876, four years before Claude Monet painted his own *Still Life: Apples and Grapes*. Neither artist ever recorded such a title in his letters or diaries, so it is unclear where these names came from; it is very likely that a dealer or collector provided the title.

San Francisco art dealer John Pence noted that he will regularly *interject suggestions* when artists bring in untitled pieces. "Certain words come up when I see a painting." He added that "sometimes, *Untitled* is a perfectly good title, but in general I don't think it's a good solution. And, if artists use it too frequently, it can be a serious bookkeeping problem for the gallery in keeping track of what has been sold to whom."

At times, Pence will suggest a change in a title where the artist has used words improperly or unwisely ("it shows ignorance") or add to a title when it might be more specific. Instead of just saying *Portrait*, Pence recommended naming the subject; in a landscape, the particular locale would be mentioned. "It doesn't hurt to say Yosemite rather than just a geyser." Again, he claimed that the value of specificity was to the artist and dealer, rather than to the collector, who generally doesn't care what the work is titled.

Artists are also creatures of habit, who may pursue the same or similar subject in a number of works but need titles that differentiate between them. "Jacob Collins uses the same titles again and again," Pence said. "I tell him, 'Maybe, you should call this one *Vanitas 3.* "

Dealers may be the most common source of titles, but not the only ones. Edouard Manet painted his most famous work, *Olympia*, in

1863 but had no name for it. The poet and critic Charles Baudelaire referred to it the following year as *Nude with a Black Cat*, but it was Manet's friend Zacharie Astruc, a critic and fellow painter, who named the painting *Olympia*, which Manet used when he submitted the work to the 1865 salon. Art critic Clement Greenberg devised poetic names (*Lavender Mist*, *Cathedral*, or *Alchemy*) for some of Jackson Pollock's paintings—the artist himself had only given them numbers (*Number 27, 1950*, for example)—and Jack Levine credited his wife with providing the title for his painting *Gangster Funeral*, which now resides in the collection of the Whitney Museum of American Art. The title of Levine's most renowned painting, *The Feast of Pure Reason*, he found in the night town scene of James Joyce's novel *Ulysses*, which the artist had been reading in 1937, the year he created the painting. The *Telemachus* character in the novel, Stephen Daedalus, is "knocked down by two constables," Levine said. "They knock his glasses off and he loses his stick. Leopold Bloom, who helps the young man onto his feet says, 'Your stick, sir.' And Stephen says, 'Stick? What need have I of a stick in this feast of pure reason?' "

chapter

10

Spending Money, Making Money

Art is often expensive to buy, but it also may be costly to make—and, then, to insure, frame, crate, ship, and promote. As in any other business, artists look to make money but, in order to do so, they may need to invest some money. Some of these expenditures are undoubtedly necessary—without art supplies, works cannot be created, for instance—but others need to be taken on faith. Publicists, whose work was discussed in chapter 1, may generate media attention (or they may not), but if and when they do it is never fully clear that their work (and the costs involved) is paid for by additional sales. Health insurance, which is discussed in chapter 11, is another expenditure that may or may not be cost effective: What if you don't get sick? Or, if you get sick once in five years but the medical attention received would have been cheaper if paid out of pocket than through monthly or quarterly HMO payments, was having health insurance worth it? Artists may choose to become a corporation, in order to limit their liability in the event of a lawsuit, but these suits are quite rare, only leaving them owing money to lawyers, accountants, and the attorney general of the state in which they live. Other artists may decide to invest in the services of a career coach, who will help them devise a marketing strategy, create press materials and even arrange exhibitions, but no amount of marketing savvy and glossy brochures will sell artwork that no one wants to buy. Much about an artist's life is taken on faith.

Artists and Advertising

If it is difficult to determine whether expenditures are warranted in the case of publicity, insurance, and career development, it is just as difficult with regard to advertising costs. Gail Wells-Hess, an artist in Portland, Oregon, spends roughly $6,000 per year on something that many people would view as quite ethereal: "creating a presence." That money pays for advertising her paintings in magazines. If the goal of those ads were limited to selling her paintings, it is not clear that the money would be well spent at all, since most of the people who call or e-mail her (that information is listed in the ad) "get sticker shock when they find out what my paintings cost," she said. "A lot of people think that a painting should cost $100." Sometimes, galleries have contacted Wells-Hess based on her advertisements, inquiring about exhibiting her paintings, and some sales have resulted from that, but can anyone say that the ad created those sales or that the work of the gallery owners did? Advertising itself has an ethereal quality that requires belief in its power and effectiveness, often defying simple cause-and-effect and leading Wells-Hess to claim that she is "not trying to sell a painting but to create a name and presence." Toward that end, she has even advertised paintings that cost less than the ad itself. "Selling the painting is an added treat, when that happens."

Based on the increasing quantity of artists' advertisements found in art and other consumer magazines, a growing number of other painters and sculptors have a similar idea. Seeing a painting reproduced in a magazine, even though the publication received money to publish it, has the mysterious effect of elevating the stature of the artwork and the artist in the eyes of readers, many artists, and gallery owners claim. Bill Mittag, a painter in Phoenix, Arizona, who spends $10,000 per year on ads in *American Art Review* and *Southwest Art* magazines, noted that whatever painting he uses in the advertisement is usually snatched up by a buyer early on. As a result, he created a Web site in order to direct callers to other examples of his work. "I'll advertise 'till I die," he said. Mittag's paintings are exhibited in eleven galleries west of the Mississippi River, and most of the sales of his artwork take place in those galleries, but they only advertise his paintings when there is

a one-man show, which doesn't take place very often. In addition, many of the galleries have only seasonal markets, and this leads to long stretches of time when public attention is not paid to his work. The ads, he believes, keep people interested in his work throughout the year and, when he is called or e-mailed by potential collectors, "I refer them to whatever gallery is closest to them."

Certainly, some artists want to make direct sales as a result of their ads, and those happen, too. Huntington, Massachusetts, sculptor Andrew DeVries, whose annual advertising budget is in excess of $35,000, noted that the first ad he ever placed, in the *Maine Antique Digest*, "resulted in the sale of a $36,000 piece." (The buyer saw the ad and called him up.) On the other hand, the ads placed in *American Art Review* by Camille Przewodek of Petaluma, California (costing from $2,000 to $5,000 per year, depending upon their size) have produced "very few" sales through the artist's Web site, where readers are directed. However, collectors do visit her Web site (a "hitometer" counts those) and learn where the artist will be traveling next. "I love to travel," she said, "and I do so as much as I can." She teaches between three and five art workshops annually, attends Plein-Air Painters of America events (of which she is a member), and visits the galleries that display her work. "A lot of people like to meet the artist. They don't fly somewhere to meet me, but if I'm in town or not that far away they come out to meet me." Half of her sales come about from meeting people who have seen her work in an advertisement. Considering the cost of travel, the ads may be the least expensive element in her marketing strategy, and Przewodek's approach raises the question of how many people would purchase her work if they didn't meet her, but she is firmly convinced that advertising is the key element to her sales success.

"Advertising brings credibility," she said. "It says to the world, 'I am a serious, committed artist.' People who look at the ad see success, because I can afford to advertise."

Belief in advertising often leads to beliefs about how to advertise. Noting that subscribers tend to keep art magazines around for months or years and may look at the same advertisement again and

again, Palo Alto, California, painter Lesley Rich said that artists should "use a good image" in the ad, "not one with bad design or things wrong with it. Why have your name connected with something shabby?" Gail Wells-Hess claimed that certain colors and subjects were "guaranteed to sell" and should be included in ads, such as red poppies in Summer issues and "a pear or still-life in the Winter." Strong, contrasting colors are the key, to Bill Mittag's mind, because "light colors will wash out on you" in the reproduction and the four-color separation process used in printing the ad will not adequately capture a delicately blended tone. Anatoly Dverin, a painter in Plainville, Massachusetts, stated that he only buys full-page ads, because "I don't want to share the page with another artist; it creates competition. The other artist may use, I don't know, some combination of red and blue that kills the balance of color in my painting." People only start recognizing your name, said Andrew DeVries, if there is something else going on, such as an exhibition or an opportunity to meet the artist where potential buyers can go in person—"by themselves, ads can't do it all."

The purpose and nature of advertising is a subject on which there is considerable disagreement, although there is one point on which everyone agrees: One needs to think of advertising as a long-term, rather than a one-shot, effort. To develop name and artistic recognition, the same or similar images must be present in ads that follow one magazine issue after another. Many artists split the costs of advertising with their galleries in advance of an exhibition, and some galleries carry the entire expense, but it is rare for a gallery to pay in full or in part to advertise an artist when there isn't a show. If the concept is to keep one's name and images before the public on an ongoing basis, one-shot ads are not likely to produce the desired results. Too, galleries generally have a local audience, and the advertisements they place are likely to be in local or regional publications rather than national ones.

Different gallery owners have their own purposes in mind when they place an advertisement in a newspaper or magazine, and they may not be quite the same as the artist's. For them, advertising increases attendance rather than sales, as those who visit once may come again

(buying work, if not by the artist on display on the first visit, by a different artist another time), and it improves the chances of media coverage (the publishing's world dirty secret).

Galleries usually have sizeable budgets for advertising and promotion—promotion refers to press packages, which are intended for the media, rather than advertising that is aimed at the general public—and they buy ads for every exhibition, although the amount of advertising and the nature of the particular ads are dependent upon the importance (and the volume of sales) of the particular artists. Artists who want to stay in the public eye between shows find that they must take on the job of year-round advertising. "If you're going to advertise," Wells-Hess said, "the trick is to make a commitment for at least a year, because you can't judge the response in less than one full year."

A year of advertising can be a great financial burden on an artist, especially if the aim is not direct sales but largely keeping one's name and art in front of the collecting public. The bimonthly *American Art Review*, which is a relatively inexpensive art publication in which to advertise, charges $3,295 for a single full-page ad and $1,895 for a half-page (smaller ads are also available); there is a price break for each additional ad taken out in the course of twelve months, which may be helpful because "most artists tell us they didn't really sell a painting until after three or four ads," according to Tom Kellaway, editor and publisher of the magazine. Prices are higher at *Art & Antiques*, where a full-page ad costs $9,200 ($8,640 per ad if one purchases three and $7,910 per ad for six), a half-page is $6,080, one-third of a page is $5,070, and one-quarter page is $3,680 (again, with price reductions for buying a series of three or six). *ARTnews* also lowers prices for repeat advertisers, with one-time, four-color full-page ads costing $8,300, and a half-page at $5,975. (For three ads, the full page rate is $8,050 each, and half pages cost $5,650 each.)

With cash flowing outward, it may be quite understandable if artists panic after an ad or two does not produce any sales or commitments from a gallery. "I got one call from an interested buyer," said John Loughlin, a painter in Lincoln, Rhode Island, who placed ads in two issues of *American Art Review*. "I quoted a price, and he never got back

to me. I don't know if I will do any advertising again. It's good to get exposure, but that doesn't put bread on the table." Many artists, even those who strongly believe in making a long-term commitment to advertising, recognize that a lot of the money they spend will produce nothing and, even when there are results, they cannot always point with certainty that the ads were the principal cause. The only call that Anatoly Dverin received one month after placing an ad in *American Art Review* was from a sales representative from another art magazine, asking him to advertise there. Robert Gamblin of Portland, Oregon, who founded a paint supply company and paints on the side, noted that he "got really close once" to a sale when he "shipped a painting to someone in California who wanted it on approval." Unfortunately, that person sent the work back. Another true believer, Michael Budden of Wrightstown, New Jersey, called his advertising plan a success: "Of course, if measured in terms of actual sales, well no, it hasn't been successful; but if measured in terms of recognition, then it has been a big success, because people have seen my ads. People tell me, 'I saw your ad.' Down the road, I expect some of them to become buyers."

As one decision leads to another, artists who take on the job of advertising their own artwork also assume the role of selling their work directly to the public—regardless of whether or not they are currently represented by galleries—and must create the mechanisms for these sales (Web sites, employees, brochures, a dedicated telephone line, crating, shipping, framing), which adds to the overall expense. Few people are like Bill Mittag, who will pay thousands of dollars for ads simply to refer potential buyers to his dealers. Yet, as Wells-Hess claimed (and many other artists agree), direct sales are not the main purpose or goal of advertising. Artists need to have all the personal qualities that can sell their work directly but may not have abundant opportunities for putting those qualities to use. Because "75 percent of the time, the people who respond to my ads are shocked by the prices of my work," Wells-Hess uses that time on the telephone not to make a sale but "as an opportunity to educate people about what art costs and why it's worth it. Maybe I'm nurturing a potential art patron."

In some ways, advertisements for artwork are at a disadvantage when compared to advertisements of more mundane objects. A photograph

of a kitchen appliance or other product in an ad sells, not only the machine itself, but a sense of what it will mean in one's life: This car will impress my friends; that coffee maker will make great espresso for dinner parties; this food processor will allow me to make gourmet treats in just minutes. In effect, these ads offer an image of one's own ideal life rather than just a thing with a specific use. However, when showing works of art, ads present just the images themselves, and potential buyers must imagine how the artwork would fit into their lives and homes. Also, as photographic reproductions of art in ads are shown smaller than the originals, in almost all cases, they tend to conceal the very details that give them character. That is one reason that Internet sales of artwork have been so lackluster.

Advertising does offer the opportunity to establish name recognition and, along with the familiarity of seeing someone's name or images repeatedly, a sense of celebrity: People know the names of more laundry detergents than they ever will use. (This may be the reason that art advertising may add to the number of inquiries or visitors to a gallery without necessarily increasing sales of artwork.) The magazine advertisements for Lexington, North Carolina, landscape painter Bob Timberlake often feature a photograph of him and his name in large type, with much smaller reproductions of his paintings underneath, as well as information on where his works may be seen or purchased. "What you do in advertising is the same thing over and over, so that people recognize you when they see you," Timberlake said, noting that he has been interviewed repeatedly about his artwork on television. "I've been told that I'm recognizable and that the name Timberlake is recognizable."

He spoke disparagingly about most artists' advertisements, which largely consist of one large reproduced image in a one-time ad, as not being part of any marketing plan. He places ads in the same publications on a regular basis, in order to familiarize readers with his name. "Do I want to sell the name or the product?" Timberlake asked. "I want to sell the name, because you'll see the name many more times than you'll see that one picture."

Some artists find that advertising is just one element in the process of establishing control over their own careers. The number of galleries

that will doggedly pursue collectors through paid ads and other means throughout the year are few and far between, which regularly frustrates artists. (It may frustrate some art dealers, who find that the artists they represent take out ads and make direct sales, setting themselves up in implicit competition for sales with the gallery.) For others, advertising is the means to an end. Both Camille Przewodek and Michael Budden stated that they would like a gallery to take on the job of selling their work directly in order that they could be less involved in the business of being an artist and more of a full-time creator of art. "I want someone else to promote my work," Przewodek said, "but there aren't many galleries that will do it, and I also find that I am better and more creative at promoting myself than anyone else."

Incorporating

Owen Morrel, a New York City sculptor, has a lot of publicly installed works to his credit, any number of which have been sited on the roofs of major Manhattan landmark buildings. In the same breath, Morrel also announces that he has "a wife and family, a home, a dog and a cat, a car, skateboards and computers, a lot of this and that." Most people like to separate the personal and professional sides of their lives, but he knows that any lawsuit resulting from his work—it falls down on someone, someone helping to install it gets hurt, a supplier isn't paid, some point in the commissioning contract is neglected—could wipe him out. "We live in a litigious society," he said, "and I don't want it all to be taken from me if someone is unhappy about something and decides to sue me for everything I've got."

As a result, Owen Morrel became Owen Morrel, Inc., a corporation of which he is the principal shareholder and employee (there are some part-timers). Anyone who wants to bring a lawsuit concerning Morrel's work may only go after the assets of the corporation, rather than those of the artist himself. Setting up and operating a corporation, which includes holding annual meetings, taking minutes, and electing officers aren't what students are taught in art schools. In addition, incorporating is not an inexpensive process, because fees much be paid to lawyers and accountants, as well as to the secretary of state

when the business is set up and annually to accountants and the secretary of state thereafter. Since 1978, when Morrel first became a corporation, he estimated that he has paid out between $40,000 and $60,000 in fees—"the down payment on a Ferrari. But I sleep at night, and I think it's the right thing to do."

An artist's business entity won't alter how an artist creates but only how he or she operates as a profit-making operation. The corporation might have a single shareholder (the artist) who elects the officers (the artist) who hires employees (the artist), and these employees are paid by the corporation, which receives all payments for sales and commissions. The artist's pension and health insurance may also be provided by the corporation. One clear benefit to incorporating is that, while a self-employed artist—in Internal Revenue Service jargon, a "sole proprietor"—may deduct only a portion of his or her health insurance expenses on the annual tax returns, a corporation is permitted to deduct the full amount.

There are different types of business entities that artists may establish. Some artists form C-Corporations, and must pay a corporate income tax, as well as taxes on their personal income, but can deduct their salaries as business expenditures, carry forward losses, and reinvest profits back into the company. In a C-Corporation, the first $50,000 in profits are taxed at 15 percent, which is considerably less than what an individual netting $50,000 might pay to the federal government. Many other artists form S-Corporations, which file returns to the federal government but do not pay tax at the corporate level and distribute profits back to the artist-shareholder at the end of the year (on which the artist pays income tax). Yet other artists have established partnerships or the newer creation, limited liability companies, which (like S-Corporations) pass through all earnings to the artist and permit a greater flexibility in setting up and running an organization than the more traditional corporation.

For most artists and craftspeople, incorporating wouldn't make any sense at all, especially if they don't earn a sizeable amount of money from the sale of their work. Worries about being sued for breach of contract or as a result of dispute with a supplier or because an assistant

is injured on the job are remote for most painters and other artists. "Why should I set up a corporation?" painter Frank Stella said. "Why would anyone want to sue me?"

Even when incorporating does make sense, certain aspects of running a corporation can seem almost ludicrous, especially when the business consists of just one or two people. Kent Ullberg, a sculptor in Corpus Christi, Texas, and his wife, Veerle, are the sole shareholders, directors, and officers of Ullberg Studios, Inc.—he is president and treasurer, while she is vice-president and secretary ("Actually, I think I do most of the treasurer's job, too," Veerle said). Once a year, they formally meet to write up annual meeting minutes "what we've been arguing about like hell all year: what we should buy, what we should invest in," he said. "When you're just two people, and married at that, it does seem a little absurd to say we will only talk about our plans at an annual meeting. A lot of things we discuss at the dinner table."

On the other hand, "meetings take place all the time" at the studio of Glenna Goodacre, Ltd., the corporate entity of Santa Fe, New Mexico–based sculptor Glenna Goodacre, according to her studio manager, Daniel Anthony, "so it's really no problem to have one of these meetings be our annual meeting."

There are a number of reasons that artists and craftspeople set up corporations, partnerships, or limited liability companies, but protecting themselves from a lawsuit is a central concern. Artwork sometimes can be the cause of death or injury to people working on it or to bystanders, resulting in a legal action: One of the umbrellas installed on a California hillside by the environmental artist Christo was uprooted by a strong wind, killing a tourist; a child was hurt after falling off a Goodacre sculpture he had ill-advisedly climbed. The corporate entities created by these artists protected their personal assets from any claims that were made. "When the specific project has a tendency to be dangerous, I always recommend incorporating the project," said Christo's Chicago attorney, Scott Hodes. In fact, Christo's "Umbrella Project" was separately incorporated to "further insulate the artist from any claims that might be made. When the project is over, and after the statute of limitations has run and you have paid off all the debts of the

project, you can close the corporation, which leaves nothing for anyone to go after if they feel like suing you."

Lawsuits against artists can come from all directions: Someone visiting an artist's studio, such as during an open studio event, may get injured; also in the studio, a paint bucket or can of turpentine could spill and ruin someone's dress, or a toxic substance might cause an allergic reaction. Equally, collectors may become upset if the fragile objects they bought are damaged, accusing the artist of not making it sufficiently durable. Of course, a corporate shield would not protect the artist personally in the event that an accident is the result of gross negligence or demonstrably shoddy workmanship; the corporation would not protect the assets of an artist who infringes on another artist's copyright. However, if there is a "contractual dispute between an artist and a supplier, the supplier couldn't go after the artist personally but only after the assets of the corporation," Hodes said. "That takes away a lot of the supplier's leverage and will make the supplier more likely to settle the dispute rather than go to court."

There are occasions when suppliers and creditors attempt to get around the corporate protections. Josh Simpson, a glass artist in Shelburne, Massachusetts (Josh Simpson Contemporary Glass, Inc.), noted that "you can borrow money as a corporation, but then at the closing, the bank will ask that you also personally sign for the loan, so they can still go after your home, your first-born, everything."

As noted above, a corporate identity isn't for every artist. "I don't recommend that artists incorporate," said Ralph Lerner, a New York attorney and the author of *Art Law*. "It's extra paperwork and, anyway, most artists don't comply with the requirements set out in the law." The tasks of sending out notices for meetings, holding those meetings, and taking minutes at them would strike most artists "as a needless burden, which they may follow through on the first year but not bother with after that. Artists just do things the way they always do and think that by having a corporation they get to avoid paying so much in taxes and getting sued." Individual and corporate roles may be further confused when the business operates on a July–June annual cycle, whereas artists file taxes based on a calendar year.

Another Manhattan lawyer, Ronald Spencer, who represents the Jackson Pollock-Lee Krasner Foundation, also worried that artists won't "keep up the structure of the corporation and will mix up their own finances with it." The potential problem arises if there is a legal claim against the corporation. "A creditor knows that there aren't a lot of assets in the corporation to go after, but, if the creditor can show that the artist hasn't abided by the rules, then it can be claimed that the corporation is really a sham corporation, basically the alter ego of the individual artist-shareholder." The result is what lawyers call "piercing the corporate veil," allowing the party bringing a lawsuit to go after the artist's personal assets. The more successful the artist, the more paperwork that person will have when documenting expenses and revenues, requiring the artist to observe the legal niceties that the federal and state governments require in order to preserve their limited liability. Some artists find that it is simply easier to turn the technical issues over to lawyers and accountants, which adds to the cost, even though their main reason for forming a corporation was to save on taxes.

Trouble may also arise if an artist sets up a business entity simply as a means of escaping financial responsibility. Louise Nevelson's Sculptotek, Inc., for example, was successfully challenged in 1996 by the Internal Revenue Service in Tax Court for excessive administrative costs, all charged on tax returns as deductions, which the IRS viewed as tax evasion. As the artist had died some years earlier, her estate was charged with a substantial tax and penalties, and the lawyer who had set up Sculptotek, Inc., was later sued for malpractice.

As a practical matter, artists principally concerned about liability claims can obtain liability insurance policies on their own, the same type that they could purchase as a corporation. "That's really what most artists do," said John Silberman, a New York City lawyer who represents artist Richard Serra, whose large metal abstract sculptures have twice killed workmen installing them. "You don't need all the other stuff."

Deciding whether or not to form a corporate entity may be a toss-up for those artists and craftspeople in the position to establish one. Susan Duke Biederman, a New York attorney, worried that "incorporation

might have a chilling effect" on organizations and agencies that provide grants and fellowships to artists—"it sounds like they're businesses, not artists." Josh Simpson also described a "pejorative bend" to the idea of an incorporated artist. On the other hand, Kent Ullberg claimed that providing a corporate identification number to suppliers "gives you formal heft, makes you more legitimate even though you're just a little studio." The decision to incorporate may also depend on the types of risks one faces on a regular basis and, as Owen Morrel suggested, how much protection an artist needs to get a good night's sleep.

Soliciting Investors

For all the talk about how the art world is really an industry and how artists should think of themselves as being in business, actual examples of corporate behavior in the fine arts often comes as a surprise. Two sculptors, Zachary Coffin in Atlanta, Georgia, and Sharon Louden in New York City, have applied business models to financing the creation of recent work, both developing a prospectus and soliciting investors, both offering the opportunity for a significant return on investment.

For both artists, the plans grew out of the need for money to pay for materials and fabrication. In 2002, Louden was invited by the Kemper Museum of Contemporary Art in Kansas City, Missouri, to exhibit a yet-to-be-built sculpture in its main gallery. Sounds great: The exhibition would surely bolster the artist's career, and the imprimatur of a major art museum would likely improve the chances that the work might be purchased. The problem was the $20,000 cost of creating the work, entitled *The Attenders* and consisting of 16,105 individual pieces that are clipped together and hang from the ceiling. Louden and her husband, Vinson Valega, a jazz musician and former commodities trader, developed the idea of issuing shares to people who would invest in the work. The potential investors were a cherry-picked group, consisting of "people who had bought my work in the past or who had expressed interest in buying my work," Louden said. Between twelve and fifteen people were contacted, eight of whom agreed to contribute, combining to cover the $20,000.

Louden wrote up a prospectus for investors, describing 100 shares that would sell for $200 apiece and a return on investment ranging from 50 to 150 percent, depending on how long it took to sell the finished work: A $4,000 investment would be worth $6,000 if sold in the first year, $10,000 if sold in the fifth. If the work was not sold after five years, each investor would receive some portion of *The Attenders* for their own collections. As it turned out, the installation was purchased within months of exhibition by the Mayfield Village, Ohio–based Progressive Mutual Insurance Company, which has an extensive contemporary art collection (*http://art.progressive.com*), and each investor received his or her money back with a 50 percent profit. The project was successful enough to convince Louden to pursue the investing concept again, this time for $15,000, for a work that was displayed at the Neuberger Museum in Purchase, New York. "All the investors who did it before have expressed interest," she said.

A similar but more lawyerly approach was taken by Zachary Coffin, who created a limited liability corporation (LLC) to finance the creation of a monumental—65-ton assemblage of granite and steel—outdoor sculpture called *The Temple of Gravity* that was to be exhibited at the Burning Man Arts Festival in Nevada in August, 2003. The festival provided the artist an initial grant of $20,000, but that still left Coffin $60,000 short of the actual costs of fabricating the piece.

"In real estate, it's quite common for developers to form an LLC when they look to put up a building," said Atlanta lawyer David Decker, who added that he has "set up a lot of LLCs" for developers and formed one for Coffin. "The beauty of an LLC is that it can take out insurance to insulate the investors from claims, and it is only intended to have a limited life span. The investors come in, pool their money, the project is completed and sold, and then the money is distributed back to the investors, and the LLC is dissolved."

Investor-seeking LLCs are not unknown in the arts. Most theater productions that reach Broadway are either LLCs or a related entity, limited partnerships. They are also found in the film and music recording industries, where the search for financial backing

is essential for projects to proceed. Many fine artists will incorporate themselves as businesses, in order to purchase various forms of insurance and protect their personal assets from lawsuits, and those who create public artworks (murals and sculptures) often incorporate these projects for the same reasons. All of Christo's projects, for instances, are set up as limited liability corporations.

The ten actual investors—all from Georgia—who own the majority of shares of Coffin's LLC, bought in at $1,000 per share with a minimum purchase of five shares. These ten people—some of whom are collectors of Coffin's work or fans or friends of the artist or, in one case, the aunt and uncle of the corporation's business manager, Keith Helfrich, all personally contacted by the management team—may expect a 200-percent return on their investment, Coffin said, when the work is sold. "One of the investors had lost a lot of money in the stock market," he noted. "He knew my work and thought it a better bet than a mutual fund." As an incentive "goodie," all of the shareholders received the management team's prospectus affixed to a 50-pound slab of sculpted granite, suitable for pedestal or coffee table display.

The business plan of Gravity Group, LLC, is to exhibit *The Temple of Gravity* at a variety of locations, generating interest in the piece and eventually resulting in its sale to some museum, sculpture park, corporation, or other collector for an amount exceeding $200,000. So far, the sculpture has traveled to a spa in Desert Hot Springs, California, "and there have been a number of inquiries," Helfrich said, but no offers to purchase the work have come about as yet. "We expect and have explained to investors that the work may not be sold for several years," he said. "Investors have to be flexible."

Hanging over the corporation is the prospect that *The Temple of Gravity* may never be sold. An earlier outdoor sculpture for which Coffin created an LLC and found investors, entitled *Rock Spinner*, which was first exhibited in 2001, is still on the market. Helfrich noted that the corporation's business plan takes this possibility into account, as investors may deduct losses on their tax returns, based on

the actual expense of fabricating the sculpture and transporting it from site to site. "If it doesn't sell," he said, "we would have the work appraised and donated to a nonprofit or public institution, and then the investors would be able to declare a charitable contribution," declaring deductions on their tax returns based on their share of the corporation. Expecting the appraised value of *The Temple of Gravity* to top $200,000, shareholders would be able to deduct more than they actually invested.

The experiences of Louden and Coffin differ in a number of respects, but there is one glaring contrast. Coffin is a minority shareholder in the corporation that owns *The Temple of Gravity*, with 21.5 percent of the shares. His contribution was not cash but "sweat equity," based on his actual labor. (The corporation's management team—Helfrich and Corbett Griffith, an engineer who has performed structural safety tests—have received less than ten shares apiece as payment for their efforts. David Decker, the accountant, and even the corporation's Web designer [*www.templeofgravity.com*] all agreed to be paid in shares of the corporation.) Louden, on the other hand, did not own any shares of "The Attenders," only pocketing the net proceeds of the sale, that is, after the investors were paid. (She declined to reveal the selling price.) For her next project, however, "I will definitely buy shares for myself. I deserve to make a profit, too."

chapter

Help That Is Tailored to Artists' Needs

One regularly hears about the "art world," the "gallery world," and the "artist community" as though they were monolithic entities. In fact, there are many art worlds, niche markets, creators all striving to distinguish themselves from everyone else and numerous exceptions to every generalization. However, certain elements of forming and maintaining a career are common to most, if not all, artists. They need somewhere to work, somewhere to live, affordable materials to work with, medical care they can afford, and money to help them accomplish their goals. In this, artists are like everyone else in our society, but the concerns of visual artists are often peculiar to their type of work.

Workspaces and Residencies for Artists

Various types of assistance exist for artists. For instance, a group of 10 nonprofit organizations in New York State—known collectively as the Artists Workspace Consortium (*www.nysawc.org*)—provide free studio space, art materials, technical help, and a stipend to artists, and has developed a program to encourage more groups to assist emerging artists in the same way. These residencies are distinguished by the free materials and assistance artists receive, since they may be learning new skills and techniques. Many artists communities, such as Yaddo and MacDowell, offer artists space in which to work, leaving them alone during their period in residency. Staff of the Dieu Donne Papermill in Manhattan, on the other hand, work with artists learning to produce

handmade paper; in addition to twelve days in the studio, artists receive a $1,200 stipend. Similarly, staff at the Islip Art Museum on Long Island assist artists wanting a large space to create and display an installation in its carriage house; residencies range from two-and-a-half weeks ($500 stipend plus materials) to five months ($2,500 stipend plus materials). Sculpture Space, in Utica, which has brought in twenty artists per year since 1976 for two-month residencies, provides a $2,000 stipend, $100 transportation allowance, and free housing for its residents in addition to supplies and technical know-how. Each organization has its own guidelines—Sculpture Space limits its residencies to residents of New York and New Jersey, while the Islip Art Museum has arranged residencies for artists from abroad—but they all aim to provide time, space, and materials for artists, plus a little money.

"The emphasis at a workspace is on technical assistance," said Ann Kalmbach, executive director of the Women's Studio Workshop in Rosendale, New York, one of the consortium's members, which has residencies for four artists per year, lasting between six and eight weeks for which the artists receive a $2,000 per month stipend. "There is an active engagement with the artist. By learning new techniques, artists are able to push the boundaries of the medium they're working in."

The members of the Artists Workspace Consortium are:

The Islip Art Museum
50 Irish Lane
East Islip, NY 11730-2098
(631) 224-5402
www.islipartmuseum.org

Center for Photography at Woodstock
59 Tinker Street
Woodstock, NY 12498
(845) 679-9957
www.cpw.org

CEPA Gallery
617 Main Street
Buffalo, NY 14203
(716) 856.2717
www.cepagallery.com

Dieu Donne
433 Broome Street
New York, NY 10013
(212) 226-0573
www.dieudonne.org

Harvestworks
596 Broadway
New York, NY 10012
(212) 431-1130
www.harvestworks.org

Lower East Side Printshop, Inc.
306 West 37th Street, 6th Floor
New York, NY 10018
(212) 673-5390
www.Printshop.org

Sculpture Space, Inc.
12 Gates Street
Utica, NY 13502
(315) 724-8381
www.sculpturespace.org

Smack Mellon
92 Plymouth Street
Brooklyn, NY 11201
(718) 834-8761
www.smackmellon.org

Socrates Sculpture Park
32-01 Vernon Boulevard at Broadway
Long Island City, NY 11106
(718) 956-1819
www.socratessculpturepark.org

Women's Studio Workshop
P.O. Box 489
Rosendale, NY 12472
(845) 658-9133
www.wsworkshop.org

Health Insurance for Artists

No news to anyone, obtaining adequate and affordable health care and health insurance has become a major problem for a sizeable

portion of the population. And artists of all media and disciplines are among the most likely groups not to have any health insurance coverage. According to a survey sponsored by the National Endowment for the Arts, less than 75 percent of the composers, filmmakers, photographers, and video artists questioned have any form of coverage. Of all artists in larger cities, the survey found that 30 percent lacked health insurance. One of the reasons for this is the fact that most artists earn too little money to afford insurance; 68 percent of the artists in the survey had household incomes of $30,000 or less.

Perhaps the ongoing debate in the United States on how to provide coverage for the millions of people without health insurance will result in significant improvements. Perhaps the increasing prevalence of health maintenance organizations (or HMOs) may put out of business many of the arts service organizations that currently offer group-rate plans to their members, as artists may believe that they have less of a need to join such organizations. In this latter scenario, a lot of the career services that only service organizations provide will be lost to artists as well.

Until the health care situation is improved to include all citizens of the United States, regardless of their ability to pay, artists will continue to rely on their own sources of help and coverage. A number of literary, media, performing, visual arts, and crafts organizations provide group-rate health insurance plans for their members. Membership in the health insurance plan of some of these organizations is confined to artists residing permanently within the particular city or state, while extending nationwide in others. For example, the Chicago Artists' Coalition's health insurance program is available throughout Illinois and in some of the peripheral states around Illinois, such as Michigan and Wisconsin. Iowa, which also borders Illinois, is not eligible unless there were enough Coalition members seeking health insurance to warrant creating a group-rate program there. On the other hand, seven organizations—Artists Talk on Art, Editorial Freelancers Association, National Association of Teachers of Song, National Sculpture Society, New York Artists Equity, New York Circle of

Translators, and the Organization of Independent Artists—all use the same health maintenance organization, limited to the states of Florida, New Jersey, and New York.

The insurance industry is regulated by each state, and rates are higher in some states than in others. Massachusetts and New York, for instance, are "guaranteed insured" states, meaning that those wanting insurance coverage cannot be denied policies because of their health (preexisting condition), age, or sex. Medical care and services in New York are also more expensive than in most other states. Those higher costs and mandated coverage are factored into the prices of policies; as a result, New York policy holders are likely to pay more than their counterparts in Illinois or California. Other factors that drive up or down the cost of health insurance are age, gender, group, or individual policies, whether one lives in a city or suburb, the amount of deductible, the number of dependents, and various options one may attach to a policy (such as dental or mental health insurance).

Many of the organizations offering health insurance programs rarely ask detailed questions about what prospective members do in the arts or otherwise, and it is unlikely that, say, a musician would be denied a medical insurance claim for belonging to a primarily visual artist group. The American Craft Association, an arm of the American Crafts Council, wants its members to be involved in "the crafts or some related profession," and the Maine Writers and Publishers Alliance requires members to be self-employed.

Membership itself is usually not free, as annual dues range from $25 to $50, sometimes more. The costs of individual or group insurance cove-rage range widely, depending upon the particular plan and its benefits, the insurance carrier, state laws, and the number of people enrolled in the plan. Artists generally have been a more difficult group to insure because of industry concerns that they do not earn enough money to pay their premiums as well as that they do not generally take adequate preventive care—a result of their poverty—and require more expensive treatments. A number of insurance carriers also believe that artists as a whole are more likely to contract acquired

immunodeficiency syndrome, or AIDS, than other occupational groups, which has led to companies greatly raising premiums for, or completely dropping, plans that cover artists of all media and disciplines. There is no factual basis for this belief, but the subject of AIDS and negative ideas about artists in our society generally tend to exist well outside rational discussion.

Becoming a member does not immediately enroll an artist in an organization's health care program, and insurance carriers are permitted to deny coverage to any individual. Insurance carriers usually require new members to complete a questionnaire or take a physical, and enrollment for a health plan sometimes must wait for a period of months. Over the years, insurance companies have seen people join a group's insurance program in order that someone else pay for a needed operation and then drop the health plan after they have recovered. Artists need to look at health insurance as a long-term commitment, and they also should shop around for the most suitable membership groups that they are eligible to join.

A reason to buy insurance through an arts organization is that the coverage plans may be tailored to a particular group. Lenore Janacek, an insurance agent who has crafted insurance plans for artists' groups, noted that she looks for "companies that are sympathetic to artists. Artists, for instance, are users of mental health providers, so that should be part of the area of coverage. Artists are also interested in alternative forms of health care, so I look for companies that provide coverage in that area." Because artists may not have a lot of money, she noted that some artists are offered the choice of a basic Blue Cross plan, with some premiums as low as $35 per month.

Various types of health insurance plans are available, all with their own rules and enrollment requirements and procedures. Beyond the fee-for-service and HMO possibilities are also hospitalization (base plan, medical, surgical) and major medical insurance plans.

Among the questions to keep in mind when shopping for insurance coverage are: Who in your family is covered (someone with a

preexisting condition, dependents, and to what age)? What services are covered? Is there a waiting period (and, if so, what is it) before coverage begins for someone with a preexisting condition? Are there limitations on the choice of health care providers or where health care may be obtained? Is the policy renewable (guaranteed renewable: the company cannot cancel a policy as long as premiums are paid on time; optionally renewable: the company may terminate the policy on specified dates; conditionally renewable: the company may refuse to renew a policy for specified reasons)? What are the family and individual deductibles or co-payments? What is the average annual premium increase for the plan, and how high and under what conditions will premiums increase?

A valuable source of information on health care options for the arts community is the Artists' Health Insurance Resource Center (*www.actorsfund.org*), which was established by the Actors' Fund of America with support from the National Endowment for the Arts. Among the databases are individual and group insurance plans available by state, how to select an appropriate plan and links to other sources of information. The organizations offering health (and perhaps accident, dental, life, liability, studio, and disability) insurance include:

American Association of Museums
1225 I Street, N.W.
Washington, D.C. 20005
(202) 218-7673
(800) 323-2106
E-mail: *marketing@aam-us.org*
Health insurance available to independent curators, consultants, professional staff, artists, and volunteers working for museums. Membership fees range from $35 to $140.

American Institute of Graphic Arts
164 Fifth Avenue
New York, NY 10010
(212) 807-1990
(800) 548-1634
E-mail: *membership@aiga.org*
www.aiga.org

American Society of Interior Decorators
608 Massachusetts Avenue, N.E.
Washington, D.C. 20002–6006
(202) 546–3480
E-mail: *communications@asid. noli.com*
www.asid.org

Artists Talk on Art
19 Hudson Street
New York, NY 10013
(212) 965–9515
www.nearbycafe.com

College Art Association of America
275 Seventh Avenue
New York, NY 10001
(212) 691–1051
(800) 323–2106
(800) 503 9230
E-mail: *nyoffice@collegeart.org*
www.collegeart.org
Offering major medical, hospital indemnification, professional liability, cancer, and disaster insurance coverage. Membership fees start at $25 annually.

Graphic Artists Guild
90 John Street
New York, NY 10038
(212) 791–3400
E-mail: *PaulAtGAG@aol.com*
www.gag.org

International Sculpture Center
1050 17th Street, N.W.
Washington, D.C. 20036
(202) 785–1144
www.sculpture.org
Group-rate health insurance available nationally, except for those living in Washington, D.C., Maine, New Hampshire, New Jersey, Puerto Rico, and the Virgin Islands. Membership is $95 annually.

National Art Education Association
1916 Association Drive
Reston, VA 20191–1590
(703) 860–8000

Group-rate health insurance available to residents of Connecticut, but not New York or New Jersey.

National Artists Equity Association
P.O. Box 28068 Central Station
Washington, D.C. 20038-8068
(202) 628-9633

National Association of Artists' Organizations
918 F Street, N.W.
Washington, D.C. 20005
(202) 347-6350
E-mail: *naao2@artswire.org*
www.naao.org

National Sculpture Society
1177 Avenue of the Americas
New York, NY 10036
(212) 764-5645
(800) 722-0160
www.sculptor.org/nss
Membership is $40 annually

New York Artists Equity Association
498 Broome Street
New York, NY 10013
(212) 941-0130
E-mail: *reginas@anny.org*
www.anny.org
Group insurance coverage currently available only to residents of New Jersey, New York, and southern Florida. Membership is $35 annually.

Society of Illustrators
128 East 63rd Street
New York, NY 10021
(212) 838-2560

American Craft Association
21 South Eltings Corner Road
Highland, NY 12528
(914) 883-5218
(800) 724-0859

Health insurance plan was discontinued but will be restored with a new carrier. Continues to offer casualty and liability insurance.

Empire State Crafts Alliance
Contact: 501 West Fayette Street
Syracuse, NY 13204
(315) 472-4245
www.escacraft.com
Membership is $30 annually

Association of Independent Video and Filmmakers
304 Hudson Street
New York, NY 10003
(212) 807-1400
E-mail: aivffivf@aol.com
www.aivf.org
Insurance available only to those working a minimum of 30 hours per week in the field of film and video.

Group-rate health insurance plans are also offered by organizations of self-employed people, and artists may be qualified for membership:

ABG Business Associates. Ltd.
154 Commack Road
Commack, NY 11724
(516) 499-6100

American Association of Retired Persons
601 E Street, N.W.
Washington, D.C. 20049
(800) 523-5800
(800) 424-3410
E-mail: membership@aarp.org
www.aarp.org

National Association for the Self-Employed
2121 Princt Line Road
Hurst, TX 76054
(800) 232-6273
www.nase.org

Group-rate health insurance available for residents of Connecticut and New
Jersey, not New York. Membership fees dependent on a choice of three insur-
ance plans—$72, $240, or $360 annually.

National Association of Socially Responsible Organizations
3204 18th Street, N.W.
Washington, D.C. 20010
(800) 638-8113
www.nasro-co-op.com

National Small Business United
1156 15th Street, N.W.
Suite 1100
Washington, D.C. 20005
(202) 293-8830
(800) 345-NSBU
www.NSBU.org
Membership is $75 annually

Small Business Service Bureau
P.O. Box 15014
Worcester, MA 01615-0014
(508) 756-3513
(800) 343-0939
Membership varies by state, starting at $85 annually

Support Services Alliances
P.O. Box 130
Schoharie, NY 12157
(800) 836-4772
www.ssainfo.com
Membership is restricted to residents of New York State. Membership fees are
determined by the number of people in the group.

United States Federation of Small Businesses
249 Greene Street
Schenectady, NY 12305
(800) 637-3331
www.usfsb.com

Working Today
P.O. Box 1261 Old Chelsea Box Station
New York, NY 10113-9998
(212) 366-6066
E-mail: Working1@tiac.net
www.WorkingToday.org

Artist Housing

Before the arts were thought of as good for the economy and setting up house in abandoned factories was seen as chic, artists sought inexpensive places to live and create their work. Some of the most prized works of art of the postwar era were produced by artists living and working illegally in an area of lower Manhattan that, at one point in the 1960s, was slated for demolition as part of an urban renewal program. Within ten years of the cancellation of that plan, finding a spacious high-ceilinged, huge-windowed home in a one-time manufacturing plant had become all the rage, stemming the exodus of the upwardly mobile from the city to the suburbs and leading city leaders to legalize loft-living. (The term "Yuppie," for young urban professional, came into use, describing the new face of city living.) This scenario was repeated in Boston, Chicago, Los Angeles, Minneapolis, and a variety of other cities around the country.

However, as the middle-class was drawn back into the cities, building owners raised rents significantly to take advantage of the higher incomes, displacing the artists who had pioneered loft-living. (The term "gentrification" came into use to describe this phenomenon.) Artists found themselves where they had started decades before, looking for inexpensive space in which to live and work. The situation could be endlessly repeated—move in, fix up, get priced out—but nonprofit groups, private developers, and governmental agencies have worked together in a number of cities around the country to create permanent, affordable live–work space for artists. Perhaps, the most active housing developer for artists is Artspace Projects in Minneapolis, which has taken ownership of, and renovated, twelve buildings in Minnesota and has worked with other groups in creating artist housing in Connecticut, Illinois,

Maryland, Michigan, Nevada, Oregon, Pennsylvania, Texas, Washington, D.C., and Washington State.

Artspace started out as a housing referral agency for artists in the 1970s; members of the organization identified buildings that would be suitable for artists and negotiated lease agreements with landlords for potential tenants. However, the organization found itself running on a treadmill, endlessly talking with landlords and never catching up to the problem. "Artists would get into a building, but then the process of gentrification began and, soon enough, artists would be back out on the streets again," said Teri Deaver, a project manager for Artspace. "We realized that we were not doing these people any good." In 1982, the organization began the process of becoming an artist live–work space developer, purchasing its first building, the Northern Warehouse in downtown St. Paul, and creating fifty-two units for artists four years later.

Working with groups in both Washington, D.C., and Seattle, Artspace Projects has taken part in the construction of new buildings for artists, but the focus has primarily been on rehabilitating older ones, for two main reasons. Older, industrial buildings seem particularly suited for artists' lofts, since they originally were designed to bear the weight of heavy machinery (helpful for sculptors, for instance), have high ceilings, and large windows (providing a substantial amount of natural light, which helped the former factories operators keep down the costs of electricity), and are quite spacious. "It's very expensive to build something from scratch with twelve foot-tall ceilings," said Will Law, chief financial officer at Artspace Projects, "but old warehouses already have them." A second reason is that there is a greater number of funding sources for the renovation of buildings than for new construction.

The financial underpinning of Artspace Projects' artists sites is complicated, consisting of a patchwork of funding sources. The principal mechanism is the sale of tax credits, such as for historic preservation, affordable housing and environmental cleanup, which provide between 40 and 75 percent of the total costs. (As a means of encouraging housing initiatives by private developers, the federal

government may award not actual money but, rather, a certain number of tax credits, based on the cost of the project. These tax credits are then sold to individual companies with substantial tax liabilities or, more often the case, to companies set up by tax attorneys, which resell the tax credits to a variety of corporations. They may use those credits over a ten-year period. The initial recipient of the tax credit—the developer—receives real money, usually between 75 and 80 cents on the dollar for the value of the tax credit, which then goes toward construction or renovation.) The remaining financing usually is provided by foundations, government grants, and through bank loans.

The issue of income eligibility is a very serious concern at these units; tenants who don't actually qualify could result in the government revoking the tax credit and lead to the purchaser of the credit suing the developer. Other than income eligibility, individuals must present proof that they are practicing professional artists, and artists housing projects often form a committee to evaluate an applicant's portfolio and references.

The buildings that Artspace Projects and other, similar live-work developers refashion are not exclusively for fine artists. Writers, musicians, performers, craftspeople, graphic designers, and even, in some instances, hair stylists who can make a case that theirs is an art form are eligible for rental or purchase units. Because the buildings will be both residential and studio spaces, the admissions committee may deem inappropriate those applicants whose work may involve noxious fumes or heavy, loud machinery. An artist may employ other people in the studio as assistants or bring in collectors to look at work, although either or both may pose a parking problem for other tenants, but not use the studio strictly as a retail space, such as a commercial art gallery. The studio cannot be used as an additional bedroom, either. Similarly, a plein air artist may be subjected to tougher questions about how much he or she actually needs the studio space or whether it will mostly be used for storage.

Most of Artspace Projects' tenants stay as residents for at least five years, and some considerably longer, which compares favorably to other affordable housing projects that do not focus on a specific occupation.

Among the private nonprofit and public agencies pursuing affordable artist housing initiatives around the country are:

California

ArtHouse
Fort Mason Center
Building C, Room 255
San Francisco, CA 94123
(415) 885-1194

ArtHouse Oakland

c/o C.L.A.
1212 Broadway Suite 834
Oakland CA 94612
(510) 444-6358
www.arthouseca.org

District of Columbia

Cultural Development Corporation of D.C.
916 G Street, N.W.
Washington, D.C. 20001
(202) 315-1305
www.culturaldc.org

Illinois

Acme Artists
2418 West Bloomingdale
Chicago, IL 60647
www.acmeartists.org

Massachusetts

Boston Redevelopment Authority
One City Hall Square
Boston, MA 02201
(617) 722-4300
www.cityofboston.gov/bra/artist/artist.asp

Michigan

The Enterprise Group of Jackson
414 N. Jackson Street

Jackson, MI 49201
(517) 788-4455
www.enterprisegroup.org

Minnesota
Artspace Projects, Inc.
250 Third Avenue North
Minneapolis, MN 55401
(612) 333-9012
www.artspaceusa.org

New York
New York Coalition for Artist's Housing
Brooklyn Arts Council
195 Cadman Plaza West
Brooklyn, NY 11201
(718) 625-0080
www.brooklynartscouncil.org

Rhode Island
Rhode Island State Council on the Arts
Artist Housing Initiative
One Capitol Hill, 3rd Floor
Providence, RI 02908
(401) 222-3880
www.arts.ri.gov

Utah
Artspace Utah
329 West Pierpont Avenue, Suite 200
Salt Lake City, Utah 84101
(801) 531-9378
www.artspaceutah.org

Washington
Office of Arts & Cultural Affairs
City of Seattle
P.O. Box 94748
700 Fifth Avenue, Suite 1766
Seattle, WA 98124
(206) 733-9576
www.seattle.gov/arts/

ArtSpace Projects
510 Sixth Avenue South
Seattle, WA 98104
(206) 271-0380
www.artspaceusa.org

Materials for the Arts Programs

Joe LaMantia is not the first artist to think of using discarded objects as the stuff of his artwork. Such artists as John Chamberlain, Richard Stankiewicz, Mark di Suvero, and, before them, Pablo Picasso, all made use of seeming trash for their sculptures, but they were obliged to sift through trash heaps and junk yards, mucking up their clothes in the process. The bits of cloth, scrap metal, bottles, and cans, paper products, and even a wig that LaMantia, who lives in Bloomington, Indiana, has used in his work, on the other hand, were all sitting neatly on shelves, clean and free for the taking. What Bloomington has that Picasso's Paris did not is a Materials for the Arts program, which solicits donations of industrial discards, discontinued products, and other items from area businesses and households that could be of some use to nonprofit arts organizations and artists involved in community projects. Run by the Monroe County Solid Waste Management District, the Materials for the Arts program gives away between two and three tons of stuff every month. "I go to the recycling center at least once a month with my pick-up truck," LaMantia said, as do many other area artists and public school art teachers.

This program, which exists in a number of other cities around the United States and goes by a variety of names (Materials Exchange Center for Community Arts, SCRAP, Arts & Scraps, Creative Reuse Warehouse, Wemagination, Crayons to Computers, among them), solves a variety of problems. For communities, it lessens the problem of mounting garbage. "We were hauling away so much trash, and we just said, 'This is ridiculous. Someone should be able to do something with this,'" said Mary Kay Baker-Hunter, supervisor of Bloomington's Materials for the Arts program. At first, the give-aways were limited to public school teachers but "then, that seemed unfair," she noted. "Bloomington is so big and has so many different groups

that could use this stuff—like the Boy Scouts or Big Brother/Big Sister—that we decided to make it available to everybody."

Businesses also appreciate the program, because they will not have to pay to dispose of or to store unused items, and they are entitled to take deductions, up to twice the cost of particular items if the fair market value is higher than the cost. For artists, art teachers, and others pursuing arts activities (such as art therapists in nursing homes), the Materials for the Arts program permits a wide range of art making that might not have been as possible before. "I feel guilty I'm getting so much for nothing," said Jim Pallas, an artist in Grosse Pointe, Michigan, who has taken advantage of Detroit's Arts & Scraps to outfit his assemblage sculptures with bits of cloth, cable, wires, and metal. "The meaning that something had in its former life is transformed in the new work," he said.

Arts & Scraps, which was started in 1989, currently works with eighty area corporations that supply their reusable refuse, and it distributes approximately twenty-eight tons per year to schools, nonprofit arts organizations, and individual artists. The largest and oldest program of this sort is the Materials for the Arts program, run by the New York City Department of Cultural Affairs with secondary support from the city's Department of Sanitation, which began in 1978 and distributes 596 tons annually from more than 3,000 donor corporations. "We have only one truck to pick up everything," said program director Harriet Taub. "We could use three trucks." Unlike the programs in Bloomington and Detroit, New York City's Materials for the Arts program only allows public schools and nonprofit organizations to take items, although these objects are destined in most cases for artists and art teachers who will administer the particular arts project.

A variety of material reuse programs exist around the United States, a minority of which are dedicated to the arts (and only a fraction of those are available to individual artists). Most of these programs focus on the building trades (Habitat for Humanity, for instance, in numerous locations around the United States, or the Building Materials Resource Center in Roxbury, Massachusetts), public schools (such as the Teachers Supply Depot in Jacksonville, Florida, or the St. Louis

Teachers Recycle Center in Manchester, Missouri) and social services (Brother's Brother Foundation in Pittsburgh and the many food banks around the country).

There are a number of regional and national groups around the country that solicit donations of new and used materials from companies, making them available to artists and nonprofit arts organizations, including:

National Programs

Educational Assistance, Ltd.
P.O. Box 3021
Glen Ellyn, IL 60138
(630) 690–0010
www.ealworks.org
Serves the college community

Federal Surplus Personal Property Donation Programs
General Services Administration
Office of Federal Supply and Services, Office of Property Management
Washington, D.C. 20406
(202) 755–0268

Gifts In-Kind
700 North Fairfax Street
Alexandria, VA 22314
(703) 836–2121
www.giftsinkind.org
Provides materials for nonprofit organizations of all types

National Association for the Exchange of Industrial Resources
P.O. Box 8076
Galesburg, IL 61402
(309) 343–0704
www.naeir.org
Provides materials for nonprofit organizations of all types

California

Art From Scrap
Community Environmental Council
302 East Cota Street
Santa Barbara, CA 93101
(805) 884–0459

www.communityenvironmentalcouncil.org/artfromscrap
Provides materials for individual artists and nonprofit organizations

Creative Reuse/North Bay
P.O. Box 1802
Santa Rosa, CA
(707) 546-3340
E-mail: *creativeuse@earthlink.net*
Provides materials for individual artists and nonprofit organizations

East Bay Depot for Creative Use
6713 San Pablo Avenue
Oakland, CA 94608
(510) 547-6470
(510) 547-6535
www.eastbaydepot.org
Provides materials for individual artists and nonprofit organizations

Generation Green's Dumpster Diversion Project
Moraga, CA
(925) 671-7508
www.generationgreen.com
Provides materials for individual artists and nonprofit organizations

LA Shares
3224 Riverside Drive
Los Angeles, CA 90027
(213) 485-1097
www.lashares.org
Provides materials for individual artists and nonprofit organizations

RAFT (Resource Area for Teachers)
1355 Ridder Park Drive
San Jose, CA 95131
(408) 451-1420
www.raft.net
Provides materials for nonprofit arts organizations, as well as schools

SCRAP
Scrounger's Center for Reusable Arts Parts
834 Toland Street
San Francisco, CA 94124
(415) 647-1746
www.scrap-sf.org
Provides materials for individual artists and nonprofit organizations

SCRAP
Student Creative Recycle Art Program
Riverside County Fairgrounds
46-350 Arabia Street
Indio, CA 92201
(760) 863-7777
Provides materials for individual artists and nonprofit organizations

Colorado
Creative Exchange
5273 South Newton Street
Littleton, CO 80123
(303) 347-1193
www.creativexchange.org
Provides materials for individual artists and nonprofit organizations

Connecticut
Connecticut Materials Exchange
62 Cherry Street
Bridgeport, CT 06605
(203) 335-3452

Florida
Resource Depot
3560 Investment Lane
Riviera Beach, FL 33404
(561) 882-0090
www.resourcedepot.net
Provides materials for individual artists and nonprofit organizations

Reusable Resources Adventure Center
P.O. Box 360507
Melbourne, FL 32936
(407) 729-0100
Provides materials for individual artists and nonprofit organizations

Georgia
Materials for the Arts
City of Atlanta Bureau of Cultural Affairs
675 Ponce de Leon Avenue
Atlanta, GA 30308
(404) 817-6815
www.bcaatlanta.com
Provides materials for nonprofit arts organizations

Illinois

Creative Reuse Warehouse
222 East 135th Place
Chicago, IL 60627
(773) 821-1351
www.resourcecenterchicago.org
Provides materials for individual artists and nonprofit organizations

Indiana

Monroe County Solid Waste Management District
3400 South Walnut Street
Bloomington, IN 47401
(812) 349-2876
www.mcswmd.org
Provides materials for individual artists and nonprofit organizations

The Reuz Station for Arts and Crafts
The Hammond Environmental Education Center
2405 Calumet Avenue
Hammond, Indiana, 46394
(219) 853-2420
Provides materials for individual artists and nonprofit organizations

Kansas

The Recycled Materials Center (at the Children's Museum)
4601 State Avenue
Kansas City, KS 66102
(913) 287-8888
www.kidmuzm.org/links/recycle.html
Provides materials for nonprofit arts organizations

Louisiana

Recycle for the Arts
2831 Marais Street
New Orleans, LA 70130
(501) 949-0144
www.recycleforthearts.org
Provides materials for individual artists and nonprofit organizations

Maine

Ruth's Reusable Resources
1 Bessey School
Scarborough, ME 04074
(207) 883-8407
www.ruths.org
Provides materials for individual artists and nonprofit organizations

Waste Share
Auburn, ME
(207) 795-0972
www.artsandscraps.org
Provides materials for individual artists and nonprofit organizations

Maryland
The Loading Dock
2523 Gwen's Falls Parkway
Baltimore, MD 21218
(410) 728-3625
www.loadingdock.org
Provides materials for individual artists and nonprofit organizations

Reuse Development Organization
c/o The Loading Dock
2523 Gwynns Falls Parkway
Baltimore, MD 21216
(410) 669-7245
www.redo.org
The association of materials exchange programs across the United States

Massachusetts
Recycle Shop
Children's Museum of Boston
The Jamaica Way
300 Congress Street
Boston, MA 07130
(617) 426-6500, ext. 416
www.bostonkids.org
Provides materials for individual artists and nonprofit organizations

Community Resource/Recycle Center
38 Montvale Avenue
Stoneham, MA 02180
(781) 279-4658

Michigan
Arts & Scraps
17820 East Warren
Detroit, MI 48224
(313) 640-4411
www.Artsandscraps.org
Provides materials for individual artists and nonprofit organizations

Creation Station
200 Museum Drive
Lansing, MI 48910
(571) 337-8793
E-mail: *recycle@ci.lansing.mi.us*
Provides materials for schools and nonprofit organizations

The Scrap Box
581 State Circle
Ann Arbor, MI 48108
(734) 994-0012
www.scrapbox.org
Provides materials for individual artists and nonprofit organizations

USPS Project
4800 Collins Road
Lansing, MI 48924-9731
(571) 337-8793

Missouri

St. Louis Teachers Recycle Center
3120 St. Louis Avenue
Manchester, MO 63106
(636) 227-7095
www.sltrc.com
Materials for art teachers

The Surplus Exchange
1107 Hickory
Kansas City, MO 64101
(816) 472-0444
www.surplusexchange.org
Provides materials for individual artists and nonprofit organizations

Minnesota

Artscraps
1459 St. Clair Avenue
St. Paul, MN 55105
(651) 698-2787
www.artscraps.org
Provides materials for individual artists and nonprofit organizations

Minnesota Materials Exchange
MnTAP
University of Minnesota Gateway Center
200 Oak Street, S.E.
Minneapolis, MN 55455
(612) 624–1300
www.mnexchange.org

New Hampshire
Donation Network
21 West Auburn Street
Manchester, NH 03103
or
18 Franklin Street
Nashua, NH 03064
(603) 645–9622
Provides materials for individual artists and nonprofit organizations

New Mexico
Wemagination Center
4010 Copper, N.E.
Albuquerque, NM
(505) 268–8580
E-mail: *wedonate@unm.edu*

New York
ERC Community Warehouse
21428 Route 22
Hoosick Falls, NY 12090
(518) 686–7540
www.erccw.org
Accepts donated property and sells it at low prices

Hudson Valley Materials Exchange
Building 404
1101 First Street
Stewart International Airport
New Windsor, NY 12553
(845) 567–1445
www.hvmaterialsexchange.com
Provides materials for individual artists and nonprofit organizations

INWRAP
Industrial Waste Recycling and Prevention Program
29-10 Thompson Avenue

Long Island City, NY 11101
(718) 786-5300
Provides materials for individuals and nonprofit organizations

Materials for the Arts
33-00 Northern Boulevard
Long Island City, NY 11101
(718) 729-3001
www.mfta.org
Provides materials for nonprofit arts organizations

Materials Resource Center
1521 Lincoln Avenue
Holbrook, NY 11741
(631) 580-7290
www.materialresourcecenter.org

Materials Reuse Project
275 Oak Street
Buffalo, NY 14203
(716) 845-6500
www.buffaloalliance.org
Provides materials for schools and nonprofit organizations

Western New York Materials Exchange
GLOW Solid Waste
3837 West Main Street Road
Batavia, NY 14020-9404
(800) 836-1154
www.co.genesee.ny.us
Publishes a newsletter identifying area businesses disposing of equipment and materials

North Carolina
The Scrap Exchange
Recycling for the Creative Arts
548 Foster Street
Durham, NC 27701
(919) 688-6960
www.scrapexchange.org
Provides materials for artists and nonprofit organizations

Ohio

Art & More
SWACO
4149 London-Groveport Road
Grove City, OH 43123-9522
(314) 297-8561

Crayons to Computers
1350 Tennessee Avenue
Cincinnati, OH 45229
(513) 482-3290
www.crayons2computers.org
Provides materials for nonprofit arts organizations

ReUse Thrift Store
100 N. Columbus Road
Athens, Ohio 45701
(740) 594-5103
www.reuseindustries.org
Provides materials for artists and nonprofit organizations

Oregon

SCRAP
School and Community Research Action Project
3901A N. Williams
Portland, OR 97227
(503) 294-0769
www.scrapaction.org
Provides materials for individual artists and nonprofit organizations

MECCA
Materials Exchange Center for Community Arts
449 Blair Boulevard
Eugene, OR
(541) 302-1810
www.materials-exchange.org
Provides materials for individual artists and nonprofit organizations

Pennsylvania

Please Take Materials Project
Creative Artists' Resource Project
2026 East York Street
Philadelphia, PA 19125-1221
(215) 739-2583
www.pleasetake.org
Provides materials for individual artists and nonprofit organizations

Rhode Island

Recycling for RI Education
95 Hathaway Center
Providence, RI 02907
(401) 781-1521
www.rrie.org
Provides materials for nonprofit arts organizations

Tennessee

Materials for the Arts
Community Resource Center
416 Metroplex Drive
Nashville, TN
(615) 781-1086
www.community-resource-center.com
Provides materials for individual artists and nonprofit organizations

Vermont

The ReStore
186 River Street
Montpelier, VT 04602
(802) 229-1930
www.therestore.org
Provides materials for individual artists and nonprofit organizations

Washington

Second Use
7953 Second Avenue South
Seattle, WA 98108
(206) 763-6929
www.seconduse.com
Provides materials for individual artists and nonprofit organizations

Sources for free supplies are not limited to city-run agencies or private organizations that sponsor materials exchange programs. Artists may themselves contact local businesses and ask directly for needed supplies. As an example, Eric Rudd, former director of the Contemporary Artists' Center in North Adams, Massachusetts, an artist community that emphasizes printmaking, noted that he has collected sundry machines, printing presses, and artists quality papers ($50,000 worth, at retail value, from Strathmore Paper), as well as a variety of office supplies and furniture. "You can get some very good equipment if you just ask, and know whom to ask," he stated. "It's much easier getting materials than money."

Certainly, there is more publicly listed information on businesses that donate money to the artist; corporations—manufacturers, wholesalers, and retailers—that make donations of the products they produce usually don't do so regularly and are generally loath to advertise this practice, not wishing to undermine their commercial endeavors with philanthropy. "We don't publicize our donations too much," Stacy Wygant, a spokeswoman at International Paper Company, said. "We want to be known for selling paper, not giving it away." However, the managers of each of the company's thirty papermaking mills around the country are given the latitude to donate old computers and other office supplies, cash and reams of paper (when available) to local nonprofit (including schools) groups, with the proviso that the recipients cannot resell the items.

Almost all corporations donate material and products at one point or another. Just as with cash donations to arts and other groups, this kind of giving depends on the financial well-being of the business and on which products are in ample supply. Some formerly generous companies may go years without making a simple donation. It is often the case that corporations that donate money to the arts also give materials. Polaroid, for instance, has its Polaroid Foundation, which gives cash awards, but artists may also write to the company's curator with requests for film, cameras, and anything else the company makes. The request must cite the needs of a specific photographic or cinematographic project.

Although some companies will accept telephone solicitations for donations, eventually all will need a letter that states with some specificity what products will be needed, how those products are to be used in the creation of an art project, what the art will look like, and who will benefit from that project. The letter allows the company to examine the project's merits as well as protecting the person within the company who actually makes the donation in the event of an audit. The letter should also note the artist's qualifications and competence in carrying out the project and any sponsoring organization, such as a funding source or art gallery that plans to exhibit the completed work.

Harold Gulamerian, president of Utrecht Manufacturing Corporation, which creates paints and other art materials, noted that he is contacted

frequently by artists who need something. "They usually call," he stated. "Some write. I prefer not to get phone calls, but the amount of time it takes telling someone to write and not to call might as well be used listening to what they want. They'll still need to put it all in a letter eventually, though."

Although Utrecht is based in Brooklyn, New York, Gulamerian is contacted by artists from all over the country. He decides what to give based on product availability and whether or not what "the artist is talking about appeals to me. If the product they want is in short supply, I tend to say 'no.' But if an artist wants product X, and I happen to have a lot of product Y, I'm not going to unload Y on him. I'll try to give him what he wants. Of course, if the artist wants a million different things, I'd try to give him, say, a 20 percent discount."

Emergency Funds for Artists

A lot may happen to an artist or artisan in a career: Important sales, prestigious awards, museum exhibitions, write-ups in major magazines. They may also lose much of their work in a studio fire or fall off a ladder while creating a mural. The glamour part of the arts and crafts world is much better documented than the catastrophes that may place an artist's life or career in jeopardy. A high percentage of artists and craftspeople have no health or studio insurance, creating a small margin for any type of sickness or accident that may occur.

"Injury and illness top the list" as reasons that craftspeople regularly apply to the Craft Emergency Relief Fund, according to Dorothy Bocian, assistant director. The fund, which has been in existence since 1985, provides both loans (a no-interest "quick loan" up to $3,500 and a low-interest "Phoenix loan" up to $8,000) to help craftspeople get back on their feet and a $1,000 grant for people with chronic or terminal illnesses and who are unlikely to be rehabilitated.

At Change, Inc., a foundation that Robert Rauschenberg set up in 1971 to aid needy artists facing substantial medical expenses (and later expanded to include damage to a studio, potential eviction, high utility charges, and other emergencies), there are no loans but

only awards to qualifying artists, up to $1,000. Additionally, whereas Craft Emergency Relief Fund has an application form, Change, Inc., only requires applicants to submit a letter detailing the nature of their emergency. Still, the basic procedure is the same. An individual describes a major problem in his or her life, offering some form of proof of both the catastrophe (such as bills or estimates and accident reports) and an inability to pay (the previous year's tax return), as well as some indication of the professional's standing as an artist or artisan (résumé, reviews, announcement of a performance, perhaps a letter or two of reference)—students are not eligible.

There are a number of emergency funds and loan programs for artists and craftspeople, all with their own procedures and limited grant-making budgets. Uniting almost all of them is the fact that they were created and funded primarily by artists wanting to help others in distress. Change, Inc., was established by Rauschenberg and his accountant, Rubin Gorewitz, to systematize the artist's habitual generosity, which consisted largely of simply handing out cash to people who needed it. "I was doing his taxes one year," Rubin Gorewitz said, "and I told him, based on what he had earned, what he owed the government. He said that was impossible; he said that he didn't have any money left, because he had been giving away so much. He expected a big deduction, not to owe anything to the government."

The following organizations offer financial aid for fine artists and craftspeople:

Aid to Artisans, Inc.
14 Brick Walk Lane
Farmington, CT 06032
(860) 947-3344
www.aid2artisans.org
Provides assistance in product development and design consultation, business training, and marketing assistance through bringing new artisan products to major venues, direct grants to artisan groups through ATA's Amex Grants Programs in India and Mexico, as well as through its own small grants program.

Artists Community Federal Credit Union
155 Avenue of the Americas
New York, NY 10013-1500
(212) 366-5669
This membership credit union offers savings accounts, investment programs, and loans for artists in all disciplines. To become a member, you need to open an investment account (share/money market, certificates of deposit, or IRA), complete an application, and pay an inexpensive one-time membership fee.

Artists Fellowship
c/o Salmagundi Club
47 5th Avenue
New York, NY 10003
(212) 255-7740
Grants for emergency aid to visual artists and their families, primarily in New York

Artist Trust
1835 12th Avenue
Seattle, WA 98122-2437
(206) 467-8734
(866) 21TRUST
www.artisttrust.org
Artist Trust administered the Artists' Quake Aid (AQUA) relief fund program, through which a total of $40,000 was awarded to forty-eight artists in awards ranging from $250 to $1,500.

Change, Inc.
P.O. Box 54
Captiva, FL 33924
(212) 473-3742
Up to $1,000 is available for medical, living, or other emergencies. Open to artists of all disciplines, with no geographical restrictions; however, students are not eligible.

Chicago Artists' Coalition
Ruth Talaber Artists' Emergency Fund
11 East Hubbard
Chicago, IL. 60611
(312) 670-2060
www.caroline.org
Emergency grants to $500 for visual artists in Illinois facing fire, flood, medical, and other unexpected, catastrophic events.

Chicago Artists' Coalition
Federal Credit Union
11 East Hubbard

Chicago, IL. 60611
(312) 670-2060
www.cacoline.org
Lower interest rates on loans

Craft Emergency Relief Fund, Inc.
P.O. Box 838
Montpelier, VT 05601-0838
(802) 229-2306
www.craftemergency.org
Immediate support to professional craftspeople facing career-threatening emergencies such as fire, theft, illness, and natural disasters

J. Happy Delpech Foundation
1579 North Milwaukee, Suite 211
Chicago, IL 60622
(312) 342-1359
Grants of up to $250 to artists in the Midwest with AIDS or serious illness

Florida Craftsmen, Inc.
501 Central Avenue
St. Petersburg, FL 33701-3703
(727) 821-7391
www.floridacraftsmen.net
Florida Craftsmen, Inc. has contributed to the Craft Emergency Relief Fund, making it possible for members to benefit from two sources of funding when they apply to CERF.

Glass Art Society
1305 Fourth Avenue Suite 711
Seattle, WA 98101-2401
(206) 382-1305
www.glassart.org
GAS has contributed to the "G.A.S. in CERF" fund, making it possible for GAS members to benefit from two sources of funding within the Craft Emergency Relief Fund.

The Adolph and Esther Gottlieb Foundation
Emergency Assistance Program
380 West Broadway
New York, NY 10012
(212) 226-0581
www.gottliebfoundation.org

Grants of up to $10,000 to assist established painters, printmakers, and sculptors (working in a "mature phase" for over 10 years) facing an unforeseen, catastrophic incident, and who lack the resources to meet that situation. Each grant is given as a one-time assistance for a specific emergency, examples of which include fire, flood, or emergency medical need.

Indian Artist Disaster Relief Fund
c/o Arizona Indian Arts Alliance (AAIA)
Box 250
Tumacacori, AZ 85640
(520) 398-2226
www.indianartistsofamerica.com
In the process of forming, the Indian Artist Disaster Relief Fund intends to provide funds for American Indian artists who have suffered losses through death, long-term illness, or other tragedy.

New York Artists Equity Association
498 Broome Street
New York, NY 10013
(212) 941-0130
www.anny.org
Interest-free loans for health insurance and emergency medical aid are available to visual artists living in the New York tri-state area (New York, New Jersey, Connecticut). Maximum loan amount $2,000.

Photographers + Friends United Against AIDS
594 Broadway, Suite 508
New York, NY 10012
(212) 219-2672
Apply to the Critical Needs Fund

Pollock-Krasner Foundation
863 Park Avenue
New York, NY 10021
(212) 517-5400
www.pkf.org
Financial assistance to artists of recognizable merit and financial need working as painters, sculptors, mixed media, and installation artists. The Foundation has also established an emergency grant program to deal with the crisis of September 11th.

Tennessee Association of Craft Artists
P.O. Box 120066

Nashville, TN 37212-0066

(615) 385-1904

Those members of the association who qualify for CERF no-interest loans (full-time professional craft artists experiencing a career-threatening emergency) are provided additional assistance.

Visual Aid

731 Market Street, Suite 600

San Francisco, CA 94103

(415) 777-8242

www.visualaid.org

Visual Aid, an organization that encourages artists with life-threatening illnesses to continue their creative work, offers grants to visual artists with AIDS, cancer, or other life-threatening illnesses. Visual Aid serves professional visual artists in the nine-county San Francisco Bay Area. Grants take the form of vouchers for art supplies. In addition, Visual Aid's grantee services include volunteer studio assistants, career skills workshops, an exhibition program, a résumé service, an Archive of grantee artists, and an Art Bank, through which grant recipients can receive donated art supplies.

Wheeler Foundation

P.O. Box 300507

Brooklyn, NY 11230

(718) 951-0581

Fellowships and emergency grants to visual artists of color who are at least 21 and living in the tri-state greater New York City area. Grants from $500 to $2,000.

The following organizations offer financial aid for artists of many different disciplines:

Aid for Aids

8235 Santa Monica Blvd., Suite 200

West Hollywood, CA 90046

(323) 656-1107

www.aidforaids.net

ANEW (Artists Now Exhibiting Work)

3301 N.E. 17th Court

Fort Lauderdale, FL 33305

(954) 560-3464

www.anew.org

ANEW is a membership organization that helps provide artists of all disciplines with marketing and exhibiting assistance. For emergency assistance, membership is preferred but not required.

Montana Arts Council
P.O. Box 202201
Helena MT 59620-2201
(406) 444-6430
www.art.state.mt.us
Opportunity Grants are given throughout the year to enable the Council to respond to artists or organizations opportunities or emergencies.

UNESCO
International Fund for the Promotion of Culture
1 rue Miollis
75732 Paris France
33 1 45 68 42 15
Funds are designed for artists with a disability; artists facing exceptional emergency situations; however, they are limited and principally destined for beneficiaries from developing countries.

Will Rogers Institute
1640 Marengo Street, Suite 406
Los Angeles, CA 90033
(877) 957-7575
(323) 223-7773
www.wrinstitute.org
Subsidizes therapeutic medical care, including prescriptions, equipment, physical therapy, occupational therapy, and more. To qualify for assistance, the applicant is required to have worked 30 months out of the past 60 months as a full-time employee in the entertainment industry. Each person who requests assistance must fill out an application to explain financial hardship.

Legal Assistance for Artists

When the first volunteer lawyers for the arts group was created in New York City in 1969, the idea was simple: Help artists and arts organizations understand their legal rights and obligations through workshops and one-on-one consultations. These VLA groups, which now exist in twenty-six states and the District of Columbia, are information clearinghouses, most of the time providing advice on contracts and licenses, how groups should incorporate and run their organizations, and how individuals and organizations can protect their intellectual property (copyrights, trademarks, and patents). A much smaller amount of their time is helping individuals and groups resolve legal disputes, but a local VLA chapter may be an artist's first recourse

when a problem arises. For good reason: At a relatively small cost—$20 or $30—artists may discuss their dispute with a practicing attorney, who will provide a legal analysis of the problem and offer an opinion on how it might be settled. That type of counseling is both the VLA's greatest strength and shortcoming, because these groups arm people with information about their rights but don't actually provide the costly legal representation to protect those rights. At times, VLA attorneys might write a letter to an offending party, threatening legal action, if some wrong were not corrected, although they are more likely to refer artists and organizations to an arts-knowledgeable lawyer who has registered with the VLA group. That lawyer would take the case at a regular or reduced fee, sometimes accepting artwork in lieu of a fee, occasionally working on a contingency basis (they are only paid out of their clients' settlement), usually requiring a retainer and charging hourly fees. Some lawyers do take cases on a pro bono, or volunteer, basis, but, as one staff attorney for Texas Accountants and Lawyers for the Arts said, "lawyers are reluctant to get themselves in situations where they have to take time away from their paying clients." Going to trial is an expensive proposition, with court costs and a lawyer's fees (hundreds of dollars per hour, usually) that add up to thousands (or tens of thousands) of dollars. If artists had that kind of money, they wouldn't need charitable organizations in the first place. The American legal system is so expensive, time-consuming, and emotionally draining that "we never recommend litigation," said William Rattner, executive director of Lawyers for the Creative Arts, a VLA group in Chicago, Illinois.

Recognizing this gap between free legal advice and costly legal representation, a third approach is being tried by a number of VLAs around the United States. Arts resolution services, or mediation, are being offered by volunteer lawyers groups in California, Colorado, Georgia, Illinois, Missouri, Texas, and the District of Columbia. In mediation, the two parties are brought together in order to resolve differences, if not amicably at least in a less costly manner. "Mediation is cheap, it's private, it's fast, and you don't need a lawyer," Rattner said, adding that "it makes people feel better afterwards, than if they had gone through litigation or the small-claims court system, and that is the whole point." That feel-better quality arises from the fact that "you get a chance to tell

your story, in a more comfortable setting, just you, the other person, and a mediator. It's not like litigation, where you have to answer questions. There is a great value in just venting." In addition, the other side is able to tell its version ("some people aren't fully aware that there is another side"). Another benefit is the fact that the two sides will themselves craft a resolution and are not "reliant on a judge with a gavel."

The mediator—who may be a practicing lawyer, professional artist, arts administrator, or an accountant who has received special training in problem resolution—acts as a referee, conducting a conversation, keeping it on track and generally trying to clear the air. Part of the mediation session involves caucuses, a form of "shuttle diplomacy," in which the mediator meets separately with one side, then the other, to determine areas of possible agreement and generally edging both sides towards a common goal or consensus.

Not every problem or dispute can be handled through mediation. Mediation relies upon the good will of each side to want to resolve the matter short of hiring lawyers, through a structured conversation they enter into voluntarily. Someone who claims that "I'm reasonable, but the other guy isn't," probably would have little faith that mediation could accomplish anything. Mediation is used, and is useful, when there is a preexisting relationship that the two sides—say, a visual artist and an art dealer—want to maintain. However, it may also be the case that "people don't want to be perceived as jerks and are willing to sit down and hear the other person out," said Jane Lowry, executive director of Texas Accountants and Lawyers for the Arts. "Eighty-five percent of the time, you can get parties to mediation and, once you establish the ground rules—no interrupting, let everyone have their say—you find that empathy kicks in. Most people want to do the right thing. People will be happy with the outcome, which you never see in court."

Below is a list of volunteer lawyers for the arts organizations around the country. In states where no such group exists, artists may contact the state bar association for the names of lawyers who handle arts and entertainment law matters, some of whom may take a case on a pro bono basis. (Those with asterisks have arts mediation programs.)

California

California Lawyers for the Arts (Statewide)★
www.calawyersforthearts.org

Beverly Hills Bar Association Barristers Committee for the Arts
300 S. Beverly Drive
Beverly Hills, CA 90212
(310) 553-6644
(310) 344-8720

California Lawyers for the Arts (Oakland)
1212 Broadway, Suite 834
Oakland, CA 94612
(510) 444-6351
E-mail: *oakla@there.net*

California Lawyers for the Arts (Sacramento)
926 J Street
Sacramento, CA 95814
(916) 442-6210
E-mail: *clasacto@aol.com*

California Lawyers for the Arts (San Francisco)
Fort Mason Center, Building C
San Francisco, CA 94123
(415) 775-7200
www.calawyersforthearts.org

California Lawyers for the Arts (Santa Monica)
1641 18th Street
Santa Monica, CA 90404
(310) 998-5590
E-mail: *usercla@aol.com*

San Diego Lawyers for the Arts
Craddock Stropes, Lawyers for the Arts
625 Broadway
San Diego, CA 92101
(619) 454-9696
www.sandiegoperforms.com/volunteer/lawyer_arts.html

Colorado

Colorado Lawyers for the Arts★
P.O. Box 48148
Denver, CO 80204

(303) 722-7994
www.coloradoartslawyers.org

Connecticut

Connecticut Volunteer Lawyers for the Arts
Connecticut Commission on the Arts
755 Main St.
Hartford, CT 06103
(860) 256-2800
www.ctarts.org/vla.htm

District of Columbia

Washington Area Lawyers for the Arts★
1300 I Street, N.W.
Washington, D.C. 20005
(202) 289-4295
www.thewala.org

Florida

Florida Volunteer Lawyers for the Arts
1350 East Sunrise Boulevard
Ft. Lauderdale, FL 33304
(954) 462-9191, ext. 324
www.artserve.org

Volunteer Lawyers for the Arts of Pinellas County
14700 Terminal Blvd., Suite 229
Clearwater, FL 33762
(727) 453-7860
www.pinellasarts.org/smart_law.htm

Georgia

Southeast Volunteer Lawyers for the Arts★
c/o Bureau of Cultural Affairs
675 Ponce de Leon Avenue, N.W.
Atlanta, GA 30308
(404) 873-3911
www.glarts.org

Illinois

Lawyers for the Creative Arts★
213 West Institute Place
Chicago, IL 60610
(312) 649-4111
www.law-arts.org

Kansas
Mid-America Arts Resources
c/o Susan J. Whitfield-Lungren, Esq.
P.O. Box 363
Lindsborg, KS 67456
(913) 227-2321
E-mail: *swhitfield@ks-usa.net*

Louisiana
Louisiana Volunteer Lawyers for the Arts
225 Baronne Street
New Orleans, LA 70112
(504) 523-1465
www.artscouncilofneworleans.org

Maine
Maine Volunteer Lawyers for the Arts
c/o Terry Cloutier, Esq.
477 Congress Street
Portland, ME 04101
(207) 871-7033
E-mail: *tcloutier@lambertcoffin.com*

Maryland
Maryland Lawyers for the Arts
113 West North Avenue
Baltimore, MD 21201
(410) 752-1633
www.mdartslaw.org

Massachusetts
Volunteer Lawyers for the Arts of Massachusetts, Inc.
249 A Street
Boston, MA 02110
(617) 350-7600
www.vlama.org

Michigan
ArtServe Michigan
Volunteer Lawyers for the Arts & Culture
17515 West Nine Mile Road
Southfield, MI 48075-4426
(248) 557-8288, ext. 14
www.artservemichigan.org

Minnesota

Springboard for the Arts
Resources and Counseling for the Arts
308 Prince St., Suite 270
St. Paul, MN 55101
(651) 292-4381
www.springboardforthearts.org

Missouri

St. Louis Volunteer Lawyers and Accountants for the Arts★
6128 Delmar
St. Louis, MO 63112
(314) 863-6930
www.vlaa.org

Montana

Montana Volunteer Lawyers for the Arts
P.O. Box 202201
Helena, MT 59620-2201
(406) 444-6430
E-mail: *mac@state.mt.us*

New Hampshire

Lawyers for the Arts/New Hampshire
New Hampshire Business Committee for the Art (NHBCA)
One Granite Place
Concord, NH 03301
(603) 224-8300
www.nhbca.com/lawyersforarts.php

New Jersey

New Jersey Volunteer Lawyers for the Arts
c/o New Jersey Law Journal
230 Mulberry Street
Newark, NJ 07101
(973) 854-2924
www.amlaw.com

New York

Volunteer Lawyers for the Arts★
1 East 53rd Street
New York, NY 10022
(212) 319-2787
www.vlany.org

North Carolina
North Carolina Volunteer Lawyers for the Arts
P.O. Box 26513
Raleigh, NC 27611-6513
(919) 699-NCVLA
www.ncvla.org

Ohio
Volunteer Lawyers and Accountants for the Arts-Cleveland
113 St. Clair Avenue
Cleveland, OH 44114
(216) 696-3525

Toledo Volunteer Lawyers and Accountants for the Arts
608 Madison
Toledo, OH 43604
(419) 255-3344

Oklahoma
Oklahoma Accountants and Lawyers for the Arts
211 North Robinson
Oklahoma City, OK 73102
(405) 235-5500
E-mail: *eking@gablelaw.com*

Oregon
Northwest Lawyers and Artists
Oregon Lawyers for the Arts
621 S.W. Morrison Street
Portland, OR 97205
(503) 295-2787
E-mail: *artcop@aol.com*

Pennsylvania
Philadelphia Volunteer Lawyers for the Arts
251 South 18th Street
Philadelphia, PA 19103
(215) 545-3385
www.pvla.org

ProArts
Pittsburgh Volunteer Lawyers for the Arts
425 Sixth Avenue
Pittsburgh, PA 15219-1835
(412) 391-2060
www.proarts-pittsburgh.org/vla.htm

Rhode Island

Ocean State Lawyers for the Arts
P.O. Box 19
Saunderstown, RI 02874
(401) 789-5686
www.artslaw.org

South Dakota

South Dakota Arts Council (SDAC)
800 Governors Drive
Pierre, SD 57501
(605) 773-3131

Texas

Texas Accountants & Lawyers for the Arts★
1540 Sul Ross
Houston, TX 77006
(713) 526-4876
www.talarts.org

Utah

Utah Lawyers for the Arts
P.O. Box 652
Salt Lake City, UT 84110
(801) 533-8383

Washington

Washington Lawyers for the Arts
819 North 49th
Seattle, WA 98103
(206) 328-7053
www.wa-artlaw.org

Index

Books from Allworth Press

Allworth Press is an imprint of Allworth Communications, Inc. Selected titles are listed below.

Fine Art Publicity: The Complete Guide for Galleries and Artists, Second Edition
by Susan Abbott (paperback, 6 × 9, 192 pages, $19.95)

Artists Communities: A Directory of Residences that Offer Time and Space for Creativity, Third Edition
by Alliance of Artists' Communities (paperback, 6 × 9, 336 pages, $24.95)

Guide to Getting Arts Grants
by Ellen Liberatori (paperback, 6 × 9, 272 pages, $19.95)

The Artist–Gallery Partnership: A Practical Guide to Consigning Art, Revised Edition
by Tad Crawford and Susan Mellon (paperback, 6 × 9, 216 pages, $16.95)

Legal Guide for the Visual Artist, Fourth Edition
by Tad Crawford (paperback, 8 ½ × 11, 272 pages, $19.95)

Business and Legal Forms for Fine Artists, Third Edition
by Tad Crawford (paperback, includes CD-ROM, 8 ½ × 11, 176 pages, $24.95)

The Fine Artist's Career Guide, Second Edition
by Daniel Grant (paperback, 6 × 9, 320 pages, $19.95)

The Business of Being an Artist, Third Edition
by Daniel Grant (paperback, 6 × 9, 352 pages, $19.95)

An Artist's Guide: Making It in New York City
by Daniel Grant (paperback, 6 × 9, 256 pages, $19.95)

Marketing and Buying Art Online: A Guide for Artists and Collectors
by Marques Vickers (paperback, 6 × 9, 224 pages, $19.95)

The Fine Artist's Guide to Marketing and Self-Promotion, Revised Edition
by Julius Vitali (paperback, 6 × 9, 256 pages, $19.95)

The Artist's Quest for Inspiration, Second Edition
by Peggy Hadden (paperback, 6 × 9, 272 pages, $19.95)

The Artist's Complete Health and Safety Guide, Third Edition
by Monona Rossol (paperback, 6 × 9, 416 pages, $24.95)

Please write to request our free catalog. To order by credit card, call 1-800-491-2808 or send a check or money order to Allworth Press, 10 East 23rd Street, Suite 510, New York, NY 10010. Include $6 for shipping and handling for the first book ordered and $1 for each additional book. Eleven dollars plus $1 for each additional book if ordering from Canada. New York State residents must add sales tax.

To see our complete catalog on the World Wide Web, or to order online, you can find us at **www.allworth.com**.